ARTISTS OF ISRAEL: 1920-1980

This exhibition has been made possible by grants
from the National Endowment for the Arts, a
Federal agency; the Joe and Emily Lowe
Foundation; the Federal Council on the Arts and
the Humanities; and El Al Israel Airlines

Published by Wayne State University Press for The Jewish Museum/New York Detroit, 1981

ARTISTS OF ISRAEL: 1920-1980

Exhibition curator Susan Tumarkin Goodman
Essays by Moshe Barasch, Yona Fischer, and Ygal Zalmona

THE JEWISH MUSEUM/NEW YORK

February 19–May 17, 1981

Library of Congress Cataloging in Publication Data

Jewish Theological Seminary of America. Jewish Museum.
 Artists of Israel, 1920-1980.

 Exhibition itinerary also includes: Tucson Museum of Art, Tucson, Ariz.,
Oct. 11-Dec. 6, 1981; Memorial Art Gallery, Rochester, N.Y., Jan. 4-Mar. 1,
1982; Metropolitan Museum, Coral Gables, Fla., Mar. 22-May 1, 1982.
 Bibliography: p.
 Includes index.
 1. Art, Israeli — Exhibitions. 2. Art, Modern — 20th century — Israel —
Exhibitions. I. Goodman, Susan Tumarkin. II. Title.
N7277.J48 1981 709′.5694′074013 80-6231
ISBN 0-8143-1686-7
ISBN 0-8143-1687-5 (pbk.)

Exhibition Itinerary

THE JEWISH MUSEUM/NEW YORK
February 19–May 17, 1981

TUCSON MUSEUM OF ART
Tucson, Arizona
October 11-December 6, 1981

MEMORIAL ART GALLERY OF THE UNIVERSITY OF ROCHESTER
Rochester, New York
January 4-March 1, 1982

METROPOLITAN MUSEUM AND ART CENTER
Coral Gables, Florida
March 22-May 1, 1982

Editor: Jean Owen
Art Director: Richard Kinney
Catalogue Designer: Don Ross
Typography: Poly Tech
Printing: Thomson-Shore
Installation: Ralph Appelbaum

Lenders to the Exhibition

Julian J. and Joachim Jean Aberbach, New York
Yaacov Agam, Paris
Selma and Stanley I. Batkin, New York
Mrs. Rosine Bemberg, Paris
Shelomo and Tina Ben-Israel, Hollis, New York
Mr. and Mrs. Aaron Berman, New York
Mr. and Mrs. Menashe Blatman, Tel Aviv
Mr. and Mrs. Michael Caspi, Tel Aviv
Mr. and Mrs. Moshe Castel, Tel Aviv
Trude Dothan, Jerusalem
Samuel Dubiner, Ramat Gan
Jud and Vivian Ebersman, New York
Benni Efrat, New York
Mr. and Mrs. Samuel M. Eisenstat, New York
Mr. and Mrs. Herman Elkon, New York
Yona Fischer, Jerusalem
Sidney Frank, New York
Catherine Goetschel, New York
Michael Gross, Haifa
Joseph D. Hackmey, Tel Aviv
Judd Hammack, Santa Monica
Marilyn and Gary Hellinger,
 Greenwich, Connecticut
Yhudit Hendel, Haifa
Richard Hollander, Kansas City
Susan Jacobowitz, New York
Janet and George Jaffin, New York
Alvin and Judith Krauss, New York
Mr. and Mrs. Ben Kukoff, Los Angeles
Mrs. Sara Levi, Tel Aviv
Aaron and Barbara Levine, Rockville, Maryland
Albert A. List Family Collection,
 Greenwich, Connecticut
Ronald D. Mayne, Roslyn Heights, New York
The McCrory Corporation, New York
Joshua Neustein, New York
Mr. and Mrs. Arnold Newman, New York
Geraldine Nuckel, Little Ferry, New Jersey
Jane Bradley Pettit, Milwaukee
Dina and Raphael Recanati, New York

Dr. and Mrs. Don Rubell, New York
Buky Schwartz, New York
Yehiel Shemi, Kibbutz Cabri
Mr. and Mrs. Stephen L. Singer, New York
Mr. and Mrs. Jerome L. Stern, New York
Lee and Elizabeth Turner, Kansas
Mr. and Mrs. Clement J. Wyle, New York
Ayala Zacks-Abramov, Tel Aviv
Mr. and Mrs. Israel Zafrir, Tel Aviv

Albright-Knox Art Gallery, Buffalo, New York
Brandeis University Art Collection,
 Rose Art Museum
The Solomon R. Guggenheim Museum, New York
Haifa Museum of Modern Art
Hirshhorn Museum and Sculpture Garden,
 Smithsonian Institution
The Israel Museum, Jerusalem
The Jewish Museum, New York
Los Angeles County Museum of Art
The Metropolitan Museum of Art, New York
Museum of Art, Carnegie Institute, Pittsburgh
The Museum of Modern Art, New York
Rubin Museum Foundation, Tel Aviv
Skirball Museum, Hebrew Union College,
 Los Angeles
Stedelijk Museum, Amsterdam
Trustees of The Tate Gallery, London
The Tel Aviv Museum

Bineth Gallery, Tel Aviv
Engel Gallery, Jerusalem
Givon Fine Art, Tel Aviv
Gordon Gallery, Tel Aviv
Sara Levi Art Gallery, Tel Aviv
Marlborough Fine Art (London) Ltd.
Betty Parsons Gallery, New York
Max Protetch Gallery, New York
Pucker-Safrai Gallery, Boston
Bertha Urdang Gallery, New York

Contents

Foreword

Seventeen years have gone by since an exhibition of Israeli art was seen in New York (shown at The Jewish Museum, it was organized for The Museum of Modern Art by William Seitz in 1964). While that effort was a pioneering venture, it was limited in scope, and much has happened in the art of Israel since that time.

The current exhibition reflects a different approach and set of objectives, and we are grateful to the National Endowment for the Arts, which initially recognized the importance of this project, as well as to the Joe and Emily Lowe Foundation. Through their generosity The Jewish Museum has been able to mount this first historical retrospective in America of Israeli art.

An exhibition of this dimension could only have been achieved with the support and encouragement of persons in many governmental agencies. Curatorial travel and assistance in transportation of the art from Israel were made possible by the Ministry of Foreign Affairs in Jerusalem, in particular Aviva Briskman, Department of Cultural and Scientific Relations of the Ministry of Foreign Affairs, and David Rivlin, Director of the Department of Cultural and Scientific Relations of the Ministry of Foreign Affairs. In New York the Israel Consulate lent its full cooperation, and we especially thank Yoseph P. Kedar, Consul General, and Natan Shaham, former Consul for Culture and the Arts, as well as Consul Chaim Rosen-Thal. Their help did not in any way inhibit The Jewish Museum's complete freedom in the selection of artists or individual works of art.

We wish to acknowledge the generosity of the Federal Council on the Arts and Humanities, which is responsible for indemnification of art shipped from Israel.

Three major museums in Israel were more than gracious in lending some of their prized works of art and in providing assistance in countless ways. To Martin Weyl, Chief Curator of The Israel Museum, Jerusalem, Marc Scheps, Director of The Tel Aviv Museum, and Gideon Tadmor, Director of the Museum of Modern Art, Haifa, our special thanks.

Much credit is due to Susan Goodman, Chief Curator of The Jewish Museum, who has met with enthusiasm the difficult task of selecting "Artists of Israel: 1920-1980." Her criteria for judgment appear in her Preface.

The Jewish Museum is especially pleased to originate this exhibition of the work of thirty-six Israeli artists and to portray another view of Israeli life than that of political conflict and the struggle for survival.

Joy Ungerleider-Mayerson
Director, 1972-1980

Acknowledgments

In order to become familiar with the art of Israel, which has been sparsely reproduced and critically interpreted in English, it was necessary to rely upon many individuals in Israel, who provided invaluable assistance. They enabled me to become acquainted with the work of numerous Israeli artists and to learn the inflections and subtleties in the art of this small but complex country. Joy Ungerleider-Mayerson has acknowledged crucial contributions by organizations and individuals, and I would like to add my expression of gratitude. I cannot adequately thank Yona Fischer and Ygal Zalmona for their valued guidance, information, and support. In addition to their assistance, they, along with Moshe Barasch, prepared the perceptive essays which enrich the catalogue.

My deepest gratitude goes also to the museum professionals, scholars, and critics in Israel who provided invaluable counsel, notably Marc Scheps, Sara Breitberg, Ellen Ginton, Gideon Ofrat, and Meir Ronnen. Special thanks go to Ziva Amishai-Maisels, who gave a great deal of time to this project, making many fruitful suggestions for both the exhibition and the catalogue, and to Stephanie Rachum, who, in addition to her personal help, was of great assistance in coordinating the transportation of the works from Israel.

Other individuals whose assistance I gratefully acknowledge include those who gave generously of their expertise and judgment: Meira Geyra, Mike Gladstone, Henry Feingold, Jacob Baal-Tshuva, and Sandy Batkin.

It is largely due to the efforts of Bertha Urdang, whose Rina Gallery in New York was the first in this country to open a window to a number of important avant-garde Israeli artists, that many of us were able to keep abreast of developments in Israeli art over the last decade.

Our sincerest appreciation must be expressed to Stanley Batkin, Paul Frankel, Milton Glaser, George Jaffin, Jerry Stern, and Bank Leumi for generous contributions toward the poster and exhibition.

The lenders, listed elsewhere, who agreed to part with their works for the duration of the exhibition's travels have our deepest thanks; without them "Artists of Israel" would not have been possible.

I thank all those on the museum staff who gave their time, talents, and energies to this project; from among them Devora Tulcensky and Carolyn Cohen should be singled out for their capable and willing assistance with exhibition coordination and catalogue preparation.

My sincerest gratitude is to Joy Ungerleider-Mayerson, former Director of The Jewish Museum, for providing invaluable guidance, encouragement, and vision from the inception of this project.

S. T. G.

Preface

Artists of Israel is intended to recognize a country which, though small and geographically remote, has been able to produce painting and sculpture of a quality and sophistication comparable to that of the major Western art centers, even while building a new society under the pressure of several wars. It is now time for a historical reflection on these artists, whose work is being evaluated with increasing seriousness in the artistic centers of the world. Only now do we have the necessary perspective to assess what has been produced during the last six decades, so that we are able to mount the first retrospective exhibition in America of modern Israeli art. The sole previous serious investigation, more limited in scope than the present exhibition, was undertaken by The Museum of Modern Art in New York over fifteen years ago, organized by William Seitz and mounted at The Jewish Museum. Since then, knowledge of Israeli art in the West has been based on occasional exhibitions of selected Israeli artists in a few private galleries. Although many of these barriers still exist, art books now being printed in several languages and periodicals that disseminate the latest work of artists throughout the world have helped improve our understanding.

The period which we shall consider was marked by the establishment of an entirely new social and cultural system in Israel. At the beginning of the twentieth century there were no art traditions, museums, academies, or other institutions to transmit an artistic heritage from generation to generation. Many of the Jewish pioneers in Palestine hoped to create a truly "original" national art. However, while we do not discern in the works gathered here any "national" style — any quality or characteristic which distinguishes this art from that of other countries — this survey of the last sixty years does reveal that a visual statement has been formulated which is of an aesthetic level high enough to be worthy of inclusion in the major international art forums.

While we will not try to identify the style of any particular artist as "Israeli," for the purposes of this exhibition we shall concentrate on those artists who *acknowledge* Israel as their native land. And indeed, some of the intangibles in the development of an artist must relate to the time and place in which a major segment of his maturation occurs. Each of these artists is "Israeli" in the sense that his or her vision and creative orientation have been strongly conditioned by the Holy Land — its landscape, its ethnic types and costumes, its monuments and archeological remains. Each artist has had to resolve personally, in pictorial terms, the aesthetic dilemma of the Near East — the bridging of the gap between Occident and Orient. The range of reaction is broad. One group of artists embraces "local color"; another rejects it totally. A number of painters are concerned with Jewish iconography, almost an equal number with experimental abstraction.

Since Israeli art resists being divided into clearly defined movements or schools, we have organized the material around major tendencies, while at the same time examining the achievements of individual artists. The artists are examined and grouped with reference to their common search for a viable approach to style and content. While making a personal statement, each artist has also contributed to and reflects the general artistic climate of Israel during these years. The divisions by decade or common goal are provided as a guide only, since much painting obviously flows between years and generations.

In preparing this exhibition, numerous experts in Israel were consulted, yet there is no question that a personal and American perspective was brought to the selection of artists and that it may differ from an Israeli view. We have not attempted to be encyclopedic, but rather, by concentrating on those artists who, we believe, represent the highest level of a particular group or who excel in individual expression, to search for quality, new insights, and an indigenous sensibility in Israeli art. Other artists could have been included, or a smaller number shown in depth, but these thirty-six were selected because they represent the range of aesthetic sensibilities and ideas which has prevailed in Israel since the 1920s.

The greatest challenge lay in the choice of artists from the most recent decade. Those selected are now thirty-three years old and older, and are thus in mid-career. They have been in the forefront of artistic innovation for many years, but they are still actively creating and growing. Since they provide a significant and accurate reflection of today's art activity, we shall have to consider a showing of the work of the younger Israeli artists as a future project of prime importance.

The development of modern art in Israel today cannot be understood without taking into account the integration and synthesis of European and American influences. The movement of artistic talent has been a part of Israeli culture since the 1930s, when artists like Moshe Castel, Tziona Tagger, and Menachem Shemi carried back from Paris their reaction to the ferment in the art world there. From the 1950s until today, a significant group of artists matured abroad and came back to develop their skills in an Israeli context. Many leading Israeli artists produced some of their best work abroad: artists such as Menashe Kadishman, Arie Aroch, Lea Nikel, and Igael Tumarkin, to name just a few, have lived in Europe and the United States and then returned to enrich the visual culture with their personal insights and experiences. The fact that some of the works in this exhibition were created outside Israel should therefore not be surprising nor be seen as a criterion for differentiation.

The parameters of this exhibition are broad. During the six decades it spans, a number of highly articulate and intelligent artists have taken their place in the vanguard of Israeli society and developed the means to express the most significant modern tendencies in art. Because they do not embrace a single dogma or school, they are as divergent and dissimilar as Israel itself.

Susan Tumarkin Goodman
Chief Curator

Cultural Chronology

	ISRAEL HISTORY	INTERNATIONAL FINE ARTS	ISRAEL FINE ARTS
1906	40,000 Jews immigrate to Palestine, mainly from Eastern Europe (1904-17)	Cézanne dies; Picasso begins *Les Demoiselles d'Avignon;* growth of Fauvism, Expressionism	Boris Schatz settles in Jerusalem; founds Bezalel School of Arts and Crafts and a museum
1909	Founding of Deganya, the first kibbutz; founding of Tel Aviv	First Futurist Manifesto, published by Filippo Tommaso Marinetti; Cubism appears in Paris	
1911		First exhibition of the Munich group Der Blaue Reiter	
1912		Wassily Kandinsky writes *On the Spiritual in Art;* Marcel Duchamp paints *Nude Descending a Staircase*	Ticho settles in Jerusalem; Rubin makes first trip to Palestine
1913		Armory Show takes place in New York; periodical *Art in America* founded; growth of Suprematism in Russia	
1915		Naum Gabo makes first constructions in Moscow	
1916		Dada movement founded in Zurich	
1917	Balfour Declaration establishes a national homeland for the Jews in Palestine	De Stijl movement founded by Piet Mondrian and Theo van Doesburg; first issue of its magazine published	
1919	453,000 Jews immigrate to Palestine (1919-48)	Bauhaus established by Walter Gropius in Weimar; Le Corbusier and Amedée Ozenfant found the Purist movement in Paris and the review *L'Esprit nouveau*	*Ha'aretz,* Hebrew daily newspaper, founded
1920	British Mandate in Palestine; founding of the Histadrut, the General Federation of Jewish Labor; Joseph Trumpeldor dies in defense of Tel Hai; Haganah established	Gabo and Antoine Pevsner draw up Realist Manifesto in Moscow	Hebrew Artists' Association, later Association of Painters and Sculptors in Palestine, founded in Jerusalem
1921	Arab riots in Palestine	U.S.S.R. denounces avant-garde art; many artists leave as a result	Exhibition of arts and crafts at Jerusalem citadel (Tower of David); Te'atron Ivri, first professional Hebrew theater, founded

	ISRAEL HISTORY	INTERNATIONAL FINE ARTS	ISRAEL FINE ARTS
1922	Jewish population is 84,000	Gabo, El Lissitzky, and Marc Chagall go to Berlin; Chagall publishes *My Life*, etchings	Hebrew recognized as official language
1923		Kurt Schwitters publishes *Merz Review* in Hanover	First annual "Tower of David" exhibition in Jerusalem organized by Hebrew Artists' Association; Avraham Melnikov elected its fir chairman; Zaritsky and Danziger immigrate
1924		André Breton publishes first Surrealist Manifesto in Paris; Le Corbusier publishes *The City of Tomorrow*	Rubin returns from U.S.; has firs one-man show in Jerusalem; Aro Krakauer, and the poet Chaim Bialik immigrate
1925		First group exhibition of Surrealists, Paris; "International Exhibition of Decorative Arts and Modern Industry" held in Paris, marking Art Deco style	Opening of Hebrew University i Jerusalem
1926		Willem de Kooning arrives in New York	Avraham Melnikov constructs th country's first monument, *Trumpeldor Memorial at Tel Hai*
1928	The Va'ad Leumi (Jewish National Council) recognized by the Mandatory Government		Habimah Theater, founded in Moscow in 1917, moves to Tel A
1929	Riots against Jewish population	Museum of Modern Art opens in New York	Exhibition of Palestine painters a Levant fair in Tel Aviv; sixth century mosaic synagogue floor uncovered at Beit-Alpha
1931		Whitney Museum of American Art opens in New York	
1932	Jewish population is 175,000	Ben Shahn paints series of gouaches on Sacco and Vanzetti; Bauhaus moves to Berlin because of political pressure	Tel Aviv Museum opens with one-man show by Rubin; Boris Schatz dies; *Gazith*, art periodica founded by Gabriel Talphir
1933		Bauhaus closed by Hitler; eleven hundred refugee artists and architects immigrate to U.S. (1933-44)	Ardon and Steinhardt, among other artists and architects, immigrate from Germany

Cultural Chronology

	ISRAEL HISTORY	INTERNATIONAL FINE ARTS	ISRAEL FINE ARTS
1935		Works Progress Administration created by U.S. government	Architect Eric Mendelsohn works in Jerusalem, 1935-39
1936	Riots against Jewish population	Alfred H. Barr's *Cubism and Abstract Art* published	Palestine Broadcasting Service established; Palestine Orchestra, later Israeli Philharmonic Orchestra, founded by Bronislaw Huberman; first concerts conducted by Arturo Toscanini
1937	Commencement of Aliyah Beth (illegal immigration to Palestine); Peel Commission Report proposes partition of Israel into Jewish and Arab states; establishment of underground movement I.Z.L. (Irgun Zvai Leumi)	New Bauhaus opens in Chicago; Picasso's *Guernica* shown in Spanish Pavilion at Exposition Universelle, Paris; Museum of Non-Objective Art, later renamed The Solomon R. Guggenheim Museum, opens in New York; John Graham publishes *System and Dialectics of Art*, widely read among avant-garde artists	
1938		"Entartete Kunst" ("degenerate art") exhibition circulated by Nazis in Munich	Martin Buber immigrates; appointed professor of social philosophy at Hebrew University; Levanon exhibits at Venice Biennale
1939	British White Paper issued restricting Jewish immigration to 10,000 a year		Elias Newman publishes *Art in Palestine* in New York; New York World's Fair opens; Palestine participates with its own pavilion
1940			Ardon named director of Bezalel School until 1952
1941	Palmach, the Permanently Mobilized Striking Forces of the Haganah, established	Bertolt Brecht comes to U.S.; National Gallery of Art opens in Washington, D.C.	Gershom Sholem publishes *Major Trends in Jewish Mysticism*; Karl Schwartz publishes *Modern Jewish Art in Palestine*; Janco immigrates
1942		de Kooning and Pollock have first public exhibition in group show at McMillen Gallery, New York	
1944		Mondrian dies in New York	Cameri Theater founded in Tel Aviv

	ISRAEL HISTORY	INTERNATIONAL FINE ARTS	ISRAEL FINE ARTS
1947	U.N. Resolution on Partition	Abstract Expressionism develops in U.S.; Pollock exhibits drip paintings; Matisse exhibits *Jazz*; Jean Dubuffet founds Société de l'Art Brut in Paris	Dead Sea Scrolls discovered; Aharon Avni opens studio for painting and sculpture in Tel Av
1948	State of Israel proclaimed on May 15; Jewish population is 650,000; 684,000 Jews immigrate (1948-51); outbreak of War of Independence	CoBrA group founded in Paris by Asger Jorn, Karel Appel, Corneille, and Christian Dotremont; Robert Motherwell begins *Elegy to the Spanish Republic* series	New Horizons group establishe Zaritsky and Janco; includes Cas Stematsky, Streichman, and Tagger; exhibits at Venice Bienn
1949	First regular government; Ben-Gurion elected prime minister		First New Horizons exhibition a Tel Aviv Museum
1950		Works by de Kooning, Arshile Gorky, and Pollock exhibited at Venice Biennale	First exhibitions of the Group of Ten; Levanon exhibits at Venice Biennale
1951		"Abstract Painting and Sculpture," exhibition of art done since the Armory Show, opens at Museum of Modern Art, New York	Haim Gamzu publishes *Painting Sculpture in Israel*
1952			Janco, Rubin, and Streichman exhibit at Venice Biennale
1953			Agam has first one-man show devoted to kinetic art at Craven Gallery, Paris; "Seven Painters Israel" show opens at Institute Contemporary Art, Boston; later travels in U.S.; artists' colony established in Ein Hod
1954			Ardon, Aroch, and Streichman exhibit at Venice Biennale; Arikl exhibits at Milan Triennale
1955		"Documenta I" held at Kassel, Germany	"Israëlische Kunst" show at Stedelijk Museum, Amsterdam; Shemi, Steinhardt, Stematsky, a Streichman exhibit at São Paulo Bienal

Cultural Chronology

	ISRAEL HISTORY	INTERNATIONAL FINE ARTS	ISRAEL FINE ARTS
1956	Sinai campaign		Bergner and Stematsky exhibit at Venice Biennale
1957			Bergner, Levanon, and Paldi exhibit at São Paulo Bienal
1958		Jasper Johns has one-man exhibition in New York, marking beginning of Pop Art movement; Solomon R. Guggenheim Museum, designed by Frank Lloyd Wright, opens in New York; Museum of Modern Art, New York, circulates "The New American Painting," introducing Abstract Expressionism to Europe; Group Zero, kinetic artists, formed in Cologne	Ardon, Bergner, Levanon, and Paldi exhibit at Venice Biennale; "Modern Painting from Israel" opens at Kunstmuseum, Bern; later travels in Europe
1959		Pop Art and "Happenings" in U.S.; Nouveau Réalisme in Paris	Ardon participates in "Documenta II"; Castel in São Paulo Bienal
1960		GRAV (Groupe de Recherche d'Art Visuel) formed in Paris by kinetic artists of eleven different nationalities	Gross and Uri exhibit at Venice Biennale; "Twenty Israeli Artists" opens at Museu de Arte Moderna, São Paulo, Brazil
1961		"Art of the Assemblage" opens at Museum of Modern Art, New York; Clement Greenberg publishes *Art and Culture*	
1962			Arikha and Bergner exhibit at Venice Biennale
1963	Ben-Gurion resigns; Levi Eshkol becomes prime minister		*Art in Israel*, edited by B. Tammuz, published; Agam exhibits at São Paulo Bienal; sculpture symposium at Mitzpe Ramon

ISRAEL HISTORY	INTERNATIONAL FINE ARTS	ISRAEL FINE ARTS
		"Art Israel," exhibition of twenty-six painters and sculptors organized by Museum of Modern Art, New York; circulates in U.S. Moshe Barasch establishes a department of art history at Hebrew University; Agam, Aroch Nikel, and Tumarkin exhibit at Venice Biennale; Agam exhibits at "Documenta III"
	"The Responsive Eye" opens at Museum of Modern Art, New York, the first major exhibition of Op Art	Israel Museum opens in Jerusalem; Dani Karavan's memorial to the Palmach Negev Brigade erected near Beersheba; Qav, periodical of modern art, founded in Jerusalem; 10+ group formed; "Schilders uit Israël" [Painters of Israel] opens at Gemeentemuseum Arnhem, Holland
	"Primary Structures" opens at The Jewish Museum, New York, marking the beginning of the Minimal Art movement	Tvai, quarterly for architecture, founded in Tel Aviv; Schwartz and Streichman exhibit at Venice Biennale
Six Day War		S. Y. Agnon Nobel laureate in literature; Arikha and Tumarkin exhibit at São Paulo Bienal
	Marcel Duchamp dies; his The Machine shown at the Museum of Modern Art, New York	Kadishman exhibits in "Documenta IV"; Ardon exhibits at Venice Biennale; "Israël à Travers les Âges" opens at Musée du Petit Palais, Paris
Golda Meir becomes prime minister	Conceptual Art emerges as major movement; Christo wraps coastline in Australia	
	Robert Smithson completes The Spiral Jetty in Great Salt Lake, Utah, and popularizes Earthworks movement	Jerusalem River Project by Georgette Batlle, Gerard Marx, and Joshua Neustein
	Video Art popular	New Tel Aviv Museum opens; "Concepts + Information" opens at The Israel Museum; Gross exhibits at São Paulo Bienal

Cultural Chronology

	ISRAEL HISTORY	INTERNATIONAL FINE ARTS	ISRAEL FINE ARTS
1972			Periodical *Painting and Sculpture* founded in Tel Aviv; Kadishman exhibits at Venice Biennale; Neustein exhibits in "Documenta V"
1973	Yom Kippur War	Picasso dies	
1974		Bulldozing of "Open Air Exhibition of Unofficial Art" in Moscow	Robert Rauschenberg exhibits at The Israel Museum; Burston Graphic Centre and Jerusalem Print Workshop established in Jersualem; "Beyond Drawing" exhibition opens at The Israel Museum
1977	Menachem Begin becomes prime minister; Anwar Sadat, president of Egypt, visits Jerusalem	Le Centre National d'Art et de Culture Georges Pompidou opens in Paris with exhibition "Paris-New York"; New Museum opens in New York	Beth Hatefutsoth, museum of the Jewish Diaspora, opens in Tel Aviv; "10 Artists from Israel" opens at Louisiana Museum, Denmark; Calder's last stabile erected in Jerusalem; Efrat exhibits in "Documenta VI"
1978	Camp David peace talks	"Paris-Berlin, 1900-1933" opens at Centre Pompidou, Paris	"7 Artists in Israel" opens at Los Angeles County Museum; Kadishman exhibits at Venice Biennale; "Art and Society" opens at The Tel Aviv Museum
1979	Israel-Egypt peace treaty signed	Joseph Beuys has one-man exhibition at Solomon R. Guggenheim Museum, New York; "Paris-Moscou, 1900-1930" opens at Centre Pompidou, Paris	
1980		"Pablo Picasso: A Retrospective" opens at Museum of Modern Art, New York, the most important exhibition of the artist's work to date	Buky Schwartz's Video Project is shown at Lake Placid Winter Olympics

ARTISTS' CHRONOLOGY

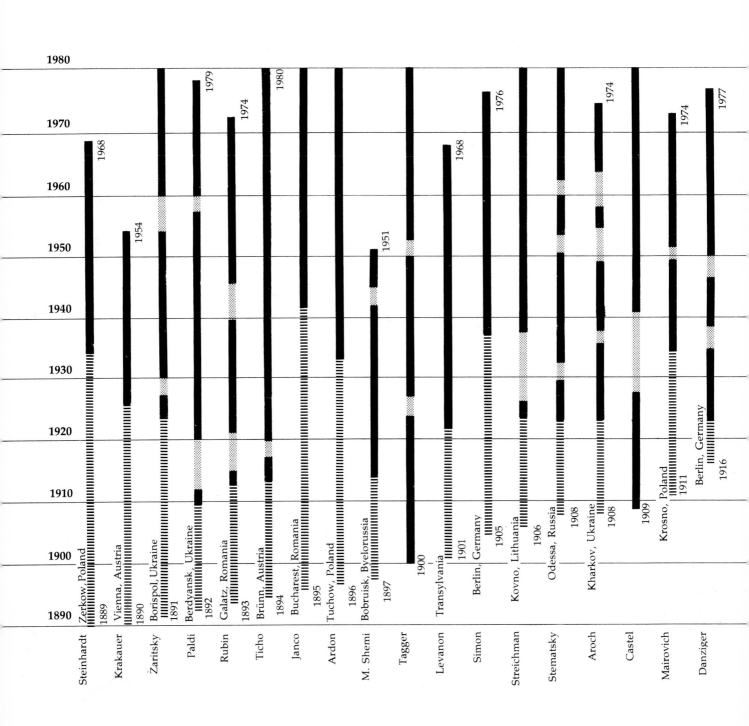

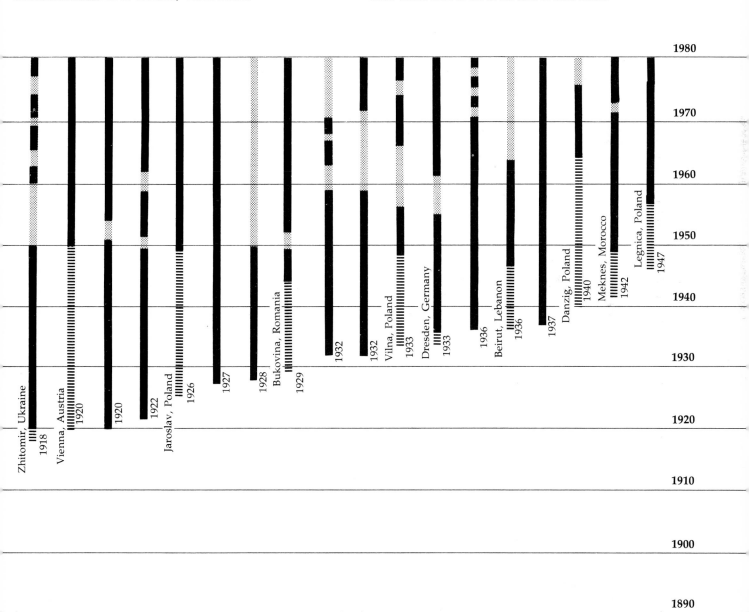

||||||||||||||||||||||||| prior to immigration

▬▬▬▬▬▬▬ lives in Israel, may travel abroad

▒▒▒▒▒▒▒ lives abroad, visits Israel

Note: The artists appear consecutively on this chart according to their year of birth. The geographical names are those which were in use at the time of their births.

1980

1970

1960

1950

1940

1930

1920

1910

1900

1890

Zhitomir, Ukraine
1918

Vienna, Austria
1920

1920

1922

Jaroslav, Poland
1926

1927

1928

Bukovina, Romania
1929

1932

1932

Vilna, Poland
1933

Dresden, Germany
1933

1936

Beirut, Lebanon
1936

1937

Danzig, Poland
1940

Meknes, Morocco
1942

Legnica, Poland
1947

Nikel

Bergner

Gross

Y. Shemi

Kupferman

Uri

Agam

Arikha

Schwartz

Kadishman

Bak

Tumarkin

Lifshitz

Efrat

Lavie

Neustein

Cohen Gan

Weinfeld

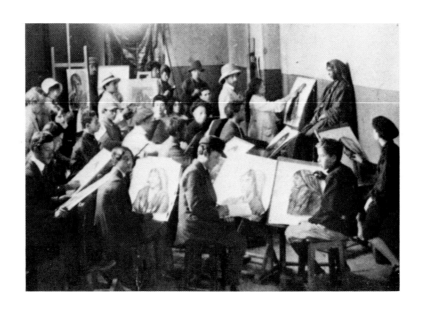

Fig. 1. Class in the Bezalel School of Arts and Crafts, early 1920s. Abel Pann is standing in the rear of the classroom wearing a pith helmet.

The Quest for Roots

By Moshe Barasch

It is a truism that it lies in the power of art to bridge the gaps of time and space. Works created in a distant, scarcely remembered past still appeal to us, and in fact become part of our present; paintings and sculptures shaped in distant parts of the world, in cultures from which we are separated by long-established traditions, speak directly to us and become part of our "world." Yet even the most universal view of art will realize that what was created at a certain time and in a certain culture has a character peculiar to that time and culture.

The dangers of generalizations about national characteristics are well known, but when we look at works of art, we cannot altogether disregard the fact that they appear rooted in certain national traditions. The art historian Heinrich Wölfflin devoted an entire book (*The Sense of Form in Art*) to the juxtaposition and comparison of what he called the Italian and the German sense of form. Early in his book *Albrecht Dürer*, Erwin Panofsky, a student of broad cultural and national entities, compared the evolution of European art since the Middle Ages to a musical fugue, in which the variations on the main theme are played by different countries: the Gothic style was created in France; the Renaissance and the Baroque originated in Italy and reached fulfillment, in greatly altered form, in Italy and the Netherlands; Rococo and Impressionism were essentially French phenomena; and eighteenth-century Classicism and Romanticism were primarily English.

Can we speak of an Israeli variation on the major themes of twentieth-century art? What features and tendencies are typical of the artistic imagery of the works shown in this exhibition? It is probably too soon to answer these questions. Historical processes of cultural growth and crystallization have their own rhythm, their own

gestation periods, and we cannot hasten their pace. We also lack the historical perspective and emotional detachment necessary to assess the phenomenon of Israeli art objectively. To a future art historian some features common to all the works presented in this exhibition may be more obvious than they are to us. But while we still cannot give a totally satisfactory interpretation of the character of the art created in Israel, it may be useful to point out some of the intellectual conditions and emotional impulses which probably play an important part in determining that character.

Roaming in Jerusalem, one is arrested by the beautiful home of the Bezalel Academy of Arts and Design; its Oriental shapes and finely carved stone, quarried near the city, give it a particular charm and flavor. Bezalel, as we know, is an art school named after the biblical artisan who was a "wisehearted man, in whom the Lord put wisdom and understanding to know how to work all manner of things for the service of the sanctuary, according to all that the Lord had commanded" (Exodus 36:1). The Bezalel School, established in 1906, was one of the first institutions of higher education to be founded in what was then a distant province of the Ottoman Empire (the first technological school was established in 1925, as was the first university). This sequence seems puzzling: it would seem that the tiny community of pioneering Jewish settlers in that distant province — financially poor, facing an uncertain future, and lacking technical skills — would have thought many other institutions more urgently needed than an art school. One must also remember that this group of pioneers did not bring any great artistic traditions with them, the preservation of which an art school might have served.

21

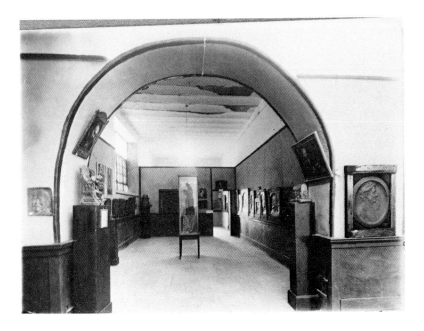

Fig. 2. Exhibition organized by Boris Schatz at the old Bezalel Museum, ca. 1925.

This system of priorities may look less puzzling, however, if we consider the new attitude toward the visual arts that had emerged in different parts of the Jewish world by the turn of the century. Throughout Jewish history we find a profound interest in, and devotion to, theoretical learning and abstract thought. Painting, some kinds of sculpture, and a great many handicrafts never really disappeared in the Jewish communities, but they were rarely the focus of intellectual interest. In the late nineteenth century, however, a profound change can be observed. In Eastern Europe, concerted efforts were made to study Jewish ceremonial objects, the carvings of synagogue lamps and ritual spice boxes, and the weaving patterns employed by Jewish women in the villages of Russia. Martin Buber's provocative article in German on Jewish art (also translated into Russian) appeared in 1901; shortly thereafter, in 1903, he edited a book on Jewish artists, *Judische Kunstler*. The establishment of an art school in that distant Turkish province reflected this general interest.

Aesthetic considerations were not the only factors at work here, however. There was also a wish to discover some basic imagery characteristic of the Jewish people, in a period when traditional religious values and living patterns were crumbling and the unity of Jewish letters was breaking up. Jewish intellectuals of that period of crisis and transition learned from various philosophers that visual imagery reflects a basic, though often hidden, cultural structure. It is also characteristic of such imagery, and of the objects in which it is embodied, that it possesses a concreteness, a tangibility, which escapes more abstract literary

formulations. In an intellectual climate of crisis, in which so many were disappointed with what seemed to them the barrenness of purely intellectual and scholastic exercises, the appeal to the senses, the direct perceptibility, of the visual arts gave them an irresistible appeal. Many Jewish intellectuals and avant-gardists craved "reality" — and reality was provided by the image realized in a picture or a sculpture. This search for aesthetic origins was, to use a now fashionable formulation, a quest for "roots," and it remains a driving force in the development of the visual arts in Israel.

Art in Israel, from the beginning of the twentieth century, meant Western art. Contact between Israeli artists and the great artistic centers in Europe and the United States was never interrupted, and it is only within this essentially Western framework that we can discuss the "origins" or "roots" that were laid bare. The vision of the East appears at an early stage of the story of Israeli art as a "root," a living source. The image of the biblical world may have had something in common with the universal myth of the Golden Age. Attempts to reconstruct something of biblical reality may have had a utopian quality, but they had tangible results. The Hebrew that was revived in the early decades of this century reflected the biblical idiom, the early layer in the history of the language, and the same tendency can be seen in the art of the period. After initial attempts to portray exotic "natives" (e.g., in the work of E. M. Lilien in the 1900s), the images of biblical heroes were endowed with an Eastern flavor (see, for example, the works of Abel Pann in the 1920s).

22

Fig. 3. *Sacrifice of Isaac,* detail of mosaic floor at Beit-Alpha, sixth century.

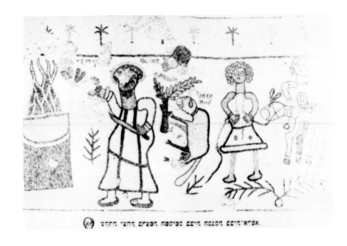

The vision of the East was, of course, not a new theme in Western art. From Roman times to Piranesi, the culture and monuments of the Near East had an almost magical inspiration and appeal for Western artists. In nineteenth-century literature and painting, the Orient continued to receive much attention; the Near East was approached with the reverence due to a great traditional culture. The work of Jewish painters coming from Europe to Jerusalem surely reflected this great Western tradition, but for them the European tradition merged with a specific, national mythology: orientalizing works represented a "revival" of the biblical reality, the "roots."

For the Jewish artist the "East" was not merely a specific group of monuments or a specific layer in the strata of this ancient region. Like so many visions, it could be sharply outlined, yet infinitely extended. The experience of living in the country and getting to know its ancient treasures lent solidity to a vision which, in Europe, was often more exotic than precise. Archeological finds — always seen as an important expression of Jewish roots in the country — became a source of inspiration for the twentieth-century painter. Did the archeological excavations provide him with an aboriginal, genuine imagery — for instance, is not the floor mosaic of the synagogue in Beit-Alpha, with its primitive shapes and folk motifs (Fig. 3), a formal visual idiom which is native, Oriental, and Jewish? Should the contemporary painter not absorb, and bring back to life, the language of forms found in this and similar monuments? (It is unfortunate that the influence of archeological excavations on the art of Israel has not been systematically studied.) Could not the Dome of the Rock, before which the contemporary artist could now stand, that time-honored emblem of Jerusalem, provide a constellation of archetypal forms?

But the vision of the East was not only a vision of a distant historical past, as represented by individual monuments. The East was a contemporary reality, a living culture. The finely chiseled shapes of Yemenite jewelry, the heraldic forms of Oriental embroidery, the intricate brassware patterns could also be sources of inspiration. It would be interesting to uncover the traces of such Oriental decorative imagery in the art of Israel, from its earliest stages to the works of abstract artists.

The vision of the East, however, powerful as it was, did not completely overshadow the traditional Jewish subjects common to many painters who came to Israel from Eastern Europe or who had experienced Jewish life there. The half-lit synagogues, the Jewish rituals, the human types and emotional experiences of the small Jewish towns in Russia are themes found in the works made on the shores of the Mediterranean as well as in those created in Parisian ateliers. Visits to the old quarters of Jerusalem or of Safed must have strongly stimulated artists' memories of Eastern Europe, while leading to a transformation of that traditional iconography. Influential painters of the 1930s and 1940s, like Budko and Jakob Steinhardt, fused the visual impressions of Old Jerusalem with memories of the European past. Is not the mysterious, dark, and bent figure of the old Jew between the walls of a street in Old Jerusalem a close relative of a similar figure in an Eastern European village? And is he not, at the same time, the fulfillment of that distant figure's dream?

In the works of present-day Israeli artists these traditional subjects are less frequently encountered, but the mood and emotional character of that imagery persist. The mysterious expressive power of the depictions of synagogues in Jerusalem and Safed by painters of the present generation are not only a matter of "style." Columns and arches are not mere architectural elements; from them reverberate memories. The re-creation in art of a world that has almost completely disappeared demonstrates the pivotal role which memory plays in the creation and maintenance of a culture. The attempt to come to terms with what is often called the "Jewish heritage," that is, the way of life in medieval and modern Jewish diaspora communities, will probably continue for generations, and painters and sculptors will share in this effort.

An interesting motif related to the medieval Jewish heritage sometimes appears in modern Israeli painting (as it does in the works of Jewish artists in the United States); this is the Hebrew script and the parchment scroll on which that script traditionally appears. The scroll, usually associated

with the Torah, has a specific meaning in medieval Jewish culture and itself becomes a sacred object. In medieval Jewish thought the letters of the Hebrew alphabet have an inherent sanctity and an inner life, and scrolls covered with letters are prominent subjects in representative modern Israeli paintings. Other medieval symbols, like the kabbalistic Tree of Sephirot, are also found in modern painting; both the Tree and the scroll appear, for example, in the works of Mordecai Ardon, who is represented in this exhibition.

Whatever the dim historical recollections which artists brought with them to Israel, whatever "Orient" they expected to find, the country itself was, in a direct, physical sense, new, surprising, and challenging. The history of Israeli painting shows the pivotal, sometimes disturbing, effect of the country upon the artist's imagination. The story of Israeli painting can be seen, to no small extent, as a continuous series of attempts to find the proper way to describe in paint and canvas what the artists saw and sensed in this landscape. For artists imbued with the spirit of European art, the country must have been astonishing even in a simple, "pictorial" sense. The great European tradition of landscape painting was developed and fully articulated (especially during the last few centuries) in countries where the light is tempered and its force subdued. Landscape painters evolved scales of light and color which are extremely rich in halftones, in delicate hues, and in fine shades, yet which are narrow in the spectrum between the brightest light and the deepest darkness; they employed fine transitions rather than sharp contrasts. These scales were not devised to depict a landscape where a dazzling light suppresses fine shades and creates sharp and dramatic contrasts. To the artists coming to this new country the unaccustomed light may have dramatized the break with European traditions, the necessity of starting from the beginning.

The character of the scenery itself was also different from the familiar lush vegetation of European landscape. The sky, a dramatic and ever-changing feature of much of Northern art, is of an altogether different quality here; it is either a stable, uneventful blue or the "brass" described in Deuteronomy ("thy heaven, that is over the head, shall be brass"; Deut. 28:23). The artist, then, was faced with the task of portraying the barrenness of a stone wilderness or the bare geological formations of the mountains of Judea. At first sight, at least, little of human interest and feeling could be discovered in this landscape, and the indigenous artistic traditions of the region, essentially decorative and non-representational, were of little help. But the variety of scenes in this little country provided artists with models for different modes of expression.

The olive orchards of Galilee and its mountains and valleys often served as patterns for what may be called an "idyllic mode" (see *Ein Kerem* of Reuven Rubin in this exhibition). Safed was frequently represented in light, diaphanous colors, almost hovering in a non-material world, radiating a mood of miraculous hope or joy. This delicacy may be derived from the natural character of the landscape itself or may reflect memories of Safed as the center of a renewed, intense kabbalistic belief in the miracle of a near-redemption.

A sublime, heroic mood often manifests itself in representations of the Judean hills and of the city of Jerusalem. Depictions of this rocky, precipitous countryside are rarely meant simply as "landscapes," that is, as aesthetic experiences of nature. We often feel in such pictures a revitalization of the experience of divinity, a profound religious emotion, without recourse to conventional iconography. Here nature — or a combination of what is actually perceived in nature and the collective memory that tinges that perception — seems to open the door to an elemental or mystical experience. Yet the sublimity of the Judean hills (as rendered, for instance, by Mordecai Ardon [Fig. 4]) could also be combined with a rare and tender beauty. For almost seventy years, beginning in 1912, Anna Ticho has tried to show the poetry within the detail, the shape of a shrub on the slope of a hill, or a crack in the rock, as well as the panorama of the hills surrounding Jerusalem (see her 1969 painting *Jerusalem,* in this exhibition). Jerusalem itself, a mystical center of Jewish thought and imagery for two thousand years, is also almost inevitably a central subject for Israeli painting. Again, in the paintings representing the city, one can see two levels of vision: the view of the landscape itself and the images and emotions of the past which that view symbolizes.

The artists' encounter with the wilderness and the desert when they came to the "Land of Israel" was, and remains, a crucial experience. In the imagery of Israeli culture the meaning of the desert is ambivalent. On the one hand, it is the embodiment of barrenness, hostile to human life, and thus vividly reminiscent of the biblical curse: "And thy heaven, that is over the head, shall be brass, and the earth that is under thee shall be iron. The

24

Fig. 4. Mordecai Ardon, *The Kidron Valley,* 1939, oil on canvas, 44 × 58 in. (112 × 147 cm.). Collection Metropolitan Museum of Art, New York; Gift of Professor and Mrs. Zevi Scharfstein, 1971.

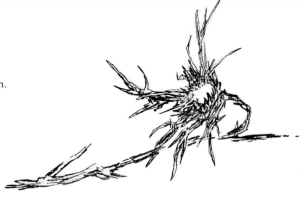

Fig. 5. Leopold Krakauer,
Thistle, ca. 1953, chalk on paper.
Collection Trude Dothan, Jerusalem.

Lord shall make the rain of thy land powder and dust: from heaven shall it come down upon thee, until thou be destroyed" (Deut. 28:23-24). On the other hand, the desert is the ultimate challenge to the creative forces of man. "Conquering the desert" has become a shorthand expression for the final triumph and justification of the Jewish undertaking. But how were wilderness and desert to be represented visually? The great traditions of European landscape painting did not furnish models for expressing these conflicting emotions, and here Israeli painters are still groping their way.

In some works of art the desert is characterized as the cursed land, the landscape of death. In a painting by Mordecai Ardon we see a large stretch of scorched soil "enlivened" by the movement of a large, wriggling viper; the deep reddish brown colors of the earth differ only slightly from the somewhat brighter red of a sun that has almost spent itself. In another typical image of the desert, Yosl Bergner shows, below a dark, oppressive sky, a stretch of yellowish ocher, the color of sand and stone, broken only by large thistles, the dry and hostile vegetation of the wilderness, their prickly, stinging leaves out-stretched like the hands of a fantastic creature. The thistle itself became a symbol of the wilderness, and perhaps of the country as a whole. Leopold Krakauer, an architect and draftsman who came to Israel from central Europe in 1924 and who, more than other artists, preserves the spirit of Expressionism, devotes a large part of his drawings to the thistle (Fig. 5). In these works the plant of the wilderness becomes a truly ambivalent image: its sharp, angular forms echo the deadly dryness of

the desert; the inexhaustible variety of its shapes manifest the vital energy hidden in this barren soil. One wonders whether, when representing this fascinating *fleur du mal,* artists did not remember the phrase (which many of them learned as children) spoken by the Lord when rebuking Adam for his sin and sending him out of Paradise into a world of toil, pain, and death: "Thorns and thistles shall it [the soil] bring forth to thee: and thou shalt eat the herbs of the earth" (Gen. 3:18). To them, the representation of a thistle — uprooted from its natural environment and placed, like an emblem, against a white ground — may well have served as a statement of the human condition.

With such thoughts in mind, we may again ask whether there is an Israeli "variation" on the great themes and trends of our age. There can be no touchstone for determining the characteristics of a national style, and, as I have said before, it is particularly difficult to do so when considering an art which is at such an early stage of development as is that of Israel. But so far it is clear, I think, that the attempts of artists in Israel to express their emotions and experiences and to create an art of universal appeal will be influenced by the visions, cultural traditions, and natural conditions mentioned. They are of a dialectical nature: they are at the same time driving forces and constraints; they constrict as well as nourish. Out of them will evolve, we hope, a unique Israeli contribution.

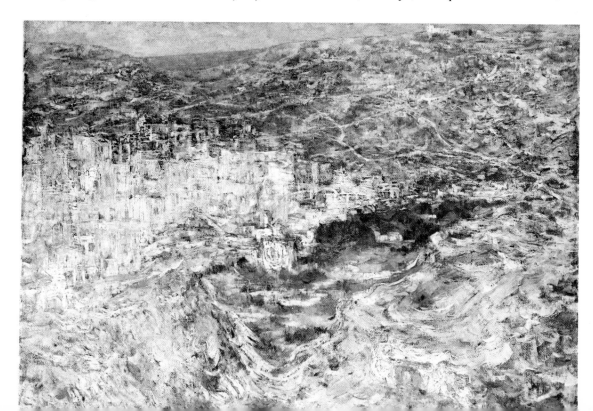

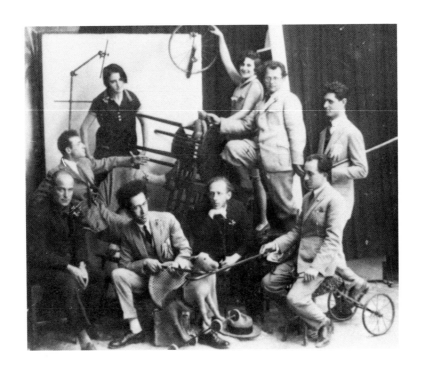

Eretz Yisrael artists in 1926. *Back row:* Tziona Tagger stands at the extreme left. *Front row:* Yosef Zaritsky is seated at the extreme left, next to Reuven Rubin; seated at the extreme right is the critic Yitzhak Katz. Pinhas Litvinovsky leans against a post behind Katz. The other persons in the photograph are unidentified.

History and Identity

by Ygal Zalmona

The distinctiveness of Israeli art stems from a unique constellation of social and historical circumstances, of utopias and traumas, myths and ideals, all of which determined the diverse styles of Eretz Yisrael artists. The history of Israeli art is in many ways the history of the artists' search for a unique identity, and this search is the underlying theme of my essay.

The founding of the Bezalel School of Arts and Crafts in Jerusalem in 1906 constitutes the first chapter in the history of modern art in Eretz Yisrael. Until then, most artistic production had been concentrated in Jerusalem. Of a popular and practical nature, religious and parochial, and completely devoid of international influences, it was created for the impoverished Jewish religious settlement in what was then a remote province of the Ottoman Empire.

Bezalel was designed to serve several purposes, primarily economic and practical, at times contradictory, which were set forth at the early Zionist congresses. It was hoped that such a school could provide employment for the Jews of Jerusalem, most of whom survived on contributions from charitable organizations — a way of life which was perceived by Zionists as passive and decadent. Other purposes were of a political nature: once a *fait accompli,* Bezalel would be a symbol of Zionist ownership of land and institutions in Jerusalem and a rallying point for the Zionist enterprise. It was also intended, at least in the beginning, to serve spiritual needs. The renowned writer and philosopher Ahad Ha-am (who was a model for Bezalel's founder and first director, Boris Schatz) spoke of the creation of a spiritual center in Eretz Yisrael, claiming that "one art school is more important than a hundred settlements."[1]

Through periods of prosperity and depression, achievement and crisis, Bezalel evolved from a small school for arts and crafts teachers and an outlet for home industries into a complex of workshops for the production of objets d'art and an art school which, although small, had high artistic standards. When it was closed in 1928, Bezalel was the best-known art institute in the Jewish world, and the Bezalel style was regarded as a distinctive and original Zionist Jewish creation. Its work was to be found in both private homes and public institutions (more frequently in Europe and the United States than in Eretz Yisrael itself). A number of major figures in the Jewish art world taught there at various times: Boris Schatz, E. M. Lilien, one of its founders, Shmuel Hirszenberg, and Abel Pann. In Schatz's novel *Jerusalem Rebuilt,* written toward the end of World War I, he describes the "futuristic" utopian Eretz Yisrael as a paradise whose inhabitants stroll the land attired in Oriental robes, call themselves by biblical names, and speak the language of the Bible (this vision was inspired by Mapu's *Love of Zion*[2]), while enjoying a technologically contemporary life style.

In essence, the Orient,[3] as perceived by those involved in Bezalel, embodied the origins of Judaism. The "rebirth of the ancient Jewish nation" was the ideal behind Schatz's literary utopia and his artistic program for Bezalel. For the members of the school, the concept of the Orient had specifically Jewish elements and was usually related to biblical scenes. This perception was doubtless anchored in the romantic-idealistic myth of life during the biblical era as a lost and ancient paradise, an Oriental Arcadia which constituted the antithesis of the Jewish shtetls and ghettos of Eastern Europe. At the same time, the term "Orient" served as a very broad and general

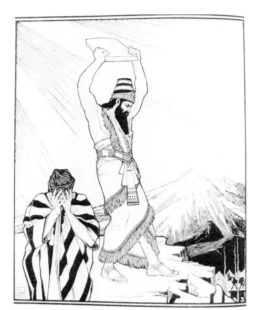

Fig. 1. E. M. Lilien, *Moses on Mount Sinai*,
illustration from *Die Bücher der Bibel*
(Braunschweig: Westerman, 1908).

Fig. 2. Ze'ev Raban, illustration from
Song of Songs (Jerusalem: Hasepher, 1923).

concept and comprised a syncretic collection of
motifs. E. M. Lilien painted biblical heroes dressed
in Bedouin robes which, intentionally, recall the
talith, the Jewish prayer shawl, in a manner
characteristic of European art toward the close of
the nineteenth century, which sought to convey the
"authentic" setting of historical events. On the
other hand, the same painter also depicted Moses
in Mesopotamian dress, his countenance adorned
by an Assyrian beard (Fig. 1), and Saul sitting in a
palace court whose walls are decorated with Islamic
arabesques. Archeological precision was obviously
not as important to the artist as the creation of a
mood through the use of Oriental "symbols." In
portraying biblical heroes, the stylistic approach
was distinctly European, not Oriental. Despite the
fact that in the school's painting classes emphasis
was placed upon the portrayal of Oriental models
"in the image of our biblical ancestors," only rarely
is the Semitic origin of Lilien's characters and
heroes stressed in his "official" works, and Western
ideals of beauty are still in force. Relations between
men and women, such as shown in the love scenes
of Ze'ev Raban's *Song of Songs* (Fig. 2) and the
various gestures of pathos are also derived from the
Western repertoire.

Lilien's secular and idealistic approach to the
Orient appears to be Hertzlian in character. His
Orient constitutes a kind of artistic tax paid to the
demands for an original style, and for a source he
drew upon the Bible rather than on the authentic
Orient around him. Herzl's vision of the Jewish
state was also essentially European (he described
it as being part of "the wall against Asian
barbarianism"). "Fredericks Heim," the Eretz
Yisrael home of one of the protagonists in Herzl's
Altneuland, is in Arab architectural style, complete
with vaulted ceiling. Its interior walls, however, are
covered in pink silk, the furniture is in the refined
English style, and the house is hung with European
paintings.

Schatz himself, on the other hand, shared
many of the views expressed by Ahad Ha-am, who
was opposed to the conception of the Bible as the
major cultural resource of the Jewish nation and
demanded that what was created in the Diaspora
not be forgotten. Consequently, Schatz frequently
depicted Jewish subjects in the Diaspora; through
his example his colleagues began to paint the Jews
of Jerusalem, and Bezalel students used them as
models (Fig. 3). As academic painters, they did not
believe in a nationalistic style of painting or
sculpture. Art was to be created in accordance with
the dictates of the classical tradition, though
craftsmen were to be open to experimentation with

a view to the creation of a national style. Schatz, who had been responsible for a similar project as one of the directors of the National Academy of Art in Sofia, Bulgaria, before establishing Bezalel, resolved that the creation of a "Hebrew" style would be the goal of his school in Jerusalem.

The objets d'art produced in Bezalel were stylistically eclectic (Fig. 4), combining Western and Oriental elements. Designs were influenced both by Art Nouveau and by Eastern European utensils. Figurative scenes depicted in the European style were produced side by side with Oriental themes such as hieroglyphics, palm trees, camels, and wings of gods in the ancient Egyptian manner. Although typical Oriental techniques were used, Western ones such as the European filigree were substituted for the original Yemenite method. The style of these objects is defined by the tension between the Western and Oriental perspective: the independent quality of Bezalel creations (non-traditional combinations of techniques and unusual proportions and spatial distribution) may have been a result of this tension. It is clear that the Bezalel teachers perceived the "Orient" as a repertory of motifs, subjects, forms, and techniques which could serve as national symbols in the creation of Jewish art. Bezalel was, in fact, an attempt to establish a spiritual and cultural center in Eretz Yisrael which would fuse the diverse elements of Judaism into a single national Jewish culture. The Orient was perceived only in terms of its links with Jewish history and the Bible. Even Abel Pann, who realistically documented the Arab community in Eretz Yisrael, did so for the sole purpose of reconstructing the biblical world.

Bezalel, then, was the artistic center of Eretz Yisrael until the early 1920s. The works of its teachers, its department heads, and, at times, its students were displayed in the few exhibitions held in Jerusalem. The limited supply of utilitarian objets d'art available came from its workshops, and the ideology of their creation and design was Bezalelian. However, normal artistic life was not possible because of the country's small population, its demographic distribution, and its relative poverty. As noted above, members of the old settlement who lived in the cities subsisted for the most part on charity, while the farmers and immigrants of the Second Aliya (the second major wave of immigration, from 1904 to 1914) lived in scattered villages.

Bezalel was closed in 1928 as a result of financial problems, charges of low standards, and harsh criticism of its rejection of modernism (what was felt to be an exaggerated emphasis on the

Fig. 3. Boris Schatz, *The Repentant Sinner*, 1905–1910, bronze relief, 19½ × 11⅜ in. (49 × 29 cm.). Collection The Jewish Museum, New York; Gift of Mrs. Alta Sudarsky in memory of her husband, Dr. Mendel Sudarsky.

Fig. 4. Silver Kiddush cup made by Bezalel School of Arts and Crafts, Jerusalem, in the 1920s.

Jewish Diaspora, clericalism, and traditionalism). The forces which led to the foundation of Bezalel in 1906 were no longer at work in 1928. The revolutionary Left, which dominated the Eretz Yisrael leadership, was impatient with Bezalel's conservatism, which was more in line with the thinking of the conservative faction within the international Jewish leadership than with domestic opinion, and preferred to cultivate modern and revolutionary art.

Outside Bezalel, the 1920s were years marked by growth and excitement in all the arts. In 1920 the Hebrew Artists' Association was founded, and by 1928 it numbered one hundred members. As in literature, there were many stylistic currents in the plastic arts. There were the Realists (Orientalists whose work was similar to that of the Impressionists abroad), the "academic" painters such as Anna Ticho and Ludwig Blum, and the Bezalel group. The most important group from the historical viewpoint were the Modernists — Nachum Gutman, Haim Gliksberg, Yosef Zaritsky, Arieh Lubin, Pinhas Litvinovsky, Menachem Shemi, Reuven Rubin, Tziona Tagger, and others. It is worth noting that many of the leading artists of the decade (e.g., M. Shemi, Rubin, Gutman, Israel Paldi, Tagger) studied at Bezalel.

The Hebrew Artists' Association mounted eight important group exhibitions and many one-man shows. A rather large number of artists came to the country (or returned) in this period. Their works were exhibited, and they soon became cultural heroes. Articles were written on the plastic arts, several publications devoted to art appeared, and a number of art schools were founded. Art critics made their appearance on the scene and formed a group of cultural experts whose goal was to provide the ideological direction for the art of Eretz Yisrael. As a result, artistic ideology became a topic of public debate.

The other arts were also active and growing. Aside from the influence of certain personalities who immigrated to the country during this period, this artistic vitality can be attributed to the consolidation of the Jewish settlement during the British Mandate period, the Fourth Aliya, from 1924 to 1930 (comprised primarily of East European middle-class Jews). Demographic changes took place in the Jewish population as a result of this influx of middle-class immigrants and the development of a secular and bourgeois urban settlement.

During the 1920s Tel Aviv became the focus of creative energy and the living symbol of Zionism, while Jerusalem's status as an intellectual center declined. Tel Aviv, founded in 1908, had some thirty-two thousand residents in 1926. Most artists and writers lived and worked there; all the important theaters and large publishing houses and newspaper networks made it their base. After four thousand years of exile, the first "Hebrew" city, with all of the psychological implications of this term, had been created. Tel Aviv's proximity to the port of Jaffa and its distance from the center of the Mandatory government in Jerusalem allowed it a certain independence of action. The bourgeois immigration to Tel Aviv created an enlightened urban proletariat and labor force, and, though on a very small scale, the city became cosmopolitan, made up of bricks, concrete, and cement, blue skies and sand, and an overwhelming sense of renewal.

Tel Aviv was a city without a history, a free city with a Jewish majority — a city which embodied the very dream of Eretz Yisrael. Its intellectuals, most of whom came from small towns in Eastern Europe, were captivated by the sense of freedom and the opportunities for a new start which it offered. In contrast, they regarded Jerusalem with reservations. It was primarily a religious settlement with a non-Jewish majority; a setting for disturbances and the home of the alien governing authorities; a city of clerical symbolism, isolated from the pioneering experience, devoid of new construction; a city of walls and stone; a city whose Jewish life was not dramatically different from that of the Eastern European Diaspora communities.

Modernism clashed with the Bezalel tradition during the 1920s: in fact, it may be claimed that the Modernists defined themselves as a group (although from the stylistic viewpoint there were substantial differences among them as individuals) in terms of this conflict, which may serve as a point of departure for a look at the changes which transpired in Eretz Yisrael art between 1920 and 1930. The issues dividing the two camps were their perception of the Orient, their concept of a national style, the issue of Modernism, and the nature of their link to Judaism. The decade was characterized by a fervent wish by the Modernists to create an original Jewish culture which would be antithetical to that of the art produced by Jews living in the Diaspora.

The Defenders of the Hebrew Language Brigade insisted, almost violently, on occasion, that Hebrew be spoken throughout the country ("speak Hebrew as fitting for a Hebrew artist in the land of the Hebrews" was the command they directed to Eretz Yisrael artists). To quote from an unsigned article on "aesthetic Hebrew," "The sound of the Hebrew letter 'Lamed' as pronounced by the Russian immigrants has an unpleasant ring. Our ears do not enjoy hearing the Hebrew language sung in a Polish-Jewish melody and thus the Russian sound in our tongue will also be disagreeable."[4] In an article on the musician Joel Engel, the writer asserts: "The hope for an end to popular music rests only in the land of national revival and renewal — a new dawn — something Hebrew rather than Diasporean."[5]

The creation of a local culture and the spiritual rebirth of the nation were posited upon abandoning the ways of the past and completely blending into the new environment of the Orient. The appeal of this position was so great that Modernist painters like Arieh Lubin and writers like Judah Burla and Pesach Bar-Adon went out of the cities to live amidst the Bedouins. Similarly, the producers of the play *Jacob and Rachel* and other theater people resided among the Bedouins for awhile to learn how their own ancestors had lived. The importance of becoming a part of the Orient was felt acutely even in the political realm: in 1923, a Zionist delegation presented King Hussein with a charter which spoke of "the two large Semite nations which have been united since ancient times by a common creative culture." The Thirteenth Zionist Congress (1923) resolved that it "viewed the revival of the Orient as one of the important factors in the rebirth of the ancient nation." Prior to this, one "Xenophon" wrote, regarding the establishment of the General Company for Oriental Studies, "We are Oriental-Western Jews and we are aware that we are returning to the Orient. We must develop the orientality within us which many of us wish, in vain, to erase."[6] The return to the Orient was perceived more as a necessity for the Jewish national revival than as one of the symptoms of that revival.

In contrast, the Bezalel artists, as noted above, did not regard the Arab as part of a real and enduring contemporary landscape. They borrowed from his life only to provide a setting for depictions of the existence of the Jews during the biblical era. Both Modernist and Bezalel approaches reflected the artists' desire to free themselves from the recent memory of the Diaspora. However, while the Bezalel disciples saw themselves as enlightened Westerners residing in a primitive Orient whose sole merit was its "biblical environment," its picturesque and exotic surroundings, the young people (actually the age difference was not significant — Ze'ev Raban, a Bezalel member, was the same age as Reuven Rubin) strove to become part of the Orient, viewing it as a powerful source of national and existential renewal.

There were four principal aspects of the Modernist perception: the discovery of the Orient as a source of moral values rather than merely a storehouse of "nationalist" motifs; awareness of the physical presence of the Arabs and an idealized portrayal of them; the influence of the Orient on stylistic characteristics in painting and sculpture — the Oriental influence was not only a collection of "symbols," attributes, motifs, and iconographic elements but testimony to the artist's desire for "existential" assimilation with the Orient; explicit references to the ancient as well as to the modern Orient.

Who is this Arab, this Oriental man, as depicted in the paintings of Modernist artists of the twenties? In the writings of the artist Nachum Gutman, the image of the Arab is the antithesis of that of the displaced Jew of the Diaspora. He is a model of belonging, a human representative of the natural and sustaining tie to the land. He is the complete opposite of the stereotypic Jew — poor and wretched, yet clever and scheming — from whom Gutman's generation fought to free themselves. This idealized figure cannot be translated into realistic pictorial terms of a precise and documentary nature. Consequently, in Gutman's paintings such figures are exaggerated: they are "unrealistic," monumental, and expressionistic (Figs. 5–6). The image of the Arab thus becomes a variation of that earthy and instinctual Gentile who appears in the literature of the Diaspora writers as a desirable model.

The most important expressions of these new perceptions were the essays of Micah Joseph Berdichevsky (1865–1921), who regarded Judaism's excessive spirituality as the source of its problems. "Ancient Israel" was an idolatrous nation, desirous of the earthly life, said he: "Be Hebrew human beings." Thoughts like these made him an important contributor to the development of the modern "Hebrew" mentality.

In his Diaspora writings, Nachum Gutman's

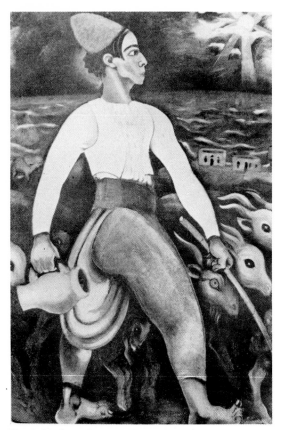

Fig. 5. Nachum Gutman, *Goatherd*, 1927,
oil on canvas, 28¾ × 21¼ in. (72 × 54 cm.).
Collection Mrs. Nachum Gutman, Tel Aviv.

Fig. 6. Hittite relief, royal porch at
Hattusa Boghaz-kevi, eleventh century

father, Simcha Ben-Zion, describes the miserable
life of the Jew, while the Gentile, who is usually a
simple Bessarabian farmer, is depicted from the
viewpoint of the Jew as a mythical image, attractive
and repellent, an object of intense curiosity and yet
a threat. The Gentile he describes can be seen in
the Arab figures which appear in the paintings and
writings of his son.

This Arab stereotype of earthiness, physical
strength, vitality, and instinct became common in
the literature and painting of the twenties. Israel
Paldi depicted muscular Arab fishermen in their
struggle against the ocean waves. Menachem Shemi
also painted monumental and broad-chested
fishermen, in a style strongly reminiscent of Picasso
(Figs. 7–8). Reuven Rubin also portrayed several
such fishermen. Gutman frequently depicted
Oriental whorehouses, which could hardly be
further removed from Jewish existence in the
Diaspora of Eastern Europe.

Stylistic primitivism was undoubtedly one of
the most explicit characteristics of Jewish painting
in Eretz Yisrael during the twenties. The idea of
national rebirth and the perception of the Orient as
an innocent world demanded realization in an
approximately primitive style. This style also
harmonized with the Modernist wish to sever all
ties with classical Western tradition, which was
considered obsolete, overly Latin and Western,
"Gentile" and bourgeois — a symbol of everything
against which the Eretz Yisrael pioneers had
rebelled (it should be noted here that the transition
to a primitivist style in the works of the Eretz
Yisrael painters began only upon their arrival in the
country, and thus was clearly related to the Eretz
Yisrael experience). After World War I, while he
was still in Romania, Reuven Rubin's subjects
were related to Christian religious iconography,
influenced by the atmosphere of Nietzschean
philosophy and Viennese expressionism in the style
of Ferdinand Hodler. Although he had lived in
Eretz Yisrael for a short period as early as 1912,
upon his second encounter with the country in 1923
Rubin wrote: "I have forgotten Rumania. New York
was very distant. In Eretz Yisrael the sun shone,
there was the sea, the open-shirted pioneers with
their tanned bodies and bronzed faces, Yemenite
girls and children with gigantic eyes. A new land
and a new life developed around me. . . . the sur-
rounding world became lucid and pure. Life was
hazy, primordial and primitive."[7]

Upon his return to Eretz Yisrael, Rubin's
palette became lighter, the empty spaces of the
scenes he painted flattened, and his images became

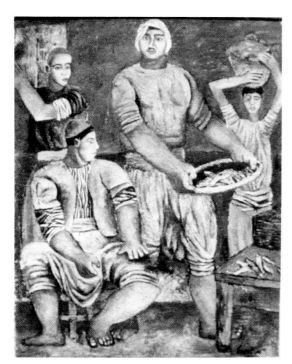

Fig. 7. Menachem Shemi, *Fisherman*, 1928,
oil on canvas, 33½ × 26¾ in. (85 × 68 cm.).
Collection The Tel Aviv Museum.

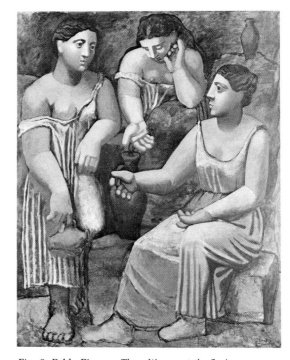

Fig. 8. Pablo Picasso, *Three Women at the Spring*,
1921, oil on canvas, 80¼ × 68½ in. (204 × 174
cm.). Collection The Museum of Modern Art, New
York; Gift of Mr. and Mrs. Allan D. Emil.

Fig. 9. Henri Rousseau, *The Sleeping Gypsy*, 1897,
oil on canvas, 51 × 79 in. (130 × 201 cm.).
Collection The Museum of Modern Art, New York;
Gift of Mrs. Simon Guggenheim.

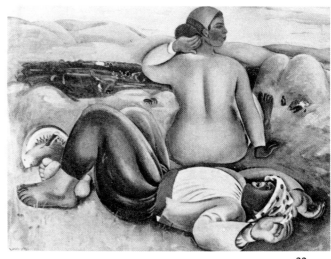

Fig. 10. Nachum Gutman, *Siesta*, 1926, oil on
canvas, 37 × 47 in. (94 × 119 cm.). Collection
Mrs. Nachum Gutman, Tel Aviv.

deliberately awkward, as if he were trying to paint like a man who had never painted before. Some of his paintings show Byzantine influences, while others recall Islamic art. In the middle of the 1920s, Rubin began borrowing from Henri Rousseau and, to an even greater degree, from such Italian primitivist painters as Ambrogio Lorenzetti. Rousseau's naive style became the model for many other Eretz Yisrael painters. Many of them used uniform color planes, giving their paintings a sculptural volume devoid of Impressionist nuances and marked by distorted perspective, all to create an atmosphere of unsophisticated immediacy and freshness (Figs. 9–10).

The interpretation of the ancient Orient as an alternative to the decadence of the West gained popularity among the country's intellectuals during the twenties. In effect, it provided the rationale for the creation of an Eretz Yisrael style. Such a style was to symbolize the Jewish nation's link to the past while expressing remoteness from the Diaspora environment and the old mentality of Europe. One of the most interesting and significant statements of this position was made in an article by Avigdor Hameiri, as a protest against a *Song of Songs* album illustrated by Ze'ev Raban and published by Bezalel. Hameiri compares the cultural characteristics of the ancient Orient with those of the Western world. The major dichotomy he sees between the two cultures lies in the Oriental perspective of monumentality and the Western concept of "pleasant but diminutive" beauty — the pyramid versus the Greek temple. Hameiri refers to this "diminution" as decadence and makes a similar literary comparison between the *Song of Songs* and Homer's *Odyssey* (the Orient versus Western decadence) in terms of metaphorical perspective. In Homer's work, all of the moral lessons are diminished by the fables (the rosy-fingered dawn), while in the Bible "each and every detail of the entire body is compared to a complete part found in nature: 'thy nose is as the tower of Lebanon . . . thy head upon thee is like Carmel,' etc. In other words, creation means building rather than dividing into small parts or imitating individual elements of nature. This — in a new word — is Constructivism."[8] Consequently, Raban's "classical" style is not true to the monumental spirit of the *Song of Songs*, Hameiri concludes. This article was written at least two years before the Eretz Yisrael artists Nachum Gutman, Menachem Shemi, and Reuven Rubin began painting in the monumental style, but it sheds light on their perception of this

style as both anti-decadent and "constructive" (and this should be related to the mentality of the pioneers of the Second Aliya) and as an expression of the unity of the "Hebrew" and biblical worlds.

The notion of drawing upon the style of the ancient Orient as a source for the new Hebrew art was greatly appealing to artists in Eretz Yisrael. As early as 1922 the sculptor Avraham Melnikov exhibited a sphinx and reliefs in the Assyrian style. In 1925 he began working on a statue in Tel-Hai honoring Joseph Trumpeldor, in the shape of a monumental roaring lion facing eastward (Fig. 11).[9] Similarly, Nachum Gutman transforms his young Arab goatherd (see Fig. 5) into a mythic figure. Although he is stepping forward, he appears to be rooted in place. Gutman's composition is based upon an equilateral triangle whose two sides are formed by the arms of the figure, creating a sense of stability. The conceptualization of the design (the head and the hands are depicted in profile, while the chest and shoulders are shown frontally) and the distortion of the limbs is reminiscent of ancient Oriental art; the sculptural carving of the body and the stylized animal heads suggest Assyrian and Persian reliefs (see Fig. 6). The surface of the canvas, the dramatic lighting, the determined stance of the goatherd, his shining reflection against a background of dark sky and landscape, the contrast of the rising sun and the fading moon, with the goatherd's head between them (a third source of light) — all work to transform this Arab youth into a heroic, timeless figure. The huge feet and powerful base of this figure seem to illustrate the phrase "having both feet on the ground," a visual metaphor for stability and permanence, worlds apart from the flying figures of Chagall.

The twenties were years of a "return to order" and to figurative art following the heyday of Cubism, both among these Eretz Yisrael artists and in Europe. The solidity of Rousseau's paintings, the massive figures depicted by Picasso from 1915 on, and the pattern of Derain's works all contributed to the new Monumentalist trend. Many pictures not very different from the Eretz Yisrael paintings of the time could be seen in the Parisian autumn salons. The influence of Picasso's paintings of gigantic women on painters such as Gutman and Shemi is very evident (see Figs. 7-10). A comparison of Gutman's massive figures with similar images by Raoul Dufy testifies to an additional stylistic source of Eretz Yisrael painting; still another influence was Russian painting. In

Russia the primitivist trend was prevalent throughout the first two decades of the century, though it appeared in Paris only in the twenties, and Reuven Rubin may have seen the exhibition of Russian artists and the paintings of Natalia Goncharova in 1921, when he visited Paris (Goncharova, in fact, had choreographed the dances of Baruch Agadati, Rubin's good friend). Russian painting also influenced the paintings of Pinhas Litvinovsky, Joseph Constantinovsky, and perhaps Yitzhak Frenkel as well.

In addition to these artists, there were other painters of the twenties whose works were important, although not similar in style. Yosef Zaritsky, for example, did a series of watercolors based on the watercolors of Cézanne, which he combined with abstract elements in the style of Michael Alexander Vrubel, a turn-of-the-century Russian Symbolist. The dominance of abstract splashes of color over figurative depictions in several of Zaritsky's works prefigured his transition to pure abstraction during the fifties.

Tziona Tagger, who studied under André Lhote in Paris in 1925, applied his principles and her own interpretation of those of André Derain to create some of the best-known portraits in Israeli painting (the portrait of the poet Avraham Schlonsky in The Tel Aviv Museum, for one) (see p. 134). Her 1926 painting of a youth, in The Israel Museum (see p. 62), testifies to a certain influence of the German Neue Sachlichkeit (New Realism). Other artists moved from primitivism to other styles and from more sophisticated to simpler forms (e.g., Israel Paldi and Arieh Lubin).

The thirties were traumatic years for Jewish settlement in Eretz Yisrael. In the wake of the severe economic crisis which erupted in 1925, many of the country's residents departed. Despite a certain recovery in the early thirties, the effects of the New York stock market crash were also felt in Eretz Yisrael. Along with this economic malaise, a crisis in the concept of Zionism developed. This crisis may be attributed to two factors. The first was the consolidation in Palestine of an Arab nationalist movement which regarded Zionism as its arch-enemy. The idealization of the Orient described earlier was dissipated by the reality of the conflict between Arab and Jew. The Arab massacre of Jews in Hebron in 1929 undermined attempts at Jewish integration in the region and led to an ideological reversal on the part of the intelligentsia of Eretz Yisrael; this, in turn, affected artistic concepts and style.[10] The second factor in the crisis

Fig. 11. Avraham Melnikov, *Trumpeldor Memorial at Tel-Hai,* 1925–1930, stone, height 118 in. (300 cm.) without base.

was the British White Paper which increased the restrictions upon Jewish immigration. This policy caused many Zionists to lose faith in their ability to fulfill the Zionist dream.

During the 1930s a substantial number of artists went to Paris from Eretz Yisrael, some for relatively limited periods, others for years.[11] The France to which they emigrated was suffering from inflation, economic crises, and a toppling art market. These years were devoid of artistic innovation, and there was no evidence of a search for new forms of expression.[12] Concentration on the figure, as exemplified in the work of Matisse, Derain, and Vlaminck, and an emphasis on traditional values were paramount. French intellectuals were divided between Communism and the nationalistic sectarianism of the Right. The

demand for a culture unique to France, based upon French tradition and local roots, was growing.

This chauvinistic search for nationalistic cultural roots contributed to the spread of anti-Semitism, and in reaction to these phenomena, more and more artists from Eretz Yisrael attempted to define the nature of Jewish art. The new emphasis on ethnic distinctions had profound effects on them. The Hebron massacre, which awakened memories of Eastern European pogroms — it seemed that the new Jew was to share the fate of the old — and the world-wide growth of anti-Semitism made the Eretz Yisrael artist in France conscious of Jewishness as a spiritual and psychological entity and as a fixed principle in history. One heard no longer of renewed Hebraicism; the term "Hebrew" was replaced by "Jewish." The illusion of becoming an "old-new" Oriental people was beginning to fade: the return to the East was a goal no longer. It was natural, therefore, for the artists from Eretz Yisrael in Paris to form an alliance with the Jewish artists from Eastern Europe who had arrived in France prior to World War I, Chaim Soutine, Michel Kikoïne, Pinkus Kremegne, and others. The two groups, related intellectually and linguistically, shared the problem of defining a distinctive Jewish character in art.[13]

In 1933 Waldemar George, writing in the Eretz Yisrael periodical of arts and letters Gazith, attempted to "determine the enduring psychological foundations of Jewish creation." He disagreed with the concept of the Semite as an adaptable personality indiscriminately absorbing the influences of foreign cultures. In Jewish art, he argued, there exists a fixed principle of Judaization of forms created by non-Jewish cultures. The Jewish Kunstwollen ("artistic intention") is expressed in the inclination to go beyond the boundaries of realism in order to dramatize form. The Jews "sacrifice form as an expression of their inner lives. . . . They transform it into spirituality. . . . Jewish art is anti-classical and anti-naturalist, and therefore it is international and even supra-national." Jewish art is the "hieroglyphics which have difficulty adapting to optimism, anthropomorphism, the superiority of man, the cult of the human body — in short — to happiness and to love of the land."[14]

These ideas were, to a great extent, a reaction to the European nationalistic concept of culture. While French theorists like Henri Daniel-Rops, G. Thibon, and others spoke of the importance of the homeland and the country in painting, Jewish theorists tried to show how a nation without a homeland could still possess artistic distinctiveness. While Fascist theorists developed a cult of physical strength, beauty, and youth, the Jews held that their art was based upon the spirit, which defines the material world. While Europeans spoke of the need to save the West from the Jews, the Jews presented their culture as a positive alternative to the West and to classicism. "This art," George predicted, "will soon become dominant in Jewish Europe, namely, Judaized Europe, if it hasn't already become so."

The artists from Eretz Yisrael borrowed a substantial number of ideological stereotypes, several of which were described by George. Yitzhak Frenkel, an Eretz Yisrael artist, asked: "Isn't the work of Soutine pictorial hysteria in the most elevated meaning of the words? . . . Isn't it French painting as seen in a distorted mirror? . . . Kremegne's paintings reflect all of the principles of French art, but how are they expressed? . . . And Chagall, the Lithuanian Jew — isn't his work a brilliant imitation of French painting?"[15] This anti-Modernist and anti-French approach is exemplified by Moshe Castel, who wrote: "Matisse and Dufy, who were followed by a period of decadence, lowered painting to the level of sterile decoration; Cubism disappeared from the horizon; Surrealism and all of the other 'isms' aspiring to change the world soon crumbled in the absence of a solid foundation."[16] For Eretz Yisrael artists the anti-French (and, according to George, anti-Western) aspects of Jewish art offered a spiritual alternative to Western Gentile culture.

The relationship between "spirit" and "matter" is important in the consideration of the development of a Jewish art. The thinking of the French art historian Élie Faure is relevant in this respect. Faure was one of the most authoritative theorists in France at this time. He himself had been influenced by the philosophy of Henri Bergson, especially by the manner in which Bergson conceived the unity of matter and spirit. For example, Faure wrote: "Everything which reaches man does so via matter. . . . the spirit is merely the relationship between solid elements . . . in enduring harmony."[17] In a monograph on Soutine he wrote of the spiritualization of the material world in the works of the Jewish artist: "if the Beef Carcass shines like the treasures of Golconda, and if the crawling things and the birds sparkle and the ancient winds blow from the nearby putrefaction like a storm, and if all this is no more than the slaughtered flesh, then this is indeed a sign that the spirit lies here . . . a tragic vision

representing . . . in this flash of desperate lyricism, the inseparable unity of matter and spirit."[18] This motif was borrowed by the Eretz Yisrael artists in their writings and paintings. Thus Castel could write: "Not without reason do we [Eretz Yisrael and Jewish painters] love Rembrandt, whose works reflect the holy spirit, having transformed the plasticity of the flesh into a biblical holiness as a *pure Jew*"[19] (italics added).

In their writings the Eretz Yisrael artists discussed here describe a number of artistic paradigms. Particularly important to them were Tintoretto, El Greco, Goya, Rouault, and, of course, Rembrandt. The works of these artists are anti-classical, expressive, dominated by a spiritual idea whose impact is strengthened by the abandonment of representative norms (the distortion of images, composition, and space and the expressive or non-realistic use of light and shade). Jewish art during the 1930s could also be so described.

How did these factors influence the actual style of the Eretz Yisrael painters? Those allied with the Jewish group in Paris began painting in impasto. The attempt to achieve lighting and textural effects similar to those of Rembrandt is discernible in the works of some of them. The influences of El Greco and Rouault are identifiable in a number of Castel's paintings; Rouault's heavy impasto and thick black outlines can also be seen in Frenkel's work. The link with Judaism and its spiritual dimensions is also expressed in the many paintings of synagogue interiors and Jewish religious events in the period. Soutine had an influence on several of Menachem Shemi's paintings (particularly those of trees) as well as on those of Castel. Nonetheless, in the paintings of the Eretz Yisrael artists, there are few examples of drastic distortions of images, particularly human images, in the style of Soutine.

It was the more moderate Jewish expressionists such as Michel Kikoïne, Soutine's good friend, who had the most influence on these painters and especially on Arie Aroch. Haim Atar was the only Eretz Yisrael painter who was directly influenced by Soutine's color and technique as well as his motifs (slaughtered hens and beef carcasses). Elements from this world were transformed by Atar into an expression of his reaction to the Holocaust (Fig. 12).

The Parisian influence also affected landscape painting in Eretz Yisrael. The need to express the Orient in vivid color, which characterized early painting in Eretz Yisrael, was no longer felt: in fact,

artists who returned from Paris preferred to paint in the evening or early morning so that they would not be caught up in the "Oriental" attitude. Menachem Shemi went one step further and wrote: "upon painting in our 'plein-air' we will become impressionists, even if we do not wish to." In order to free themselves from the feeling of "decorative, aesthetic, and analytical impressionism," he suggested that artists in Eretz Yisrael temporarily abandon landscape painting.[20]

Not all Eretz Yisrael artists pursued this style, although it does appear to be most typical of the 1930s. The work of Yosef Zaritsky, for example, during this same period was influenced by Bonnard and French *intimisme*. Paris, after all, was the art center of the Western world. A group of painters had emigrated from Germany in 1933; their culture and point of view were completely different from those of the Jewish expressionists in Paris. (It should be noted, however, that several important painters of German and Austrian origin, in

Fig. 12. Haim Atar, *Slaughtered Hen*, ca. 1945, oil on canvas, 22 × 15 in. (56 × 38 cm.). Collection Museum of Art (Mishkan Leomanut), Ein Harod.

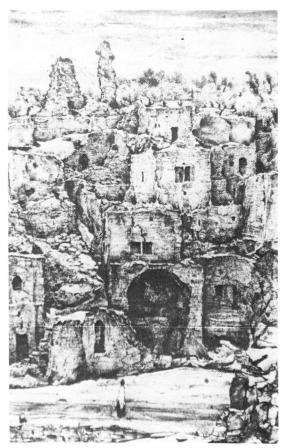

Fig. 13. Anna Ticho, *Arab Village*, 1942, pencil on paper. Collection unknown.

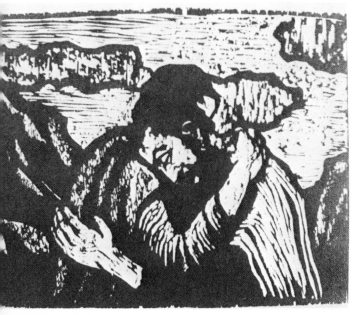

Fig. 14. Jakob Steinhardt, *Jacob and Esau*, 1950, woodcut, 11½ × 15 in. (29 × 38 cm.).

particular Anna Ticho and Leopold Krakauer, were painting in Eretz Yisrael earlier than this.) Anna Ticho emigrated in 1912 and became a cultural heroine. Her first encounter with the landscape of Jerusalem, which she depicted until her death in 1980, was a traumatic one. As she said, "The hills were bare. There was not even a single tree. I observed the scene intently and was drawn to it. I swallowed it with my eyes. The pure and recurring lines of the hills, which appeared to have been there from the Creation, extended into infinity. It all spoke to me. I felt the loneliness of the landscape but I wasn't able to record it. . . . for a whole year, I was unable to paint."[21] This sense of personal identification with the landscape dominated her art until the 1950s. Her drawings were academic and precise. (She studied in the Viennese tradition in her youth). Her landscapes were depicted from above, devoid of skies, of man, and of anecdotal detail. Her approach to her subjects was romantic — ruins, desolation, wizened old men and women, ancient olive trees, withered flowers, all indicating the effect of time upon man, trees, and dwellings (Fig. 13). Her approach was completely different from that of other Eretz Yisrael artists. In the 1950s she ceased painting from nature and developed her landscapes "from within," from an abstract web of broken lines which, by means of thickening and accentuation, combine to form an identifiable landscape. The organization of these pictures is emotional, and the lines and markings clearly interpret her feelings and her mystical identification with the landscape.

This type of identification is also typical of Leopold Krakauer's graphic works. Krakauer, one of the country's most important and original architects, was also a highly productive graphic artist (his symbolic drawings of the early twenties are in the collection of the Albertina in Vienna). His drawings, particularly those of the forties and fifties, are devoted exclusively to landscapes, trees, and thistles. They were all done in the studio and express an internal experience in a rapid, spontaneous broken line, devoid of deletions and corrections. Several landscapes are dramatic; all of them testify to the artist's attempt to unite the rhythms of the landscape in a gestural kind of expressionism.

In his technique Krakauer was influenced by Van Gogh's drawings, and it is also likely that there is a relationship between his thistles and those painted by Van Gogh. For Van Gogh they symbolize the aggressiveness, the dryness, and the possibility of life in a hostile environment.

For Krakauer, thistles are existential symbols, aggressive and threatening sun-like and scorpion-like shapes or images of the thorn of life and the thorn of death. His portrayal of trees is also symbolic; at times the contrast between young and old or dead trees is accented (once again they are depicted as connotative and symbolic objects, completely detached from any environment); at times associations of loneliness, sacrifice, and torture are stressed (several of his trees are anthropomorphic and reminiscent of the Crucifixion).

In Jerusalem Anna Ticho, her ophthalmologist husband, and Krakauer and his wife established a circle of German-Austrian intellectuals. This group included such world-famous cultural personalities as the philosopher Martin Buber; the writer S. Y. Agnon; Zalmon Schocken, the Zionist art and book collector and publisher; the architect Eric Mendelsohn; Samuel Hugo Bergman, the philosopher; and the poet Elsa Lasker Schüller. From time to time the group was joined by guests from abroad such as Alma Mahler. The atmosphere of these intellectual literary salons, reminiscent of Berlin and Vienna, was somewhat elitist and Central European, in contrast to the corresponding group in Tel Aviv, whose leaders came from Eastern Europe. As a result, most of the German Jews who emigrated to Eretz Yisrael in 1933 settled in Jerusalem, and when Bezalel was reopened in 1935, its teachers were mostly of German-Jewish origin.[22]

Notwithstanding their differences, many of these German artists did have a great deal in common. They were opposed to aestheticism for its own sake and believed that the artist had a moral mission and that his work should have social meaning. In contrast, non-German artists were inclined to focus on stylistic problems rather than on content and produced work characterized by personal expressionism.

Jakob Steinhardt was one of the most important and influential painters of the group from Germany. Just before World War I he, with Ludwig Meidner, created the "Pathetiker" group, whose members expressed their apprehensions and fears in apocalyptic scenes painted in a dramatic and intense expressionistic style. Even then, Steinhardt drew on biblical motifs of sin and punishment (Cain, Job, the Flood). His works emphasized the relationship between the artist with a moral mission and the biblical prophet, and he often depicted the prophets of wrath imploring their followers to repent. After World War I Steinhardt refrained from prophecy, and biblical subjects became rarer in his work. Instead, he attempted to reflect the profound intensity of the religious beliefs held by orthodox Eastern European Jews. When he arrived in Eretz Yisrael in 1933, he began to paint religious Jews walking along the dark and narrow alleys of the old city of Jerusalem, disregarding the Oriental element completely and suggesting a parallel between the Jewish experience in Jerusalem and that of the shtetl in Eastern Europe.[23]

After the Holocaust the prophecy motif reappears in Steinhardt's work. The Israeli War of Independence further inspired him to create, particularly in woodcuts, a series whose subject was biblical but whose significance was political. His portrayals of the uprooted Hagar with Ishmael in her arms and her face lifted towards heaven, of the meeting between Jacob and Esau (Fig. 14) — brothers who had been enemies in the past — and of Cain after his murder of Abel all express the Israel-Arab drama (the war between brothers) as he perceived it. The message of this series is one of hope. Several of the biblical subjects in his Israeli works reflect events in his own life, but it is difficult to isolate the personal aspects in the work of an artist whose work is so expressionistic. Following the Sinai War in 1956, he again used biblical subjects to symbolize the political conflict. The call for compassion and peace continued to be a leitmotif of his work for the rest of his life. His skill in the woodcut technique and his international reputation gave him great influence.

Another important member of this artistic group was Mordecai Ardon. He studied at the Bauhaus in 1924–25 and taught at Johannes Itten's school in Berlin. When he was compelled to leave Germany in 1933, he decided to emigrate to Eretz Yisrael although he was a Communist, not a Zionist. Until the 1940s most of his paintings showed the panorama of the Judean hills with their mysterious light, some of them reminiscent of Rembrandt's landscapes. In 1946, however, he turned to subjects related to the Holocaust (a monumental Sarah mourning her sacrificed son). In the 1950s his work developed in the direction with which we are familiar. His rich textures and glowing colors create the effect of light flickering from within. His recurring themes include the Holocaust (his interest in the subject borders on the obsessive), the passing of time, Jerusalem, clowns (identified with artists), and landscapes. These subjects are not depicted in a representative-naturalistic style but through diverse symbols, some personal, some literary, and some related to the

Kabala, the various Midrashim, and the history of art. The symbolic repertoire of Paul Klee, Ardon's teacher and friend during his Bauhaus period, is occasionally recalled, but Steinhardt's interpretation is totally personal.

In the late 1930s and the 1940s, a change evolved in the self-image and sense of identity of the Jews living in Eretz Yisrael. This change can be attributed in part to the mentality of a younger generation born in the country, in part to historical events in the period. Characteristic of this new sense of identity is the myth of the "new Jew" and the emphasis on the relationship between this ideal and the ancient history of the Semitic region. During the 1920s intellectuals and artists regarded the bond with the ancient East as an alternative to the declining West, a reflection of their biblical ties, and an antithesis to the world of the Diaspora. A somewhat similar phenomenon took place during the 1940s, but the Arabs of Eretz Yisrael no longer served as models for emulation or as possible links to the past.

The reasons for this shift are complicated. In the wake of the struggle against the British, nationalistic feeling grew. Amos Kenan expressed the prevailing psychological state when he wrote of the "desire of the Hebrew youth to prove his ownership of Eretz Yisrael to the British policeman who had been living in the country since before the young fellow was even born."[24] A basically anti-Western approach also developed as a result. The struggle against the Arabs (these years were called the "tower-and-stockade period" because of the fortified settlements established in the country) and the sense of being besieged increased the need to reassert the Jewish nation's ancient roots in the land. A sense of a regional identity which differed from the Islamic Oriental identity took shape, and the image of the Diaspora Jew as a victim of the pogroms faded. The spectacle of growing anti-Semitism in Europe, the threat to Jewish existence in the Diaspora, and the misery of the European Jew inspired the younger generation of Eretz Yisrael to turn to myths which were deep-rooted, primordial, and regional in nature and without negative "Jewish" connotations. Indeed, from the mid-thirties onward, all European art showed a tendency to return to ancient and archetypal myths. Jungian psychoanalytic doctrines and the theories of the Surrealists reinforced this interest.

When the extent of the Holocaust first began to be known in Eretz Yisrael in the late 1940s the search for roots in the ancient Near East was given further impetus, fed by the desire to sever all ties to Europe. When the state of Israel was established, a national myth was needed which would be of particular significance to its young people. The ingathering of exiles and the diverse cultures of thenvarious ethnic groups immigrating to Israel following the 1948–1949 war strengthened this desire (which was shared by the political leadership). Accordingly, in the early 1940s a group of writers known as "Canaanites" was formed.[25] It included the poet and journalist Yonathan Ratosh, the art writer and critic Benjamin Tammuz, the writer-translator-editor Aharon Amir, and others who emphasized the rupture between Judaism and "Israelism." In their view, the Israelite had been part of the Canaanite presence in the region until the exile of Judea. Monotheism was not the only religion practiced by the Israelites; there were pagan cults among them during this period. Judaism, the familiar ideology and religion, was a creation of the Babylonian exile, like the Bible. The return of the nation to its homeland, the argument ran, opened the way for a rebirth of the Israelite experience and the blotting out of the years spent in the Diaspora.

In archaic language, the Canaanite authors and poets wrote of ancient myths and pagan cults. *Nimrod* (Fig. 15), a sculpture created by Yitzhak Danziger in 1939, was influenced by primitivism and was even sculpted in the ancient Indian style. The features and the fact that the hunter is uncircumcised make this a "non-Jewish" image. It can be viewed as a crystallization of Canaanite ideas and experiences despite the fact that Danziger did not see himself as directly involved with the group. This hunter hero, although mentioned in the Bible, was also a popular mythical figure during the Canaanite period. *Nimrod* is both man and animal (the hawk is carved as part of the hunter's body); the sandstone from which it is made comes from the Nabatean capital of Petra.

The notion of a gulf separating Zionism from Judaism, the descendants of the ancient Israelites from the scattered Jewry of the Diaspora, appealed to the younger generation (in Freudian terms, Jewishness was the "great repression" of the Israelis during the 1950s). The renewal of the bond to the ancient Israelites is only possible if this history is transformed into a powerful myth which reaches into the present. Oswald Spengler defined "myth" as the perception of the past held by nations without historical consciousness, and during the 1940s and 1950s many Israelis' perception of the past became mythical in this

sense. To a great extent, the Canaanite legend also became one of the symbols of the revolt of sons against fathers who were tinged with the stigma of the Diaspora. One might say that the creator of *Nimrod* was a sort of Oedipus, while Nimrod himself was the mythical father of an entire generation of Israeli artists and intellectuals.

The myth of Canaan also contained elements of the myth of fusion with the earth as a means of returning to the womb (Mother Earth). An Israeli obsession characteristic of the 1950s, it is obviously related to the problem of "belonging." Archeology was very popular in the 1950s, and not always in a scientific and professional context. Ceramics, as an artistic medium, also gained in popularity: ceramics are created from the earth and are very much a part of ancient Oriental art. Danziger expresses the mystical identification of animal and land in his famous sculpture *The Lord Is My Shepherd* (*Negev Sheep*) (see p. 90); his bronze figures resemble rocks, mountains, land, irrigation canals, and Bedouin tents. This trend was also significant during the 1950s, although it was no longer tied to specific Canaanite ideology. In the next two decades Danziger's interest in the deep cultural roots of the region resulted in his creation of a less romantic and more "pure" art.

In the 1940s Moshe Castel completely altered his artistic approach and began depicting myths of dramatic force (such as the *Passover Sacrifice* [Fig. 16]) in a primitivist style influenced by the schematicism of prehistoric art in Eretz Yisrael, popular Arab painting, and the forms and images of the mosaics excavated by archeologists (particularly the Beit-Alpha mosaic of the sixth century; see p. 23). During the 1950s, as Israeli painting moved toward abstraction, Castel created paintings based upon ancient Hebrew letters, which also recall the style of Klee and the French painters Jean-René Bazaine and Alfred Manessier. In the mid-fifties, influenced by Antonio Tápies, Castel began a series of ground basalt reliefs (he had been impressed by the third-century basalt reliefs at Curazin). His reliefs are often reminiscent of ancient steles engraved with writings; the images they contain are based upon elements in ancient writing, such as Islamic arabesques and stylistic figures of an archaic character. During the 1950s the colors in these relief figures suggest desert and rock; later they become polychromatic, the intense colors those of the Near East (vivid red, green, shades of gold). During the 1950s this archeological trend was also evident in the crafts ("ancient-style" jewelry), in product design (ceramic utensils with the form and

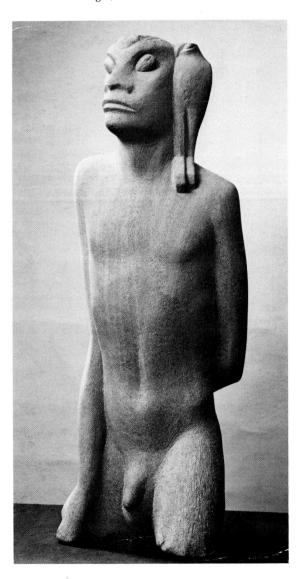

Fig. 15. Yitzhak Danziger, *Nimrod,* 1939, Nubian sandstone, 37⅓ × 13 in. (95 × 33 cm.). Collection Mrs. Sonia Danziger, Haifa.

finish of ancient Eastern vessels and utensils), in graphics (posters or product labels), and in general life style (names given to children and commercial firms, women's clothes and hair styles).

The painter Aharon Kahana also turned to abstraction in the style of images from the Assyrian repertoire or the figurative ceramics of the ancient Orient. His subjects were linked to pagan and biblical myths, such as the sacrifice of Isaac (Fig. 17). Kahana's abstraction was based upon principles which he had found in Near Eastern (as well as in ancient Judaic) culture.

Oriental pagan images appeared in the paintings of other artists as well, in the 1950s, and at times they suggest the preoccupation with archetypes and pictographs found in the work of William Baziotes, Adolph Gottlieb, Mark Rothko, and Jackson Pollock during their Jungian-Surrealist period. However, in Israel a nationalistic collective orientation is behind this trend. Mordecai Ardon's *Tammuz* (1962), showing the Canaanite deity as a musical instrument and as a mythological combination of male and female, was influenced by Sumerian sculpture; his *Venus from Beersheba* (1962) was based upon the bust of the Canaanite goddess of fertility discovered near Beersheba; *Eve* (1963), with its Cyclopean eye, is also reminiscent of Sumerian busts.[26] All of these are "Canaanite" in the broadest sense: they express Ardon's reaction against "Talmudic Judaism" and his desire to revive a Judaism linked to that paganistic and Dionysian past which, to him, constituted its "healthy" origins.

The works of a substantial number of the artists who emigrated from Germany in 1933, including Ardon (in certain paintings), Aharon Kahana, Shalom Sebba, and others, lean toward primitivism, perhaps because those uprooted and expelled from Western society longed to emphasize the Jewish people's national and cultural roots. Their acceptance of the ethic and aesthetics of the ancient Orient may have been a collective psychological reaction to the trauma of expulsion (some of the artists of German origin were drawn to the work of Danziger, who was born in Germany although his family emigrated to Israel many years earlier).

The early 1950s were marked by political activism and radicalization on the part of both Right and Left. The need to fight for the survival of the newborn nation, the presence of a proletariat concentrated in new immigrant and transit camps, Socialist-oriented riots and demonstrations, and the

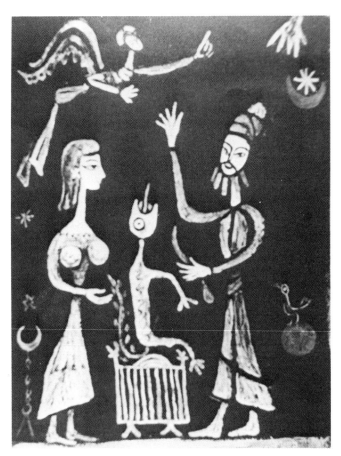

Fig. 16. Moshe Castel, *Passover Sacrifice*, 1942, oil on canvas, 28¾ × 23⅔ in. (73 × 60 cm.). Collection Mr. and Mrs. Moshe Castel, Tel Aviv.

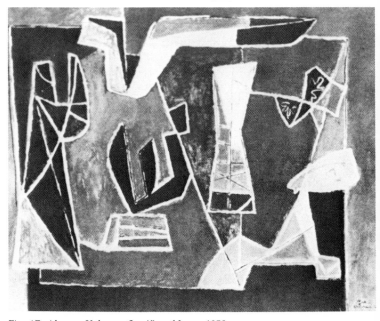

Fig. 17. Aharon Kahana, *Sacrifice of Isaac*, 1950, oil on canvas, 51 × 63 in. (130 × 160 cm.). Collection The Tel Aviv Museum.

limitations imposed on Arabs in certain areas of the country — all contributed to the intensified political atmosphere. In newspapers and magazines artists belonging to leftist groups depicted scenes of poverty in the cities and the transit camps, laborers slaving away in factories, strikes, closed employment offices, and the plight of the Arabs in Israel. The work of Renato Guttuso and the Italian Realismo group, the Brazilian Candido Portinari, Diego Rivera, Ben Shahn, Frans Masereel of Belgium — in other words, Social Realism and Expressionism — were the main artistic models for these *engagé* artists.[27] Many politically conscious artists, like Naftali Bezem, Dani Karavan, Avraham Ofek, and Moshe Gat (Fig. 18), were influenced by the anti-Formalist and anti-Modernist ideas of Andrei Zhadanov, Stalin's cultural commissar, and by those of Marxist aestheticians and philosophers such as Georg Lukacs, one of the most important Realist theorists. The kibbutz artists had a great deal in common with this group of *engagé* artists. They too were influenced by Zhadanovism and, stylistically, by the social realism of South American art. However, their works confirmed the myths of the kibbutz, and their imagery was idealized rather than critical. Yochanan Simon, for example, depicted the idyllic kibbutz life and paid tribute to the concept of motherhood in monumental figures in the style of Rivera (see his *In the Shower*, p. 127).

There were significant parallels between the kibbutz artists of the 1950s and painters who strove to express ancient Oriental values such as Shalom Sebba and Georges Gumpel, both of whom were close to Yitzhak Danziger. The monumentality and the archaic characteristics (also evident in the attire of the figures) of Gumpel's works express a sense of belonging to the region and of returning to the land. These were the same ideals the kibbutzim tried to strengthen in their ideology and their festivities and ceremonies.

New Horizons was the most publicized and long-lived group in the history of Israeli art. Originally intended as a pressure group comprised of superior artists, New Horizons was the result of a conflict within the Artists and Sculptors Association over the mediocre and unselective nature of the general exhibitions mounted by the group, in which each of its members was allowed to participate. When Zaritsky, in his capacity of association chairman, organized a representative exhibition of Israeli art for the Venice Biennale in 1948 which was not approved by all of the association's members, he was expelled. In a

gesture of solidarity, many of the association's members then left the group to form New Horizons.

It should be noted that the New Horizons artists were relatively old (the average age of the founding members was forty-five, and Zaritsky himself was fifty-seven). From the start they appeared to be an authoritative group of professionals who had already proved their artistic ability. New Horizons was not avant-garde in the popular sense of the term, as it enjoyed the support of the art establishment; in fact, its first exhibition was mounted at The Tel Aviv Museum. The fact that so many of the country's painters worked within an abstract framework during the late fifties and early sixties reflects the enormous power wielded by this group. New Horizons is also usually considered responsible for the Western-universalist orientation of Israeli art and is seen as

Fig. 18. Moshe Gat, *At Work*, 1953, woodcut.

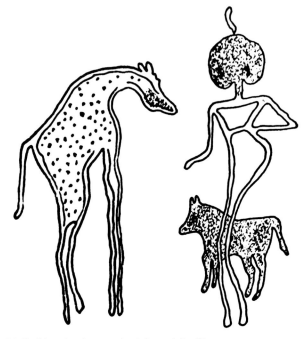

Fig. 19. Yosef Zaritsky, detail of *Yechiam*, 1951, watercolor, 14 × 21¼ in. (36 × 54 cm.). Collection Gordon Gallery, Tel Aviv.

Fig. 20. Prehistoric pictograph, Adrar of the Iforas, Sahara Desert.

the antithesis of regional artistic movements. In retrospect, however, this view does not appear to be entirely correct; the significance of New Horizons rests in the conflict between its search for roots and its attempt to align itself with Western trends in art.

Zaritsky, the dominant figure in New Horizons during its last years, stressed the importance of breaking away from "Israelism" in order to join the mainstream of world art. However, it must be remembered that in the articles of association of New Horizons, formulated in 1950, its goal was defined as "the cultivation of *original* plastic arts [italics added] while maintaining high standards and identifying with contemporary art which advocates the ideology of progress." In other words, the desire to preserve a specific culture was a matter of principle for many of the members; in fact, artists such as Danziger, Castel, Kahana, and Kosso Elul continued to develop this link with local cultural values (style and iconography), each in his own manner, even after the group dissolved.

New Horizons did not have any common artistic ideology. Its one common ground was the respect of all the artists in the group for European modernism. During its early days, each member had his own approach to art. Even at the first exhibitions at The Tel Aviv Museum in 1949, great differences were evident between the cultural naiveté of Castel, Kahana, and Elul and the

expressive and socially relevant aspects of Yohanon Simon's paintings, between the Picasso-like expressionism of Marcel Janco, applied to dramatic situations (an alarm, a bombed Arab village, an injured Israeli soldier), and the "Picassoism" of Avigdor Stematsky, between the influence of Braque's expressive deformations on Streichman and of Braque's interiors on Zaritsky.

In the course of time, the New Horizons group became the voice of abstraction in Israeli painting. It may be that the determined preservation of the principle of abstraction throughout the 1950s was an effort to create an artistic consensus despite the diverse trends within the group — an attempt to present a distinctive image to the country. It should be noted that this abstraction was never absolute, and that figurative elements are discernible even in those paintings which are most "abstract." The abstract painting of New Horizons was related, at least up until the end of the 1950s, to the manifestations of abstraction found in French painting. Only at the 1959 group exhibition did these artists begin to give titles like "Composition" to their pictures. I have already discussed Castel's transition; Kahana's schematic style was somewhat remote from abstraction, and he left the group in 1956, together with Janco and Simon, who turned to semi-abstract landscapes in the mid-fifties.

Zaritsky approached abstraction from the standpoint of the symbolism which characterized his watercolors of the twenties. During the 1930s he

produced a different type of watercolor and drawing. Although these were figurative, their thick black outlines were totally unrelated to the specific motif depicted. The result is an abstract formation which absorbs the figurative elements. In the late 1940s, his preference for non-descriptive drawings developed into a personal interpretation of the works of Georges Braque's paintings of the late thirties. In the painting *Interieur* (1947–48), white contours and color planes create a scene which is identifiable in a general manner, but not in detail. The painting becomes flattened and is perceived as a general visual impression. In 1951, he created the *Yechiam* series of semi-abstract paintings, in which the canvas is divided into amorphous areas differentiated by the techniques and rhythms of the artist's brush (Fig. 19). They are a further development of the figurative aquarelles which he based upon his impressions of kibbutz scenes (images of men and horses). Hints of similar realistic motifs are also identifiable in his completed paintings. It is surprising that the style of these details recalls the schematism of the prehistoric murals found in the Sahara Desert (Fig. 20). Zaritsky lived in Europe from 1954 to 1956, and while there his paintings became more abstract, flatter, and more structural. He was the first artist in the New Horizons group who came close to abstraction. His ideological extremism, his originality, and the power of his paintings made him the dominant figure in the group and in Israeli art in general.

Yeheskel Streichman's paintings are based upon line: architectural forms create the sub-structure and the compositional skeleton, and this framework lends significance to the forms. Streichman's works are more informal and expressive than those of Zaritsky. He aims at the reflection of a mood, and the expressive dimension of the paint is as important to him as its optical dimension. His final images are developed by means of layering and the creation of a deep internal tension; the differentiation of the surface is relatively hazy. In the late fifties his work approached the level of vital abstraction expressed in Hans Hofmann's works of the thirties.

Marcel Janco, with his friend Tristan Tzara, was a founder of the Dada movement in Zurich. While still in Romania, he worked in a style close to that of Picasso's Synthetic Cubism. In Israel, he applied the style of *Guernica* to various subjects, including the Holocaust and the War of Independence (see his *Wounded Soldier*, p. 66). During the late 1950s his style became more abstract, and he returned to the sharpened forms of his Dada period. Even then, Janco's works preserved their Expressionist dimension. Arie Aroch, also a member of New Horizons, went from a primitivism evoking Bissière and Dubuffet to a relatively abstract style inspired by Tápies, while maintaining a basically figurative and mythical focus. His influence on the younger generation was greater than that of most other members of the group. Other artists in New Horizons also reflected the influence of French painting (Abshalom Okashi was influenced by Pierre Soulages, Jacov Wechsler by Jacques Germaine and Philip Guston).

The success of New Horizons is attributable to the quality of its paintings, its international ties, the consistency of its approach, and its backing by the art establishment. Gradually, its charisma was transformed into a "trauma." Streichman and Stematsky, who taught at the Avni Art Institute in Tel Aviv during the 1950s, the only one of its kind in Israel (Bezalel placed greater stress on crafts and graphics), set the tone for a generation of students who, according to painter Raffi Lavie, "were born into abstraction." This, combined with the fact that lyrical or informal abstraction was also the dominant style in Europe, underlined the authoritativeness of this approach. New Horizons achieved a degree of international recognition and was perceived in the late fifties as part of an international movement.

Translated by Miriam Raviv

Left to right: Eliahu Sigard, Yosef Zaritsky, Menachem Shemi, Moshe Castel, Haim Gliksberg, and Tziona Tagger at the opening of an exhibition at the Habimah Theatre, Tel Aviv, ca. 1946.

Notes

1. Ahad Ha-am, "Tehyat Ha-Ru'ah" [Spiritual revival], in *Selected Essays by Ahad Ha-am*, ed. L. Simon (New York, 1962). Ahad Ha-am (1856–1927) was a leader of the Hibbat Ziyon movement.

2. Avraham Mapu (1807–1867) was the creator of the modern Hebrew novel. One of the principal exponents of the Haskalah movement, he is best known for the novel *Ahavat Ziyon* [Love of Zion].

3. The author uses "the Orient" to mean the Eastern world, including the Middle East.

4. *Teatron Ve-omanut* [Theatre and art], no. 1 (1925).

5. "About Engel," *Doar Ha-yom* [Today's post] 5, no. 128 (1928).

6. "Love of the Orient," *ibid.*, 6 (March 22, 1922).

7. He quotes this observation later, in his *My Life My Art* (New York, 1969), p. 148.

8. "The 'Song of Songs' by Raban," *Doar Ha-yom* 7 (December 14, 1923).

9. Trumpeldor, a Jewish officer, was killed in 1920 while defending the colony of Tel-Hai against Arab attack.

10. In 1929, Nachum Gutman published a political pamphlet, *Telegrams in Pictures*, a series of illustrations depicting the Arab riots and the British disregard of the slaughter. The pamphlet aroused the wrath of the Mandatory government, which demanded that all copies on sale be confiscated. (As already mentioned, during the 1920s the Arab — in the eyes of Gutman — was an object of conflicting emotions: attraction, affection, and jealousy.)

11. See The Israel Museum, *Expressionism in Eretz-Israel in the Thirties and Its Ties with the École de Paris* (Jerusalem, 1971). For a general discussion of French art in the 1930s, see Musée d'Art et d'Industrie, *L'Art dans les années 30 en France* (Paris, 1979); B. Dorival, *L'Entre-deux-guerres: Histoire de l'art* (Paris, 1960).

12. Nevertheless, it should be noted that there was avant-garde activity in France during the thirties. Surrealism and geometrical abstraction were at their peak, and a number of artists were under the charismatic influence of Picasso. Modern jazz had reached Paris (Louis Armstrong, Duke Ellington, and the Cotton Club), and musicians such as Darius Milhaud, Francis Poulenc, Georges Auric, and Arthur Honegger were creating their best works. However, these were hermetic intellectual groups of severely limited influence.

13. This alliance was also fostered by practical considerations. Jewish artists had succeeded in creating a market in Paris for their works which, although for the most part limited to fellow Jews, was quite significant. This is particularly true of Soutine, who achieved great commercial success during the 1930s. It is paradoxical that Soutine's art represented a clear reaction against his Jewishness as Maurice Tuchman has shown in his catalogue for the 1968 Soutine show at the Los Angeles County Museum of Art (*Chaim Soutine* [Los Angeles, 1968]).

14. *Gazith* 4, nos. 3–4 (Summer 1940):38.

15. *Ibid.*, p.39.

16. *Ibid.* This approach echoes the conservative view which, as already noted, was characteristic of a cross-section of European intellectuals during the 1930s. Menachem Shemi shared this view of Matisse and Dufy as having been responsible for the decadence of European art. He later wrote: "I think that subsequent to the defeat of France, that refined class which cultivated Matisse, Dufy and Bonnard had disappeared or will do so shortly" (*Gazith* 5 [1941]). Yitzhak Frenkel regarded art for art's sake and the worship of technique and intellectualism (Cartesianism) as characteristic of French art. The coldness, the importance of "speed in applying paint and intellectual surprise," he said, were foreign to the "fervor of the yearning arising from the sentimental heart" of Jewish art (*ibid.*, 4 [1940]).

17. *Histoire de l'art: L'Esprit des formes* (Paris, 1933), p. 252.

18. *Soutine* (Paris, 1929). The quotation is translated from a Hebrew version published in *Gazith* 1, nos. 3–4 (April 1932):9.

19. *Gazith* 2, no. 4 (1935):38.

20. *Ibid.*

21. Conversation with the artist.

22. Over the years, Bezalel became a sort of Israeli Bauhaus. Great importance was attached to the crafts, in the spirit of Bauhausian non-separation of pure art and crafts. This emphasis increased when Mordecai Ardon, a former Bauhaus student, became its director in 1940.

23. The ideas set forth here regarding Steinhardt's works are taken from Dr. Ziva Amishai-Maisels' article "Steinhardt's Call for Peace," *Journal of Jewish Art*, nos.3–4 (1977), pp. 90–100. In her words, "He used this timeless world as a refuge in which he could escape the tragic realities of life that he refused to face" (p. 100).

24. "And the Canaani Was Then in the Country . . .," *Proza* 2, nos. 18–19 (August-September 1977):4.

25. For further information see University of Haifa Art Gallery, *The Myth of Canaan and Its Influences on Israeli Modern Art* (Haifa, 1980).

26. These three paintings are reproduced in Michelle Vishny, *Mordecai Ardon* (New York, 1973), pls. 121–22 and p. 43.

27. Israeli artists developed ties with Social Realism throughout the world by visiting such artists as Bezem in Italy, Simon in Mexico, and the Socialist Realists in the U.S.S.R.

The Sixties and Seventies: Inner and Outer Visions

By Yona Fischer

Until about 1960, most significant changes in Israeli art were brought about by veteran artists. In the late fifties it seemed as though the success of the New Horizons group would result in an ongoing confrontation between the two major aesthetic alternatives: figurative art, rooted in what was considered to be a local tradition, and abstraction, which claimed to be universal and contemporary.

As Ygal Zalmona points out in his essay, during this period young artists like Abraham Ofek and Naftali Bezem moved away from the figurative tradition which drew upon the School of Paris, while in the late fifties pupils of Yosef Zaritsky and Avigdor Stematsky followed the "lyrical" style of the New Horizons group only in their early work. Several of these artists — Moshe Kupferman, Arie Azène, Doron, and Uri Lifshitz, among others — were invited to participate in the last New Horizons exhibition held in 1963 at the Mishkan Leomanut (Museum of Art) in Ein Harod. The choice of these artists reinforced the dominance of the "lyrical" line during the group's last years. (It is significant that two founding members of New Horizons, Moshe Castel and Marcel Janco, who represented other trends, were absent from that exhibition.) These young artists, together with Raffi Lavie and Igael Tumarkin, radically changed the face of Israeli art in the first half of the 1960s. Although they all started their careers working in an abstract style, most soon diverged from the pure abstraction of the 1950s.

Before turning to a discussion of the young artists of the 1960s, however, we should note that in this period of flux the dependence on the School of Paris for artistic guidance reappeared. The ties which had been severed during World War II were re-established. Zaritsky lived in Paris from 1954 to 1956; Castel resettled there in 1959; Israel Paldi and Avigdor Stematsky made extended visits; younger artists like Lea Nikel, David Lan-Bar, and Michael Argov followed, as did even younger ones, Yaacov Agam, Avigdor Arikha, and Igael Tumarkin. In 1960 all could have been considered as of the School of Paris. Castel and Paldi, two typical original Eretz Yisrael painters, were swept up in the wave of abstraction, and Lea Nikel developed her Expressionist style, which fell between that of the Wols and the CoBrA groups. In 1960 Paris experienced the decline of the abstract school led by artists Soulages, Manessier, and Hartung, all of whom had exhibited at the Galerie de France. At the same time interest in Nouveau Réalisme grew, and its supporters clashed with the proponents of figurative art, nurtured by the organizers of the first Biennale des Jeunes Artistes in 1959. The city remained a powerful attraction for artists of diverse backgrounds and styles: Yaacov Agam could flourish in the city where the Denise René Gallery encouraged Vasarely; Avigdor Arikha, on his path to abstraction, could encounter Matta; and Tumarkin was to discover artists using polyester and the work of Spanish artists such as Tápies, who were widely exhibited in Paris. Finally, Nouveau Réalisme itself influenced some young artists, such as Yehuda Neiman, Aika Brown, and Marc Scheps (Fig. 1).

Most of the young artists of the 1960s were sabras. Raffi Lavie and Uri Lifshitz are Israel-born; Lea Nikel and Tumarkin were brought to Israel as infants. Many of the others, including Arikha, Kupferman, Bezem, Ofek, and Bak, were Holocaust survivors who reached Israel as refugees in their teens. The distinction between sabras and survivors is noteworthy, particularly in the light of the personal identity conflict that they were to experience until their maturity, a conflict which was

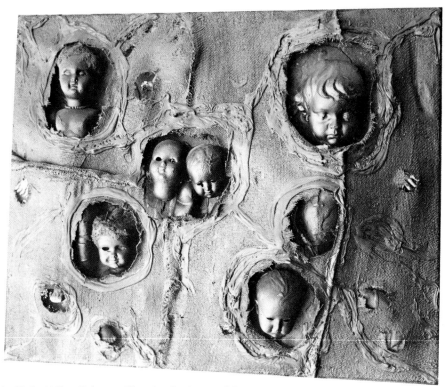

Fig. 1. Aika Brown, *Dolls in Black,* 1963, relief assemblage in plastic materials, 57½ × 38 in. (146 × 97 cm.). Brown Collection, Tel Aviv.

greater among the Holocaust survivors than among those who had spent their childhoods in Eretz Yisrael, and it was a recurrent theme in the work of those survivors all through their lives. The changes that occurred in about 1960 in Israeli literature and music reflect this conflict. In both spheres a new generation of sabras or near-sabras had grown up, "the Israeli generation," as it was called. They dreamt about the homeland and fought in the War of Independence, and the shattering of their illusions is well described by Israeli writers. The "dominant theme was that of the individual's responsibility to himself in relation to the pressures of the group," wrote Curtis Arnson. At the end of the 1950s, the members of the "transitional generation," as Arnson called it, were "confronted daily with phenomena as disparate as disenchantment with the kibbutz, the secularization and commercialization of the city and a transplanted European leadership trying to preserve its hegemony. As society's ideals tarnish, must the individual strive for their preservation?"[1]

Until 1960 music in Israel reflected the attempts of the major composers to blend melodic and formal elements drawn from the traditional music of the East and European contemporary styles. The rise of the first generation of sabras (Sêter, Orgad, Avni) caused a shift in the direction of international contemporary music. Yet in the plastic arts, around 1960, the themes of war, the kibbutz, the Holocaust, and the Bible, predominant in literature and present in music, had no place. The young Israeli artist was not involved with the "'I' within the 'we'" so characteristic of literature but rather with interpreting the contemporary world of art.

Three different sorts of difficulties confronted the young artist in this attempt. First, he was ambivalent toward New Horizons. Although its members seemed to be innovators, its struggle to establish the primacy of abstraction over figurative art was no longer a central concern to him. Zaritsky was admired as a master, but his loyalty, both on the practical and conceptual level, to a European tradition based on a balance between material-expressive and form-color values was alien to the young, instinctive, crude Israeli. The nature of the artistic education available was a second difficulty. At Bezalel, Yaacov Agam, Avigdor Arikha, and others were taught according to Ardon's

methodology; at the Avni Art Institute in Tel Aviv, Stematsky and Streichman taught Lea Nikel and later Karavan, Buky Schwartz, and Benni Efrat a technique that amounted to a short cut to Lyrical Abstraction. All these young artists later found their technical training an obstacle in their work. A third problem was that most young graduates of Bezalel and the Avni Institute, as well as the virtually self-taught kibbutz artists, lacked not only a broad artistic education but also a basic knowledge of what was happening in the art world outside of Israel. Some, as we saw, went to Paris; others, such as Kadishman, Schwartz, and Efrat, went to London. The rest tried to find a place within the collective art life of Israel.

New Horizons had taught the younger generation the value of group organization, and their participation in the last exhibition of New Horizons in 1963 secured them, at least in the short run, some recognition. A new group of artists formed in 1965, who took the name 10+, provides the best example of artists joining together without adhering to a specific style. Members of 10+, like New Horizons members before them, proclaimed no artistic ideology but laid down a flexible plan of action. The dynamic figure in the group was Raffi Lavie, a young, virtually self-taught artist who, both as painter and teacher, was to have a powerful impact on many young Tel Aviv artists. The group's first exhibition was in 1965; its second was in February 1966 at the Artists' House, Tel Aviv. Over fifteen artists were represented at the second show, among them the painters Raffi Lavie and Benni Efrat, sculptors like Buky Schwartz, an architect, a ceramist, and a photographer. For the exhibition the composer Tzvi Avni held an evening devoted to electronic music; theatrical, cinema, and modern poetry evenings were organized; and a fashion show was even presented. The catalogue simply announced "artists exhibiting different techniques and subjects" and gave the participants' names; there was no sign of a manifesto. The ostensible theme of the show was "Large Formats," along with others such as "Small Formats" and Botticelli's *Venus*, and this common denominator, however tenuous, promised pluralism of views which would allow for an expression of individual freedom. At the same time, 10+ members were keen on being recognized by the artistic establishment, as is evident from the fact that it was Zaritsky who opened the second exhibition.

The artists of 10+ appeared on the local stage as second-generation rebels. Their art is characterized by a mixture of experiments drawing upon what was known, or at least gleaned, from the outside world. Raffi Lavie was perhaps the most professional artist in the group. He was and is a painter interested only in painting: abstraction per se did not concern him. His association with Twombly in 1960 and 1961 was a happy coincidence; his canvases from that time on were monochromatic. Later, when he began drawing with pencil on, or rather in, a surface of oil paint, he was seeking a way to express a kind of automatization of the hand movement in drawing. Even in the 1960s, when figurative shapes made their appearance in his works, he remained basically an instinctive artist. In contrast, other painters from 10+, for the first time to any significant degree in the history of Israeli art, turned toward the United States. The integration of the image in the art work and the use of mixed media were borrowed from American Pop Art. The printed or painted word, one of the most obsessive features of American art, was also frequently seen in these works.

The dynamics of what was later to be called the "Tel Aviv Street" was exemplified by 10+. This was bohemian Dizengoff Street, with its cafes where young artists, writers, poets, cinema, and theatrical people met. It also included adjacent Gordon Street, where galleries sprouted like mushrooms. It was more difficult to infiltrate the museums. Eugene Kolb, who directed The Tel Aviv Museum until his death in 1959, was a convinced Socialist who supported New Horizons both as a critic and as a curator. His successor, the con- servative Dr. Haim Gamzu, maintained a more hesitant exhibition and acquisition policy toward young artists. Paradoxically, the sleepy city of Jerusalem, during the final years of the Bezalel Museum gave more support to young artistic creation during the 1960s than did Tel Aviv (its show "Today's Form" in 1963 exhibited the work of ten young artists, including the painters Lavie and Bak and the sculptors Schwartz and Tumarkin). With the establishment of The Israel Museum and of *Qav*, the only art quarterly in the country devoted to young art, in 1965, Jerusalem's support of young artists further increased.

Through this dynamic interchange, where young artists gradually took over the street, a more individual type of Israeli artist evolved, one which fed on styles and myths borrowed from the West, perhaps most of all from New York. This instinctive and intuitive nourishment in fact temporarily stifled artistic individuality. The local context, whether social or symbolic, was used only as a variation on

familiar themes or as a pretext. While New Horizons had at its core a kind of national mission which gave it its ideological character, the young artists of 10+ demanded only the right to personal liberty. The example of the kibbutz artists of the period is useful in understanding this struggle. The closed society of the kibbutz after the establishment of the state pressured artists, up until the 1960s, to express those ideals in a positive way. Although this demand was not accompanied by definite guidelines, of the kind common in totalitarian regimes, artists who tried to deviate from the norm met with so many obstacles that they often had to leave the kibbutz.

These remarks about the groups formed in the early 1960s and their activities are, by nature, somewhat broad and serve mainly to describe the general creative atmosphere of the period. The artists who were to have a determining influence on Israeli art grew from both without and within this framework. Young kibbutz artists, for example, did not follow in the footsteps of New Horizons, and 10+ was not a movement but rather an action which grew out of a certain time and place.

I spoke above of the sabra's crudeness and instinctive essence as the two poles of an unfinished and uncultivated figure. Raffi Lavie is an example of an artist who drew his power as a cultural hero from just this kind of duality. Aviva Uri is another. Her entire oeuvre, with a few exceptions in the late 1960s and early 1970s, is made up of drawing. At her first exhibition at the Tel Aviv Museum in 1957 she showed chalk portraits and landscapes. In both (despite the fact that the portraits reflect the influence of Matisse) her rawness is apparent. Her expressive, forceful contour lines build, in a cautious, almost intuitive way, a simple formal structure which frequently leads to a nervous complexity. In her transition to abstraction, which she reached in 1961, she retained her initial tie to the landscape in the composition, which is free and often based on parallel horizontal lines. She has not relinquished figurativeness but, by the constant use of handwriting, examines the relationship of the black line to the white paper. Her instinct is evident in her virtually absolute reliance on her own experience as a source for her drawings.

Another example of an artist whose artistic personality developed outside of the established framework is Igael Tumarkin. He was born in Germany, studied with Rudi Lehmann, a sculptor of German origin, and in the late fifties worked in Bertolt Brecht's theater in Berlin. After a period in Paris, he settled in Israel in 1961 and began working as a painter, a stage designer, but primarily as a sculptor. He was *engagé* not in the narrow political meaning of the word but in the sense that he was highly sensitive to the happenings around him. He has created dozens of projects, both sculpture and monuments, in which

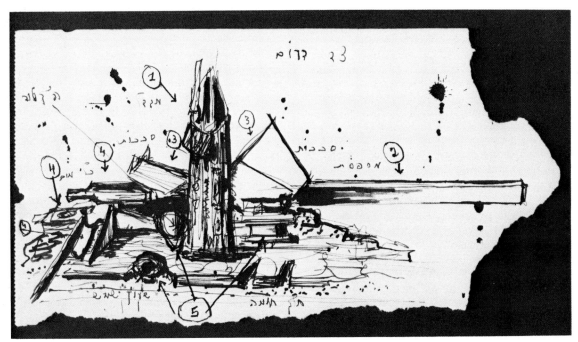

Fig. 2. Igael Tumarkin, drawing for a monument, ca. 1965, pen and ink. Collection Yona Fischer.

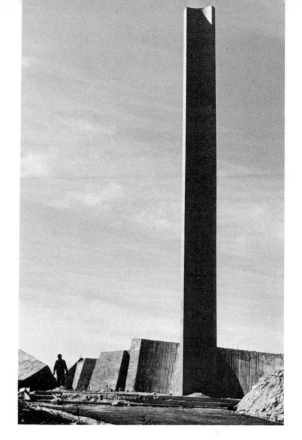

Fig. 3. Buky Schwartz, *Pillar of Heroism*, Yad Vashem, Jerusalem, 1968, concrete, height 68 ft. 10⅔ in. (21 m.).

geometric elements, junk, and at times casts of human limbs are combined with symbolic intent (see, for example, Fig. 2, a monument in the shape of a gate). In each project (only a few of which have been executed), the component elements reflect the subject of the sculpture, which itself represents the artist's reaction to a social, political, or moral situation. As Tumarkin says, he finds his work "a situation in which there is more editing than assemblage" and in which autobiographical images also serve.[2] For the past fifteen years he has traveled extensively in the West and has explored primitive cultures, constantly enriching his artistic vocabulary with new shapes and techniques (such as the mud used in rural construction in Egypt) without turning his attention from the intellectual message on which his work has always been solidly based.

Tumarkin was, in the late 1960s, a lone rebel, an *engagé* artist speaking the language of the abstraction of the 1950s. In retrospect, he and Raffi Lavie contributed more than any others to the evolution of the artist who demands his creative freedom, regardless of established opinion. Their struggle is reminiscent of the fight of European artists at the turn of the century for "cultural justice," though that earlier effort lacked the idealistic dimension found among these pioneers of abstraction. It was a time of disillusionment, in which artistic problems in Israel, together with issues of social justice, intensified. The massive waves of immigration which followed the establishment of the state had subsided, and the increasing economic, social, and cultural gap between West and East now began to be felt. It was a period of infiltrators and of hot debates on the rights of the Arab minority inside Israel, a period in which the socialistic ideals of Eretz Yisrael began to crumble and the issue of "national security" began to be trumpeted.

Over the years the number of red flags leading May Day parades has dwindled. Israeli society, in its state, municipal, and party manifestations and activities, its veterans' associations, and so on, yearns for symbols of a palpable and significant past. One such symbol is the "memorial," in all its manifestations: the Holocaust and war memorials, the monuments to fallen soldiers, etc. These are not monuments in the Tumarkin style, with their disturbing, aggressive aesthetics and complex symbols. In Israel abstraction is a convenient means to avoid confrontation with religious taboos concerning artistic representation. Israeli society is most comfortable with a simple and comprehensive

expression of an idea: the most acceptable stereotype is a pillar bearing an inscription, placed at the center of a mini-environment. Public monuments in the 1950s were spontaneous and anonymous creations; eventually, however, artists were commissioned for such projects.

The works of Dani Karavan, who belonged to the group of leftist Realists in the fifties, provide us with the most ambitious example of this kind of memorial. In his Negev monument, executed during the years 1965 to 1968, the combination of functional and symbolic elements (firing positions, watch tower, inscriptions) provides both a visual and an intellectual re-enactment of one of the battles of the War of Independence. Karavan came to environmental sculpture from painting through his experience in stage design. His strong dramatic flair is utilized very effectively in the austere concrete mass of the Negev monument. It is also reflected in the elegance of the cut stone in his Knesset Assembly Hall relief (1966) and in the dignity of the white-painted concrete of the environmental sculpture *Jerusalem City of Peace* shown at the Venice Biennale in 1976. In all, the calculated impact of the monumental dimensions of these pieces offsets any merely decorative effect of the material.

Other artists have created variations on the basic vertical motif of the monument: Yehiel Shemi, in the concrete and iron *Sea Landscape* memorial in Achziv (1964–67) and Buky Schwartz, in his *Pillar of Heroism* at Yad Vashem in Jerusalem of 1968 (Fig. 3). Kibbutz member Shemi, who started his

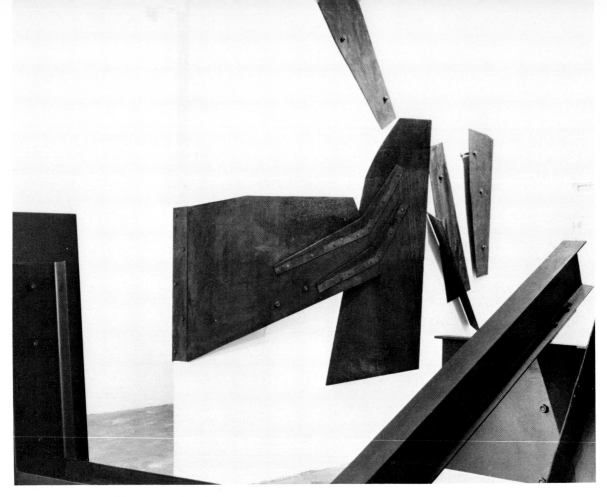

Fig. 4. Yehiel Shemi, environmental sculpture as exhibited at Betty Parsons Gallery, New York, 1975.

career as a Canaanite of sorts, in the 1950s began to express his ties to nature. When he became a member of New Horizons, he began to use iron as raw material. Then, in the 1960s, he became a Geometric-Minimalist sculptor. Shemi designed his monumental works for specific architectural contexts (environmental sculpture for interiors, such as that exhibited at the Betty Parsons Gallery in New York in 1975 [Fig. 4], and sculpture for external spaces, such as the concrete reliefs on the facade of the Jerusalem Theater of about 1970).

Tumarkin, Karavan, Schwartz, and Shemi all felt the need to draw upon nature, symbols, and historical or current events (local elements). They made use of the language of their generation, which was a universal, perhaps even cosmo-political, expressed in materials like concrete and iron and in forms which were abstract. Identifying themselves as sabras, they looked for what could be salvaged from the socialistic ideals of the generation which grew up before nationhood. With the rise of nationalism following the Six Day War, they were increasingly identified with the political Left.

These artists were not alone, however, in their historical consciousness. Others had a different, apolitical, but no less personal concern. Michael Gross, also a sabra, since the 1950s has been preoccupied in his painting with a formal interpretation of the landscape and the human figure, and in his sculpture with monolithic forms within the landscape. On his path to abstraction, though his images now went beyond visual representations of reality, Gross tried to preserve a strong sense of man rooted in the landscape, closely related to its elements: open space, light, form in space. His stone sculptures manifest an affinity and respect for the material. Gross' work illustrates a particularly Israeli paradox: although it evolved from French painting in the manner of de Stael to American Minimalism, in the local artistic milieu he is considered an individualist, outside the mainstream of Israeli art.

Aroch and Mairovich, non-sabras, followed a different path. Mairovich came to almost pure abstraction through the influence of the work of Braque, as did several others of his generation. Like a number of the other artists mentioned above, they were obsessed with the question of their place in

time. Mairovich tried to close the gap between his initial Expressionism and the abstract style which he came to regard as the true language of the late fifties. In the last years before his death in 1974, he turned to drawing in oily chalks (Pandas), which allowed a spontaneous hand movement over the paper. His tension-filled images, despite their abstraction, reflect floral rhythms and the interplay between light and natural forms.

Aroch, in contrast to Mairovich, went far beyond the issue of abstraction versus realism in art as set forth by Zaritsky and his followers. "For me," he said in 1974, shortly before his death, "the period is more decisive than the value of the work; you can analyze an artist and appreciate him, and still not touch on the time, on the need to create [which] that time caused."[3] Aroch was a man of many times. In the thirties and forties, he was a faithful disciple of the School of Paris (though he was later to claim that "its importance was in its negative influence"[4]). By the early fifties, however, when his colleagues in New Horizons were beginning to try and catch up with "their" time, he realized that it was not time that mattered, but one's place in it. His intellectual and emotional curiosity led him to the works of Tatlin, Duchamp, and Rauschenberg and into his own past. In borrowing from Russian Constructivism and from the techniques of Duchamp and Rauschenberg, he aimed "to give abstract forms the validity of concrete ones."[5] In his craftsmanlike concretization of abstract forms drawn from the world of culture and his own memory (such as Russian icons, a shoemaker's sign in his native town, and a page from the Sarajevo Haggadah), he created a private metaphorical language.

In Aroch's works of the fifties (for example, his *Bus in the Mountains* of 1955 [see p. 81]), the manipulation of the thick and nervous line over the canvas is similar to the early style of Raffi Lavie and Aviva Uri, though their development was almost completely independent of his. Aroch's influence increased after 1964, when he began drawing on colored magazine illustrations with oily chalks. Stematsky and Mairovich began using the same materials, and the younger artist Joshua Neustein followed suit. But beyond the merely technical influence, young artists (who did not always understand the personal circumstances of his investigations) saw in Aroch an artist who created a free, apparently arbitrary, signifying image.

The introverted and self-doubting Aroch was alone in proclaiming the advent of a new era in Israeli art. Doubt increased: the younger generation

rejected both the validity of the present artistic language (New Horizons was, after all, a search for language) and the sabra intuition. It sought ways to make personal statements which transcended painting. At the end of the sixties young artists found themselves at a crossroads which was not only cultural. During the period between the euphoria of the Six Day War in 1967 and the trauma of the Yom Kippur War in 1973 a chauvinistic ideology grew, and awareness of political and social issues sharpened. In this atmosphere the young artist found himself faced with one of two basic choices: the investigation of the physical world through structure, in which the distinction between object and subject is eliminated, or the inquiry into the "essence of knowledge." The epistemological choice, formulated by American critics, hints at the growing influence of the New York School on young Israeli artists of the late sixties.

The distinction between these two attitudes is not a simple one. Artists such as Neustein, Moshe Gershuni, and Efrat, for example, moved freely from one position to another over the years. Neustein, who in the late sixties collaborated with Georgette Batlle and Gerard Marx, experimented with analytical and practical processes which fell between Conceptual Art and Happenings. All three acquired their artistic education in the United States and tried to adapt recent American methods to situations of local significance and to familiar contexts. In 1962 they held an environmental display of seventeen thousand pairs of old boots at the Jerusalem Artists' House. The critic Adam Baruch wrote at the time: "This [the display] is not Israeli, just as we are not Canaanites, and this is not Israeli, just as the refined canons which provide us with the most original sculpture are not Israeli."[6] And yet their *Jerusalem River Project* of 1970 (Fig. 5),

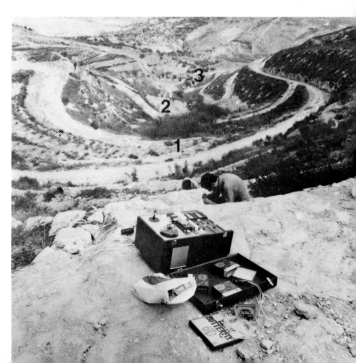

Fig. 5. Joshua Neustein, Gerard Marx, and Georgette Batlle, *Jerusalem River Project*, October 13-27, 1970.

Fig. 6. Benni Efrat, grid on surface of rock from the *Double X* series. No longer in existence.

who since 1968 had been working with epistemic manipulation of paper, examining in different ways its limits as an object, in the seventies turned his attention to the environment. His work, in a combination of techniques, which raise political and social issues, represents the kind of psychological and ideological approach common in Germany and Italy today.

Using Conceptual assumptions, Benni Efrat both affirmed and negated the basic inter-dependence of material, form, and operational activity established by Post-Minimalism. In 1969, he "erased" with white ink the printed pattern of squared paper in his *Adding to Subtract* series; in 1970 he carved a grid into the surface of a rock (Fig. 6); in 1971, he began to construct, in films, structures based on illusory situations in order to confront, through process methods, problems of knowledge. In a sort of "surrealistic logic" he challenged the way our perceptions depend on visual and psychological phenomena. In the seventies Efrat assumed additional levels of perception by freeing the object from a closed system. Using artificial light and projected shadow as an "extrapolation" of both form and material into space, he thus created an open system.

in which three tape recorders and fifty-five loudspeakers were placed in the Wadi of Abu Thor to bring the sound of rushing water to a dry mountain valley, seems to show their preoccupation with the confused and nervous physical world of which they were a part. While using concrete means to examine the totality of the inherent laws of reality, they do not lose the effect of poetic illusion. Neustein would execute other dynamic environmental activities having symbolic and metaphorical implications, but from 1972 on his work took what might be called an "epistemic" turn; that is, he began to focus on the meaning of knowledge rather than the essence of ontological existence. He presented activities such as tearing, folding, and painting paper as a physical affirmation of philosophical, semantic, or sensory assumptions. On the other hand, Moshe Gershuni,

The attention of the younger generation of artists was not confined, however, to exploring the distinction between ontology and epistemology. The issue of the Israeli artist's "place" came into sharper focus — his place in society, the in-volvement of his art in that place, and the roots of his work in his place, i.e., Israel, vis-à-vis the art centers of the world. The pattern of the young artist as a globetrotter who spends increasing lengths of time in New York, Paris, London, Milan, Am-sterdam, and Germany thus established itself. Buky Schwartz, Joshua Neustein, Michael Gitlin, Benni Efrat, Pinchas Cohen Gan, and many others have not only settled in New York but take an active part in local artistic activity.

Benni Efrat and Pinchas Cohen Gan are of Middle Eastern extraction. Efrat was born in Lebanon and Cohen Gan in Morocco. The former studied with Streichman in Tel Aviv and the latter at Bezalel in Jerusalem. When they completed their studies in London, their Western education provided them with the curiosity and courage to experiment with the innovations current among young artists there in the late sixties. But while Efrat was able to incorporate Western thinking and became involved with Conceptualism, applying a rare blend of intuition and analysis, Cohen Gan

54

returned to Israel from the West to a parochial world onto which he perceived the rules of Western culture to have been imposed. He, like Neustein before him, began using Western methods to direct his activities. At first his questions revolved around the individual — his own Moroccan descent and status as a refugee (Neustein, too, refers to himself in his biography as a refugee); then he extended his reflections further, to the cultural and social hierarchy among adjacent groups in a geopolitical environment suffused with hostile tensions; finally he focused on a philosophical discussion of the problem of man in the world of today. In 1973 he took a trip to Alaska, "to travel from one end of the earth to the other, to reach your own end, the end of geography," he wrote in his diary, and so "to move away from the object and from the plastic image itself."[7] He returned to painting to construct an equation whose three components, man, mathematical formula, and "artistic shape," form an ironic and disillusioned description of three-way alienation.

The sociopolitical content also provided a wide field of investigation. Avital Geva, a member of a kibbutz, directed a series of provocative actions before an audience from his own kibbutz. He obliterated footpaths, which represented to him a pattern of social organization; he gathered books and scattered them in a heap at the center of the kibbutz to serve as a public lending library; he created a book cemetery for unwanted books. Thus he tested the continuing validity of social conventions and ideologies in the lives of the increasingly bourgeois descendants of the pioneers. Together with Micha Ullman, an artist who created earthworks in a sociopolitical context, Geva

exchanged earth from his kibbutz with that of a neighboring Arab village in order to establish ties between these two closed human groups.

Zvi Goldstein, who emigrated to Israel from Romania in 1958, also studied at Bezalel and worked in Milan for nine years (1969–1978). He began to analyze language in 1973 (using methods resembling those of the Art and Language group in Britain) in order to investigate phenomena in the realm of social reality. In 1975 he began concentrating on the poster as a form that utilizes text as a visual-artistic medium (Fig. 7). After his return to Israel in 1978 he set out to examine the position of a peripheral culture under the economic pressure of the West and the reasons for the decline of the capitalist West and the rise of the Third World. He probed the political, cultural, and moral implications of this crisis and advocated the revival in Israel of a regional language of forms which would be both aesthetically and functionally independent.

The later work of the veteran sculptor Yitzhak Danziger,[8] who died in 1977, assumed far-reaching significance, not only in its influence on the young artists of the seventies but also in its implications for his own past work. In the sixties he created small bronze pieces which expressed his love for what he called "temporary sculpture": one of these, *Water Conduit Wet* (in the present show) manifests traces of the temporary presence of a Bedouin by a waterhole in the desert; *Enclosure* (Fig. 8) does the same for rural sheep pens. Toward 1970, however, he almost completely abandoned sculpture, concentrating his romantic sensitivity and his intellectual curiosity on investigations connected to the totality of elements of a given place. His

Fig. 7. Zvi Goldstein, *Irrationalism – A Crisis New Ideology*, 1980, poster, silkscreen on paper, 47 × 59 in. (120 × 150 cm.).

IRRATIONALISM — A CRISIS NEW IDEOLOGY

ZVI GOLDSTEIN JANUARY 1980

● As long as the economic curve in western societies pointed to a constant growth in production, export and demand, and as long as the western rate of economic expansion went step-by-step with the utilization potential of the third world, these societies succeeded in building an optimistic ruling ideology, based on faith in progress and in the value of science and technology. However, the energy crisis, the crises of monetary markets, and the rocketting inflation destroyed these myths and brought about the formation of an IRRATIONAL ideology, and of an individualistic and conservative art, reinforced by the growth of a worldwide come-back to religion, withdrawal from political activity, and by the IRRATIONAL economic behavior of society.

● Inasmuch as the pre-crisis period saw RATIONALISM as the ruling ideology which succeeded in incorporating a protest antithesis, the economic crisis of today acts as a ruling factor, without leaving an alternative ideology to IRRATIONALISM. The struggle of various art media against RATIONALISM, in the name of IRRATIONALISM, is not only erroneous, but also reactionary. In spite of the claims that IRRATIONALISM is an alternative ideology, it represents today an ideological positive value against the crisis, just as the RATIONALISM represented a similar value as against the technological society. Nevertheless, it is understandable that in the technological society "par excellence", such as the American, in which RATIONALISM is more inherent than in other societies, the possibility of a confrontation between these two tendencies was not exhausted in the sixties and seventies. The conflict between RATIONALISM and IRRATIONALISM bears the danger of a new internationalization – the danger this conflict would be imposed on marginal cultural regions where the RATIONALISTIC ideology does not rule and wherein this ideology for its own sake is positive, inasmuch as it solves basic problems.

● The phenomenon of the internationalization of RATIONALISM in art in the sixties and seventies went a long way towards the cultural American imperialism; the moral lesson to be learnt from this phenomenon may prevent a second occurrence of new cultural dictates on the art of marginal regions.

perception of a specific site as representative of an encounter between different periods and cultures brought him to reflect on the symbolic significance of "place" and its function.

In 1971, for the exhibition "Concepts + Information" held at The Israel Museum, Danziger created a "hanging lanscape," which consisted of seeds that sprouted during the exhibition and formed a hanging lawn (Fig. 9). This was a preparatory step toward his most ambitious project: *The Rehabilitation of the Nesher Quarry* (Fig. 10). As he saw it, the quarrying not only damaged the landscape but also led to an accumlative destruction of its ecology. Furthermore, the subsequent abandonment of the quarry left an area lacking in purpose and function. Danziger, together with a group of scientists, tried to preserve the signs of damage on the site while developing new functions for it. In the first stage (carried out in 1971) seeds were planted in a particular pattern. In the second stage (which was never executed) part of the site was to be set aside for building. The fine line between preservation and change is also at the root of Danziger's research during his last years related to the "sacred tree." In these ancient trees that had always served a semi-nomadic population for pagan communion ceremonies, he found a noble metaphor for the struggle between the eternal and the temporary, a struggle which he did not find reflected in formal memorials of the sixties.

The last sabra of the generation which matured in the seventies and which was highly involved with nature is the sculptor Menashe Kadishman. In his youth, as a member of a kibbutz, he sculpted in stone. In the sixties he and Buky Schwartz studied in London. The two belonged to a group of young artists who attempted to extend the context for Minimalist sculpture from gallery installation to open space. They participated in different sculpture symposia in Europe, and both had a definite predilection for monumental works. Kadishman did not waver from the basic Minimalist form for many years, even when his objects were constructed from several materials (such as metal and glass) and when he hung yellow-painted metal rectangles on a group of trees in a forest near Montevideo.[9] In the seventies his work took the form of intervention, especially in nature. For example, he painted a living tree at The Israel Museum; cut a metal sheet in the shape of a tree; erased the printed lines of telephone directory pages; "corrected" the contours of a photograph of a mountain; and painted sheep. These diverse projects have much of the sabra crudeness in them, perhaps the last such traces in Israeli art: in his contact with Conceptual art (such as erasing the lines in the phone book) he was acting instinctively, always prompted by the visual aspect of the project.

Kadishman's choice of artistic medium (whether Minimalist form or a patch of color) can

Fig. 9. Yitzhak Danziger, *Hanging Landscape*, environmental sculpture executed for the "Concepts + Information" exhibition, The Israel Museum, Jerusalem, 1971.

be interpreted as a "sign" as well as an expression of a conflict between his native sabra traditions and Western culture. The situation is much more complex with artists who came to Israel in their youth: here the conflict is clearly one of identity. Even artists as diverse as Kupferman, Arikha, Bergner, Bak, and Weinfeld share a past laden with memories which they wished to repress, and all of them, early in their careers, put their faith in the power of "modern" art to help them do so. They all, however, yielded to the need to be reconciled with that which cannot be forgotten. They are by nature individualists, and although their progress must be seen in the context of international trends of the last decade or two, the changes that occurred in their art were wrought in their own mysterious private labyrinth.

They were all born in Eastern Europe and all experienced war early in life. Moshe Kupferman, who came to Israel in 1948 and was a founding member of Kibbutz Lohamai Ha'getaoth ("The Ghetto Fighters"), studied at kibbutz seminars with Stematsky and Zaritsky. Abstraction, a style which he quite naturally adopted, led him to a dead end. In the mid-sixties his painting became a series of

Fig. 10. Yitzhak Danziger, *The Rehabilitation of the Nesher Quarry*, project begun in 1971.

Fig. 11. Avigdor Arikha shown with his *Self-Portrait*, 1976, oil on canvas, 21⅔ × 18 in. (55 × 46 cm.). Collection The Israel Museum, Jerusalem.

repetitive activities which build and contradict one another until the artist brings them to a physical and spiritual saturation, more of an acceptance of what he defines as a "situation" than satisfaction with an aesthetic result. In his drawings and paintings the emphasis is on the fact that each "activity" (covering the canvas surface, erasing it with another coat of paint, weaving a structure of horizontal parallel lines on the surface, etc.) is a decisive act, inviting an additional act — to challenge it. Kupferman does not discuss the meaning of his work, but he does not reject the view that the obsession with forms seen in his work at times corresponds to events in different periods in his life, nor does he dispute the idea that his work is based on an accumulation of constructive and destructive elements.

Avigdor Arikha's experiment in abstraction (he studied with Ardon in Jerusalem and then went to Paris, where he has been working fairly steadily since 1955) was also a kind of escape into the present as a refuge from the obsessive forms that trapped him in his early drawings. He too reached an "end of statement" situation. In 1965 he ceased painting and began to draw from nature, returning to the canvas only in 1973. The turning away from the world of contemporary art suggested to him the possibility of examining his own inner world: himself and the people and objects around him (Fig. 11). For him, capturing nature is an activity that categorically rejects any figurative inter-pretation of reality. Arikha, who speaks of the "hunger of the eye," completes a painting in one sitting. Thus his absolute loyalty to appearance,

vision and experience blend in a representation that expresses "both the transgression and the inclusion of the doubt."[10]

The path to Surrealism taken by Yosl Bergner and Samuel Bak in the sixties also took the form of a retreat from contemporary painting. In the fifties Bergner was painting scenes in a style influenced by Bernard Buffet, in which Kafkaesque figures play on the background of the facades of Eastern houses; later he turned to a description of figures and objects in essentially anecdotal situations filled with echoes of the Eastern European Jewish folktale. Samuel Bak started out as an abstract painter. In the fantastic scenes characteristic of his work today (done in a basically academic technique) metaphorical motifs of building and destruction dominate. Bergner and Bak's Surrealism, however literary it may seem, in fact conceals the secret of the objects strung together into a story rather than creating its own meaning in the Surrealist manner.

Yocheved Weinfeld, the youngest of this group, studied with Raffi Lavie and began painting under his influence. In the mid-seventies her work took a sharp turn when she adopted a narrative technique to construct a sequence of images, in part composed of photographs and documentary texts (memories of a distant childhood), in part composed of depictions of her own body and of materials connected with specific objects, to create situations in which the hero-artist takes on the role of actor-witness-victim. The sequence constructs its plurality of meaning from religious, ritual, and sexual obsessions, which interact to create a rich mosaic of symbolic elements.

Although the seventies have come to an end, in Israel, as in every art center, it is still difficult to define the trends being formulated among the new generation (Fig. 12). At present several phenomena are noteworthy: the dynamic activities of The Tel Aviv Museum under the directorship of Marc Scheps, exhibitions such as "Artist and Society" at The Tel Aviv Museum and "Borders" at The Israel Museum, and performances organized by such new faces as Gideon Ofrat and Amnon Barzel. At the same time some general features of the Israeli art scene may be discerned. The major factor is that most young artists are very well aware of what is happening in the world outside their country. They use new techniques; they are familiar with writings by other artists and the new critics; they travel a great deal and work in Europe and New York. Their artistic education is primarily acquired at the Art Teachers' Institute near Tel Aviv, where Raffi Lavie teaches, and at Bezalel in Jerusalem (which has formally been established as the Bezalel Academy of Art and Design). It would seem that the graduates of the Institute are closer in outlook to American trends of the seventies than the Bezalel graduates, who are associated with mystical Expressionism in the manner of Joseph Beuys. The experience of artists such as Neustein is being continued in a formalist sphere which takes as its point of departure conceptual assumptions which transcend Post-Minimalism. Michael Gitlin is creating three-dimensional objects in which physical activity determines their precise placement in space; Nahum Tevet, a kibbutz member who studied with Lavie, activates, with basic shapes reminiscent of Robert Mangold, organizational complexes conditioned by behavioral considerations; Micha Laury creates environments with unusual materials, such as grease, which impose a certain behavioral attitude on the spectator. Other artists are concerned with the ambivalent significance of the image: Tamar Getter and Michal Na'aman place conventional images of historical myths or associations in contexts that challenge the validity of the meanings usually attributed to them. Osvaldo Romberg belongs to a cosmopolitan group of artists whose focus is "art about art": their color scheme provides a logical analysis of the structure of old master paintings. This list, assuredly not complete, testifies to a creative, dynamic atmosphere in which personal experience has replaced the ideological struggle of the early sixties.

Translated by Judy Levy

Fig. 12. Open workshop. Ten artists working collectively in a space open to the public at The Israel Museum, Jerusalem, 1976.

Notes

1. "Israeli Prose in Transition," *Ariel*, Spring 1972, p. 96.
2. *Tumarkin by Tumarkin 1957–1970* (Hadera, 1970), p. 81.
3. *Arie Aroch* (Tel Aviv, 1976).
4. Interview with the artist in *ibid*.
5. *Ibid*.
6. *Qav* 11 (Winter 1969–70).
7. Diary entry for March 16, 1974, quoted in *Pinchas Cohen Gan Activities* (Jerusalem, 1974).
8. For a discussion of Danziger's early work, see Ygal Zalmona's essay preceding this one.
9. This project, carried out in 1969, is similar to one exhibited at The Jewish Museum, New York, the following year.
10. Quotations are from a letter from Arikha, cited in the Preface to *Twenty-Two Paintings 1974–1978* (Washington, D.C., 1978).

CATALOGUE OF THE EXHIBITION

Height precedes width; where applicable,
depth follows width. Except where noted,
all works will be shown at each of the
participating museums.

* indicates works illustrated in the catalogue.

1. The First Generation of Eretz Yisrael Artists

The Bezalel School of Arts and Crafts was founded in 1906 in Jerusalem by Boris Schatz, a sculptor and painter from Bulgaria, to train craftsmen to be professional and self-supporting. It was intended also to meet the ideological needs of a new Zionist era in Palestine, which required the creation of a national style. The Bezalel style in painting and sculpture was distinctly European. Its teachers — Schatz himself, Abel Pann, Ephraim Lilien, and Shmuel Hirszenberg — were trained in the Western academic tradition. They tended to graft Western standards of beauty, European historicism, and Art Nouveau elements onto biblical subjects and Near Eastern motifs to express their idealized views of the past and utopian visions of the future.

In 1920 the Bezalel teachers founded the Hebrew Artists' Association in Jerusalem, which was already the site of much cultural activity. The following year the first annual art exhibition was held at the ancient citadel known as the Tower of David. Within three years control of the exhibition had passed into the hands of a younger, more modern, group of artists. Many of them, like Reuven Rubin, Nachum Gutman, Israel Paldi, Menachem Shemi, and Tziona Tagger, had studied at Bezalel, while others, like Haim Gliksberg and Arieh Lubin, were new immigrants.

This generation of young artists was searching for an idiom appropriate to what they termed "Hebrew" as opposed to "Jewish" art. They were attempting to define their new cultural identity, which seemed to them completely antithetical to that of the Diaspora. They depicted the daily reality of the Near Eastern environment in and for itself, rather than using it merely as a setting for biblical scenes as the Bezalel founders had done. Their view of the Orient as a source of national renewal can be seen in their stress on exotic subject matter, glorification of the simple Arab life style, and a technique which is predominantly primitivist, although it occasionally shows the influence of Impressionism and Cubism.

PALDI, Israel

Pastorale, 1925
Oil on canvas
24 × 30 in. (61 × 76 cm.)
Collection The Tel Aviv Museum
New York only

Arab Fisherman, ca. 1925
Oil on canvas
37¾ × 47¼ in. (96 × 120 cm.)
Collection The Tel Aviv Museum

Jerusalem Landscape, 1928*
Oil on canvas
24 × 30 in. (61 × 76 cm.)
Collection The Israel Museum, Jerusalem

RUBIN, Reuven

The Sculptor Melnikov, 1923
Oil on canvas
21¾ × 27½ in. (55 × 70 cm.)
Collection The Tel Aviv Museum

Lake of Tiberius, 1926
Oil on canvas
25½ × 32 in. (65 × 81 cm.)
Collection The Israel Museum, Jerusalem

The Family, 1927*
Oil on canvas
64 × 50¾ in. (163 × 129 cm.)
Collection The Tel Aviv Museum
New York only

Old Sycamores, 1927
Oil on canvas
36 × 32 in. (91 × 81 cm.)
Lent by Engel Gallery, Jerusalem

Groves near Jaffa, 1928
Oil on canvas
26 × 32 in. (66 × 81 cm.)
Collection Rubin Museum Foundation, Tel Aviv

Ein Kerem, 1935
Watercolor
15 × 24 in. (38 × 61 cm.)
Collection Mr. and Mrs. Herman Elkon, New York

Silent Prayer, ca. 1950
Oil on canvas
32 × 23¾ in. (81 × 59 cm.)
Collection The Jewish Museum, New York; Gift of Mr.
 Richard Zeisler
Tucson, Rochester, and Coral Gables only

Pomegranates and Olive Trees, 1960
Oil on canvas
39 × 29 in. (99 × 74 cm.)
Collection Dina and Raphael Recanati, New York
Tucson, Rochester, and Coral Gables only

SHEMI, Menachem

View of H'agefen Street in Haifa, ca. 1926
Oil on canvas
19⅔ × 14 in. (50 × 36 cm.)
Collection Haifa Museum of Modern Art

The Artist's Wife with Cat, 1928*
Oil on canvas, mounted on plywood
23½ × 28⅜ in. (59 × 72 cm.)
Collection Haifa Museum of Modern Art

Hannah Zavin Hampel, 1939
Oil on canvas
24 × 18 in. (61 × 46 cm.)
Collection The Israel Museum, Jerusalem

TAGGER, Tziona

Train Passing through Hertzl Street, 1921-22
Oil on canvas
18½ × 22 in. (47 × 56 cm.)
Collection Mr. and Mrs. Menashe Blatman, Tel Aviv

Portrait of Poet Schlonsky, 1924*
Oil on canvas
24¾ × 17½ in. (63 × 44 cm.)
Collection The Tel Aviv Museum

Portrait of a Boy, 1925-26
Oil on canvas
32 × 21¾ in. (81 × 55 cm.)
Collection The Israel Museum, Jerusalem

2. Expressionism: Links with the Jewish School of Paris

The 1920s were marked by an economic crisis, anti-Jewish riots in Hebron, and a new wave of Jewish immigration. The closing of the Bezalel School in 1928 because of financial and organizational difficulties brought with it the end of the ideological conflicts between teachers and students. By the middle of the decade the cultural and artistic center had gradually shifted from Jerusalem to the newly founded, youthful, and dynamic city of Tel Aviv, which was in the process of creating a modern, Hebrew-speaking culture. The opening of the Habimah and Ohel theaters in the late twenties and the establishment of The Tel Aviv Museum in 1932 reinforced this trend, and many young artists left Jerusalem to settle in Tel Aviv.

The young artists of Tel Aviv abandoned the idealized image of the Arab and the colorful Near East, along with its artistic expression, primitivism. Inspired by the new awareness of Modernism with which Reuven Rubin, Nachum Gutman, Israel Paldi, and Tziona Tagger had been imbued after travels in Europe and the United States, they turned again to the West, opening themselves to the full impact of the early twentieth-century innovations. The works of Paldi, Gutman, Arieh Lubin, and Tagger were influenced by the Neue

Sachlichkeit (New Realism), the early works of Menachem Shemi by elements of Picasso's style. Yosef Zaritsky, who emigrated to Eretz Yisrael in 1923, reflects the influence of Cézanne in a series of watercolor landscapes, in which he was searching for a delicate balance between form and subject.

The most strongly felt influence from abroad was that of Paris. The young Bezalel artists who traveled there dreamed of freeing their art from its narrow, local, and parochial character. However, despite their wish to experience all forms of French art, they gravitated to the group of Jewish expressionists in Montparnasse, Chaim Soutine, Marc Chagall, Pinkus Kremegne, Michel Kikoïne, and Sigmund Menkes. All of them except Moshe Castel and all of their French counterparts had been born in Eastern Europe, and this common background facilitated interaction between the two groups and enabled the Eretz Yisrael artists to become acquainted with contemporary art at first hand and to define their own artistic identity.

Expressionists in Paris portrayed reality but gave it an emotionally charged, often mystical, meaning through their use of distortion. On the other hand they remained sensitive to the formal qualities of a work and utilized subdued color, inner logic, and control of the paint surface to

further their expressive ends. This kind of Expressionism is seen in the works of many Eretz Yisrael artists of this period, in Menachem Shemi's landscapes and portraits, and in Castel's and Yitzhak Frenkel's synagogue interiors. Levanon's landscapes were constructed of symbolic structures which express a sense of mystical transcendence, and Rouault's influence on artists such as Castel and Litvinovsky at the end of the thirties gave formal legitimacy to the mystical yearning so typical of the decade. In the paintings of this period a strong emotional atmosphere is created by the emphasis on the modeling of the paint and the free brushwork. It was this style which these artists brought back with them from Paris, a style to which some remained faithful for many years.

CASTEL, Moshe

Sephardic Wedding Feast, ca. 1937
Oil on canvas
21¼ × 28¾ in. (54 × 73 cm.)
Collection The Tel Aviv Museum
New York only

The Synagogue, ca. 1937
Oil on canvas
28¾ × 23⅔ in. (73 × 60 cm.)
Collection Mr. and Mrs. Moshe Castel, Tel Aviv

LEVANON, Mordecai

Jerusalem, 1956*
Oil on canvas
25½ × 30¼ in. (65 × 77 cm.)
Lent by Engel Gallery, Jerusalem

A Lane in Mea Shearim, Jerusalem, 1956
Oil on canvas
23⅔ × 29½ in. (60 × 75 cm.)
Collection Mr. and Mrs. Michael Caspi, Tel Aviv

Safed Landscape, 1964
Oil on canvas
35½ × 29½ in. (90 × 75 cm.)
Collection Mr. and Mrs. Michael Caspi, Tel Aviv

Mystical Safed, 1967
Gouache
39 × 36¼ in. (99 × 67 cm.)
Collection Mr. and Mrs. Samuel M. Eisenstat, New York

SHEMI, Menachem

Safed Landscape, 1951
Oil on canvas
17¾ × 24 in. (45 × 61 cm.)
Collection The Tel Aviv Museum

ZARITSKY, Yosef

Jerusalem Nachlat Shivaa, 1924
Watercolor
19 × 27¼ in. (50 × 70 cm.)
Collection Gordon Gallery, Tel Aviv
New York only

Landscape, 1926
Watercolor
21½ × 27½ in. (51 × 70 cm.)
Collection The Israel Museum, Jerusalem, Purchase B. de Rothschild Fund, 1963

Road in Tel Aviv, 1931
Watercolor
20 × 23 in. (50 × 58 cm.)
Lent by Engel Gallery, Jerusalem

Night Scene, 1939
Watercolor
20½ × 28 in. (52 × 71 cm.)
Collection Mr. and Mrs. Aaron Berman, New York

Yechiam, 1951
Watercolor
14½ × 20⅞ in. (36 × 68 cm.)
Lent by Bertha Urdang Gallery, New York

3. The Central European Contribution

The Nazi rise to power in 1933 resulted in the emigration of a number of German artists who had been active in progressive art circles, and it had a strong impact on the formation of Israeli art. Some, like Jakob Steinhardt, Isidor Ascheim, and Miron Sima, were Expressionists; others, like Mordecai Ardon and the architect Aryeh Sharon, had been active in the Bauhaus. They were not, of course, the first major artists to come from Central Europe:

Anna Ticho and Leopold Krakauer came from Vienna to Jerusalem in 1912 and 1924, respectively. As they matured, they devoted themselves to a subjective interpretation of the structure and tonality of the landscape of Jerusalem and its surrounding hills.

Although the new group of immigrants also took the Jerusalem landscape as their subject, they were more socially conscious and gave new

expression to past experiences. They had been considered leftists by the Nazis, and in Eretz Yisrael their social consciousness was reinforced by a strong moral commitment, and their work began to convey a moral message. Steinhardt, who had been fascinated in the 1930s and 1940s by the mysterious alleyways of Jerusalem, moved in the 1950s to the subject of the Holocaust and other manifestations of sin and retribution. Ardon, who exalted Jerusalem, creating a mystical sensibility in his paintings before World War II, after the war began a gradual metamorphosis of reality using a complex language of literary symbols to convey his message. Yohanon Simon put his principles into practice by settling on a kibbutz and depicting its life with a stylized monumentality. These artists from Central Europe made a significant contribution to the cultural life of Eretz Yisrael, not least through the leadership given to the new Bezalel School (reopened in 1935) by its directors, Ardon and Steinhardt, under whose guidance a new generation of artists grew to maturity.

ARDON, Mordecai

Kidron Valley, 1939
Oil on canvas
44 × 58 in. (112 × 147 cm.)
Collection The Metropolitan Museum of Art, New York;
 Gift of Professor and Mrs. Zevi Scharfstein, 1971
Tucson, Rochester, and Coral Gables only

Missa Dura, 1958-59*
Oil on canvas
Triptych:
 left, The Knight, 76¾ × 51¼ in. (195 × 130 cm.)
 center, Kristallnacht, 76¾ × 102¼ in. (195 × 203 cm.)
 right, House No. 5, 76¾ × 51¼ in. (195 × 130 cm.)
Collection Trustees of The Tate Gallery, London
New York only

Amulet for a Yellow Landscape, 1966
Oil on canvas
38⅛ × 50¾ in. (97 × 129 cm.)
Collection The Museum of Modern Art, New York; Gift of
 Mr. and Mrs. George M. Jaffin
Tucson, Rochester, and Coral Gables only

KRAKAUER, Leopold

Barren Landscape, 1937*
Chalk on paper
22 × 30 in. (56 × 76 cm.)
Collection Trude Dothan, Jerusalem

Crown of Thorns, 1947
Chalk on paper
22 × 30 in. (56 × 76 cm.)
Collection Trude Dothan, Jerusalem

Walls, 1947
Chalk on paper
22 × 30 in. (56 × 76 cm.)
Collection Trude Dothan, Jerusalem

Stump of a Tree and Thistle, 1953
Chalk on paper
22 × 30 in. (56 × 76 cm.)
Collection Trude Dothan, Jerusalem

SIMON, Yohanan

Untitled, 1949
Oil on canvas
37½ × 49½ in. (95 × 126 cm.)
Collection Alvin and Judith Krauss, New York
New York only

Sabbath in the Kibbutz, 1950
Oil on canvas
25 × 19½ in. (64 × 50 cm.)
Collection Shelomo and Tina Ben-Israel, Hollis, New York

In the Shower, 1952*
Oil on canvas
37 × 25 in. (94 × 64 cm.)
Collection The Tel Aviv Museum
New York only

STEINHARDT, Jakob

Street in Old Part of Jerusalem, 1935
Woodcut
19 × 15⅜ in. (48 × 39 cm.)
Collection The Israel Museum, Jerusalem

Street with Trees, 1937
Woodcut
11½ × 15⅝ in. (30 × 40 cm.)
Collection The Israel Museum, Jerusalem

Simhat Torah, 1938*
Woodcut
13¼ × 18¼ in. (34 × 46 cm.)
Collection The Israel Museum, Jerusalem

Isaiah, 1954
Woodcut
18½ × 14⅝ in. (47 × 37 cm.)
Collection The Israel Museum, Jerusalem;
Gift of the artist, 1954

Moses on Mt. Nebo, 1965-66
Woodcut
15 × 10½ in. (38 × 27 cm.)
Collection The Jewish Museum, New York

TICHO, Anna

Landscape behind Rocks, 1951
Pencil on paper
23½ × 17¾ in. (60 × 45 cm.)
Collection The Museum of Modern Art, New York;
Gift of Miss Loula D. Lasker

Jerusalem, 1969*
Charcoal on paper
27⅝ × 39½ in. (70 × 100 cm.)
Collection The Museum of Modern Art, New York;
Given anonymously

Untitled, 1974
Black and white chalk on paper
29¼ × 42½ in. (75 × 108 cm.)
Collection Stedelijk Museum, Amsterdam

Untitled, 1977
Charcoal and pastel on paper
35½ × 27½ in. (90 × 70 cm.)
Collection Mr. and Mrs. Jerome L. Stern, New York

Untitled, 1978
Pastel drawing
19⅓ × 30⅓ in. (49 × 77 cm.)
Collection Stedelijk Museum, Amsterdam

4. Toward Abstraction: The New Horizons Group

With the outbreak of World War II, communication with the Jewish artists in Paris was broken. By the war's end a new generation of abstract artists had emerged in Europe and America. The break with Paris and the trauma of the Holocaust caused several artists, such as Yitzhak Danziger, Moshe Castel, Aharon Kahana, and Jacov Wechsler, to join forces with a group of writers who were already making a distinction between Judaism and "Israelitism" or "Canaanitism." They rejected Judaism not only as a religion but as a destiny, and identified with the original settlers of Eretz Yisrael, reviving Canaanite myths and developing an archaistic stylization of pagan motifs and ancient lettering. Although their goals were primarily ideological, they began to use their archaic symbols in an abstract manner.

Most of these artists joined the New Horizons group, founded in 1948, the year the State of Israel was established. However, this group was not predominantly composed of "Canaanite" artists. On the contrary, they had no stated ideology except for the determination to free Israeli painting from its local character and literary associations, to focus on universal rather than regional art, and to view abstraction as the most appropriate idiom for the time. Accordingly, they sought inspiration from the lyrical expressionism which had recently developed in the West.

Zaritsky emerged as the dominant figure of New Horizons. His own lyrical style, notable for its rich use of color and its restrained but expressive brushwork, was adopted by a number of the most prominent painters of the group, among them Avigdor Stematsky and Yeheskel Streichman. Taking landscape as their point of departure, their paintings convey an atmospheric lyricism.

Sculpture in the 1950s employed new materials and monumental scale as it became increasingly abstract. The work of Yitzhak Danziger and Yehiel Shemi moved from a use of natural forms to abstraction, stimulated by the use of iron introduced as a sculptural medium during this period by British sculptors.

Despite the flexibility of the New Horizons aesthetic ideology, which permitted individual development, there was a split in the group between those artists faithful to the modernism of the School of Paris and those attracted to the new painting of Europe and New York. Marcel Janco and others left the group; Zvi Mairovich and Yehiel Krize were influenced by the new spirit but did not join; young artists such as Moshe Kupferman and Raffi Lavie participated in the annual group exhibitions, forming a link between the work of the founders of New Horizons and the generation coming to maturity.

CASTEL, Moshe

Manuscript, 1958*
Basalt and mixed media on canvas
76¾ × 51¼ in. (195 × 130 cm.)
Collection Mr. and Mrs. Moshe Castel, Tel Aviv

Stone of the Temple, 1958
Marble and basalt on canvas
64 × 51 in. (162 × 130 cm.)
Collection Mr. and Mrs. Moshe Castel, Tel Aviv

Basalt from the Galilee, 1963
Basalt and mixed media
51 × 38¼ in. (130 × 97 cm.)
Collection Skirball Museum, Hebrew Union College, Los
 Angeles; Gift of Mr. Earl Morse

DANZIGER, Yitzhak

Negev Corral, 1962
Bronze
26¼ × 24 × 24 in. (66 × 61 × 61 cm.)
Collection Samuel Dubiner, Ramat Gan

The Lord Is My Shepherd (Negev Sheep), 1964*
Bronze
33¾ × 90 × 67¾ in. (85 × 260 × 204 cm.)
Collection Hirshhorn Museum and Sculpture Garden,
 Smithsonian Institution
New York only

Water Conduit Wet, 1964
Bronze
16 × 24 × 6 in. (41 × 61 × 15 cm.)
Collection Samuel Dubiner, Ramat Gan

JANCO, Marcel

Wounded Soldier, 1948
Oil on carton
27½ × 19¾ in. (70 × 50 cm.)
Collection Haifa Museum of Modern Art

Ma'abarath in Grey, 1950*
Oil on canvas
30¾ × 38½ in. (78 × 98 cm.)
Collection The Jewish Museum, New York;
 Gift of Alan Stroock

Don-Quichotte, 1955
Oil on canvas
26 × 36⅔ in. (66 × 93 cm.)
Collection Ayala Zacks-Abramov, Tel Aviv

MAIROVICH, Zvi

Blue Cloud over a Brown Mountain, 1969*
Panda (oil, oil pastel, pencil, graphite, and collage)
39 × 39 in. (99 × 99 cm.)
Collection Yhudit Hendel, Haifa

Painting in Green and Grey, 1970
Panda (oil, oil pastel, pencil, and graphite)
Diptych: *left,* 39½ × 39½ in. (100 × 100 cm.)
right, 39½ × 19¾ in. (100 × 50 cm.)
Collection Yhudit Hendel, Haifa

Window with Orange Bloom, 1974
Panda (oil, oil pastel, pencil, and graphite)
39½ × 39 in. (100 × 99 cm.)
Collection Yhudit Hendel, Haifa

SHEMI, Yehiel

Bird, 1957-58
Steel
30 × 21 × 16 in. (76 × 53 × 41 cm.)
Collection Mr. and Mrs. Arnold Newman, New York
Tucson, Rochester, and Coral Gables only

Untitled, 1966*
Steel
97 × 24 × 24 in. (246 × 61 × 61 cm.)
Collection Mr. and Mrs. Stephen L. Singer, New York
New York only

Untitled, 1975
Steel
27 × 36 × 24 in. (69 × 91 × 61 cm.)
Collection of the artist
Tucson, Rochester, and Coral Gables only

Syllables, 1979
Steel
24 × 92 × 45 in. (58 × 229 × 114 cm.)
Lent by Betty Parsons Gallery, New York
New York only

STEMATSKY, Avigdor

Fall Landscape, 1962
Watercolor
24 × 36 in. (61 × 91 cm.)
Collection Samuel Dubiner, Ramat Gan

Composition, 1964*
Watercolor
27½ × 39⅓ in. (70 × 100 cm.)
Collection Mr. and Mrs. Israel Zafrir, Tel Aviv

Untitled, 1964
Watercolor
17½ × 26 in. (44 × 66 cm.)
Collection Mr. and Mrs. Clement J. Wyle, New York

Untitled, 1965
Watercolor
27½ × 41½ in. (70 × 105 cm.)
Collection Joshua Neustein, New York

STREICHMAN, Yeheskel

Soaring Bird, 1964
Oil on canvas
59 × 76¾ in. (145 × 195 cm.)
Collection The Israel Museum, Jerusalem

Zila, 1965*
Oil on canvas
39½ × 39½ in. (100 × 100 cm.)
Collection Selma and Stanley I. Batkin, New York

Untitled, 1972
Gouache
27 × 38½ in. (69 × 97 cm.)
Collection Benni Efrat, New York

ZARITSKY, Yosef

Untitled, ca. 1959
Oil on canvas
48 × 48 in. (122 × 122 cm.)
Collection Mr. and Mrs. Herman Elkon, New York

Grey and Pink, 1960
Oil on canvas
60 × 60 in. (152 × 152 cm.)
Collection Samuel Dubiner, Ramat Gan

Composition, 1962*
Oil on canvas
61 × 61 in. (155 × 155 cm.)
Collection Stedelijk Museum, Amsterdam

5. The 1960s Search for a Personal Imagery

Just as it appeared that Lyrical Abstraction was attaining the status of a full-blown artistic movement, champions of individual expression began to appear on the scene. Such artists provide an important connecting link between the activities of the New Horizons group and the search for individuality of the 1960s and 1970s.

While some artists of the 1960s were noted for their unconventional use of materials and technique, others continued to work in various expressive and figurative abstract styles. Arie Aroch, a member of New Horizons, and such younger artists as Raffi Lavie, Uri Lifshitz, and Aviva Uri emphasized the artist's personal handwriting as the principal vehicle for expressing subjective or purely artistic experience. Their images, though still essentially abstract, incorporate figurative elements relating to personal expression. Lea Nikel continued to work in a language of pure abstraction, and Michael Gross reduced space and landscape to a minimalist vocabulary. A return to figurative themes evocative of the Holocaust and to traditional Jewish subjects was apparent in the work of Mordecai Ardon, Yosl Bergner, and Samuel Bak, with Bergner and Bak using Surrealist imagery.

The need to memorialize those who died in the 1948 War of Independence and subsequent wars gave sculpture a new impetus, and a great many monuments, primarily non-figurative, were introduced into the Israeli landscape. The work of Igael Tumarkin and Dani Karavan, which forms a counterpoint to the natural environment, demonstrates a powerful play of forms and symbols, and in his sculpture as well as his monuments Tumarkin expresses his protest against violence and war through a complex symbolism of geometric and figurative abstract forms. The trend toward Geometric Minimalism was especially pronounced in sculpture, as we see in the work of Menashe Kadishman and Buky Schwartz.

The artists grouped in this section have no stylistic or ideological affinities. They run the gamut from dramatic expressionism to Surrealism to Minimalism in their attempt to find the most appropriate means to communicate their vision.

AGAM, Yaacov

Il n'y en a pas, 1956
Oil on wood
45⅔ × 56 × 2¾ in. (116 × 142 × 7 cm.)
Collection Mrs. Rosine Bemberg, Paris
New York only

Themes Counterpoint, 1959
Oil on wood
35½ × 47 in. (90 × 119 cm.)
Collection Samuel Dubiner, Ramat Gan

Naissance, 1967
Oil on wood
37¼ × 37¼ in. (94 × 94 cm.)
Collection Sidney Frank, New York
Tucson, Rochester, and Coral Gables only

Life Is a Passing Shadow, 1967-70*
Oil on aluminum
28½ × 45 × 2¼ in. (72 × 104 × 6 cm.)
Collection Museum of Art, Carnegie Institute, Pittsburgh;
 Gift of Mr. and Mrs. Harold J. Ruttenberg in
 commemoration of the opening of the Sarah Scaife
 Gallery, October 1974
New York only

Pace of Time, ca. 1970
Oil on wood maquette
23¼ × 17½ in. (59 × 44 cm.)
Collection Sidney Frank, New York
Tucson, Rochester, and Coral Gables only

The Ninth Power, 1971
Stainless steel
70 × 70 × 70 in. (178 × 178 × 178 cm.)
Albert A. List Family Collection, Greenwich, Connecticut
New York only

9 Elements Ever Beating, 1976
Stainless steel
48½ × 52⅓ × 3½ in. (123 × 133 × 9 cm.)
Lent by the artist
Tucson, Rochester, and Coral Gables only

AROCH, Arie

Bus in the Mountains, 1955*
Oil on canvas
27½ × 39½ in. (70 × 100 cm.)
Collection The Tel Aviv Museum

Domingo's Kitchen Table, 1962
Canvas and oil on wood
31 × 17 in. (79 × 43 cm.)
Lent by Bertha Urdang Gallery, New York

The High Commissioner, 1966
Oil on canvas
45½ × 28½ in. (116 × 73 cm.)
Collection The Israel Museum, Jerusalem
New York only

Untitled, 1969
Oil and graphite on wood
20¾ × 29¼ in. (52 × 74 cm.)
Collection Selma and Stanley I. Batkin, New York

A Figure, 1970-71
Mixed media on wood panel
18½ × 24⅞ in. (47 × 65 cm.)
Collection The Israel Museum, Jerusalem

BAK, Samuel

3-2-1-0, 1968
Oil on canvas
17 × 31⅞ in. (44 × 81 cm.)
Lent by Pucker-Safrai Gallery, Boston

Endgame, 1970
Oil on canvas
51 × 51 in. (130 × 130 cm.)
Collection Julian J. and Joachim Jean Aberbach, New York
New York only

Personal Data, 1972*
Oil on canvas
31½ × 25¼ in. (81 × 65 cm.)
Brandeis University Art Collection, Rose Art Museum;
 Gift of Mr. and Mrs. Donald Robinson, Pittsburgh,
 Pennsylvania

Monument with Figures, 1974
Oil on canvas
50 × 38 in. (127 × 97 cm.)
Collection Ronald D. Mayne, Roslyn Heights, New York

BERGNER, Yosl

The Artisans, 1971
Oil on canvas
57¼ × 88⅝ in. (145 × 225 cm.)
Collection Julian J. and Joachim Jean Aberbach, New York

The Gypsies of Jaffa, 1972*
Oil on canvas
28¾ × 45⅔ in. (73 × 116 cm.)
Lent by Bineth Gallery, Tel Aviv

GROSS, Michael

Crown and Robe, 1968
Stainless steel, painted
Height 186 in. (472 cm.), diameter 33 in. (83 cm.)
Collection The Jewish Museum, New York; Gift of
 Memorial Art Gallery, The University of Rochester
New York only

Roof and Window in No Man's Land, 1968
Oil on canvas
26¾ × 43¾ in. (195 × 111 cm.)
Collection The Solomon R. Guggenheim Museum;
 Gift of Lee and Elizabeth Turner, Kansas

Fields in Sunlight, 1970*
Oil on canvas
Two hinged panels, 78 × 96 in. (198 × 259 cm.) overall
Collection Lee and Elizabeth Turner, Kansas

Self-Portrait, 1974
Oil and pencil on canvas
76¾ × 38 in. (195 × 96 cm.)
Lent by the artist

LAVIE, Raffi

Painting, 1963
Oil and pencil on canvas
51¼ × 51¼ in. (130 × 130 cm.)
Collection The Israel Museum, Jerusalem

Composition, 1968*
Mixed media on plywood
47¾ × 55 in. (120 × 140 cm.)
Collection The Tel Aviv Museum

Composition, 1976
Mixed media on plywood
31½ × 47¼ in. (80 × 120 cm.)
Collection The Tel Aviv Museum

LIFSHITZ, Uri

Triptych, 1967*
Oil on canvas
Left and right: 59 × 29½ in. (150 × 75 cm.)
Center: 59 × 59 in. (150 × 150 cm.)
Collection The Israel Museum, Jerusalem

Mr. Rabinovitch, 1971
Oil on canvas
64 × 51½ in. (163 × 131 cm.)
Collection Joseph D. Hackmey, Tel Aviv

NIKEL, Lea

Painting, 1969*
Oil on canvas
34⅔ × 45⅔ in. (88 × 116 cm.)
Collection The Tel Aviv Museum

Painting, 1973
Oil on canvas
57½ × 45 in. (146 × 114 cm.)
Collection The Tel Aviv Museum

TUMARKIN, Igael

Sacrifice, 1964
Steel and scrap metal
34¾ × 15 × 7 in. (88 × 38 × 17 cm.)
Collection The Tel Aviv Museum

War Memories, 1964*
Mixed media
Triptych, 77¼ × 76½ × 7 in. (196 × 194 × 17 cm.)
Collection Mr. and Mrs. Israel Zafrir, Tel Aviv

Earthwork, 1978
Steel and earth
30 × 48 × 14 in. (76 × 122 × 36 cm.)
Collection Marilyn and Gary Hellinger,
 Greenwich, Connecticut

URI, Aviva

Drawing, 1960
Black chalk on paper
19½ × 27 in. (49 × 69 cm.)
Collection Yona Fischer, Jerusalem

Drawing, 1970
Graphite, chalk, and pencil on paper
19¾ × 21⅔ in. (50 × 55 cm.)
Collection Yona Fischer, Jerusalem

Untitled, 1976*
Color drawing on paper
27 × 32 in. (71 × 81 cm.)
Collection Mrs. Sara Levi, Tel Aviv

Untitled, 1976
Color drawing on paper
27 × 19½ in. (70 × 51 cm.)
Lent by Sara Levi Art Gallery, Tel Aviv

6. Contemporary Trends

Between the Six Day War of 1967 and the Yom Kippur War of 1973 a rift developed between artists who favored militant leftist solutions and those who took a position of extreme nationalism. The generation of artists which matured after 1967 — Joshua Neustein, Pinchas Cohen Gan, Benni Efrat, Avital Geva, Moshe Gershuni, and Micha Ullman — is identified as politically radical. They consider artistic creation to be an intellectual process with linguistic, social, political, and literary dimensions. In order to express what are basically existential sentiments, this group has adapted techniques and procedures developed by Conceptual, Earth, and Process artists on both sides of the Atlantic. The public projects of Cohen Gan, Geva, Gershuni, and Ullman present their positions on contemporary problems, their primary consideration being the exposition of ideas rather than aesthetics.

Following the 1973 war, the question of self-identity was raised, especially by some older artists. Naftali Bezem and Abraham Ofek, who belonged to the socialist Left in the 1950s and 1960s, now advocated a return to nationalistic values and denounced "foreign influences."

The second half of the 1970s could be characterized by an atmosphere of individual experimentation. The approach and aims of artists begin to differ dramatically: the only thing they seem to have in common is a desire to broaden the definition of painting and sculpture. As they matured, some artists who had once viewed abstraction as the only appropriate aesthetic abandoned it. Avigdor Arikha, for example, now draws and paints directly from nature. Moshe Kupferman calls upon his past as a war refugee, which he transmits in a refined, abstract style; the sculptors Yitzhak Danziger and Menashe Kadishman created activities on open sites which evoked their historical and/or cultural significance. The youngest artists, Yocheved Weinfeld, Tamar

Getter, and Michal Na'aman, draw their images from existential myths.

More and more Israeli artists live and work outside the country then ever before. Some of them play an active role in the development of new stylistic trends and have established a considerable international reputation. Yaacov Agam, who has lived primarily in Paris for many years, is known as a pioneer in kinetic art; Benni Efrat and Buky Schwartz currently live in New York and exhibit internationally; Joshua Neustein, Pinchas Cohen Gan, Michael Gitlin, and Nahum Tevet spend much of the year in New York; Micha Laury has settled in Paris and Schlomo Koren in Amsterdam. Their work reflects current trends in the various international art centers, and each in his own way is attempting to extend the borders of art beyond its traditional conceptions and materials.

ARIKHA, Avigdor

Self Portrait with Open Mouth, 1973
Oil on canvas
28¾ × 28¾ in. (73 × 73 cm.)
Lent by Marlborough Fine Art (London) Ltd.

Glass of Whiskey, 1975
Oil on canvas
31⅞ × 25⅝ in. (81 × 65 cm.)
Collection Geraldine Nuckel, Little Ferry, New Jersey

Open Door in the Visitor's Studio, 1976*
Oil on canvas
72 × 60 in. (183 × 152 cm.)
Collection Jane Bradley Pettit, Milwaukee

Anne Leaning on a Table, 1977
Oil on canvas
51¼ × 38¼ in. (130 × 97 cm.)
Collection Los Angeles County Museum of Art;
 Gift of Mr. and Mrs. Michael Blankfort
New York only

COHEN GAN, Pinchas

Man and Dog, 1970
Crayon on silk
48 × 48½ in. (122 × 123 cm.)
Collection Aaron and Barbara Levine, Rockville, Maryland
Tucson, Rochester, and Coral Gables only

Figuration 12, 1978*
Cardboard mounted on wood
12 panels, ca. 16 × 18 in. each, 53 × 78 in.
 (135 × 198 cm.) overall
Collection Jud and Vivian Ebersman, New York
New York only

Constructed Figuration, 1979
Painted cardboard
118 pieces, 11 × 5 × 2 in. (28 × 13 × 5 cm.) each
Collection Dr. and Mrs. Don Rubell, New York

Programmed Figure (Light Brown), 1980
Acrylic paint on plywood
48 × 21 × 5 in. (122 × 53 × 13 cm.)
Lent by Max Protetch Gallery, New York
Tucson, Rochester, and Coral Gables only

Programmed Figure (Light Gray), 1980
Acrylic paint on plywood
48 × 21 × 5 in. (122 × 53 × 13 cm.)
Collection Richard M. Hollander, Kansas City, Missouri
New York only

Programmed Figure (Light Orange), 1980
Acrylic paint on plywood
48 × 21 × 5 in. (122 × 53 × 13 cm.)
Lent by Max Protetch Gallery, New York
Tucson, Rochester, and Coral Gables only

Programmed Figure (Light Red), 1980
Acrylic paint on plywood
48 × 21 × 5 in. (122 × 53 × 13 cm.)
Collection Richard M. Hollander, Kansas City, Missouri
New York only

EFRAT, Benni

Extrapolations, 1978
Film projected on wood, canvas, and steel
78½ × 57 × 12 in. (200 × 145 × 30 cm.)
Lent by the artist

August, from *Undercover Blues* series, 1980*
Wood, latex, acrylic, and electric light projection
52 × 17 × 51 in. (135 × 43 × 130 cm.)
Collection Selma and Stanley I. Batkin, New York

Interval, 1980
Wood, latex, acrylic, and canvas
78 × 57 × 14 in. (198 × 145 × 36 cm.)
Lent by the artist
New York only

KADISHMAN, Menashe

Segments, 1968
Aluminum and glass maquette
6 × 16 × 2 in. (15 × 41 × 5 cm.)
Collection Janet and George M. Jaffin, New York
Tucson, Rochester, and Coral Gables only

Segments II, 1968
Aluminum and glass maquette
15⅜ × 31½ × 6 in. (39 × 80 × 15 cm.)
Collection Selma and Stanley I. Batkin, New York
Tucson, Rochester, and Coral Gables only

Segments, 1969*
5 painted aluminum sections on glass sheet
62¼ × 172¼ × 12 in. (152 × 437 × 30 cm.) overall
Collection The Museum of Modern Art, New York;
 Gift of Mr. and Mrs. George M. Jaffin
New York only

Sheep, 1979
Silkscreen and oil on canvas
60½ × 80½ in. (154 × 205 cm.)
Collection Selma and Stanley I. Batkin, New York

KUPFERMAN, Moshe

Arcs, 1968
Oil on canvas
64½ × 52 in. (162 × 132 cm.)
Collection Mr. and Mrs. Ben Kukoff, Los Angeles
New York only

Painting, 1974
Oil on canvas
51 × 64 in. (130 × 163 cm.)
Collection The Tel Aviv Museum
New York only

Untitled, 1978
Oil on canvas
51 × 77 in. (130 × 196 cm.)
Collection The McCrory Corporation, New York
New York only

Untitled, 1978
Oil and oilstick on canvas
51¼ × 76¾ in. (130 × 194 cm.)
Lent by Bertha Urdang Gallery, New York
Tucson, Rochester, and Coral Gables only

Untitled, 1980*
Oil on canvas
39½ × 42 in. (100 × 107 cm.)
Collection Judd Hammack, Santa Monica;
 courtesy Bertha Urdang Gallery, New York

Untitled, 1980
Oil and oilstick on canvas
39¾ × 45½ in. (100 × 115 cm.)
Lent by Bertha Urdang Gallery, New York
Tucson, Rochester, and Coral Gables only

NEUSTEIN, Joshua

Medina, 1970
Acrylic on paper
36 × 45 in. (91 × 114 cm.)
Lent by the artist
Tucson, Rochester, and Coral Gables only

Untitled II, 1971
Lacquer and paper
51 × 22½ × 5½ in. (130 × 57 × 14 cm.)
Collection Susan Jacobowitz, New York
New York only

As In Over & Out, 1978
Acrylic on paper
105 × 108¾ in. (268 × 276 cm.)
Collection Catherine Goetschel, New York

Bully Straps, 1978
Acrylic on paper
36 × 54 in. (91 × 137 cm.)
Collection Catherine Goetschel, New York
Tucson, Rochester, and Coral Gables only

Second Bully Straps, 1979*
Acrylic on paper
52 × 74 in. (132 × 188 cm.)
Collection Albright-Knox Art Gallery, Buffalo, New York
New York only

SCHWARTZ, Buky

Videoconstructions, 1978-80 *(The Chair)**
Videotapes
Lent by the artist

WEINFELD, Yocheved

Visual Images #8, 1979*
Mixed media
64 × 121½ in. (163 × 307 cm.)
Collection The Israel Museum, Jerusalem

ARTISTS OF ISRAEL: 1920–1980

Each of the following artist entries is divided into four sections:

Biography
Prizes frequently mentioned in the biographies are
as follows:
Struck Prize: established in 1946 by the Municipality
of Haifa in memory of the painter and engraver
Hermann Struck (1876–1944); awarded annually to
the best work of a painter or sculptor shown in the
Haifa and North General Artists' Association
Exhibition.
Dizengoff Prize: established in 1936 by the
Municipality of Tel Aviv-Jaffa in memory of the first
mayor of Tel Aviv, Meir Dizengoff (1861–1936);
awarded annually to a painter or sculptor for the
best work shown in the General Exhibition of the
Artists' Association in Israel.
Israel Prize: established in 1953 as a national Israeli
art award for theater, literature, music, and
painting; presented by the Ministry of Education
and Culture in Jerusalem; awarded each year, on
the anniversary of Israel's independence, to an
Israeli artist for achievements and/or contributions
to the development of Israeli art.
Sandberg Prize: established in 1967 by The Israel
Museum as an annual award to honor Willem
Sandberg, the Museum's Art Advisor from 1965 to
1968.

Individual Exhibitions

Major Group Exhibitions
Information on group exhibitions which is
abbreviated in this section is found in full in
"Group Exhibitions of Israeli Art: 1920–1980" at the
back of this catalogue.

Selected Bibliography
Only references in English have been included; they
are arranged chronologically, beginning with the
earliest entry.

Exhibition lists and bibliographies were prepared by
Emily Bilski, Judith Spitzer, and Amy Winter.

YAACOV AGAM

Born 1928 Rishon-le-Zion, Palestine;
lives in Paris

son of Rabbi Yehoshua Gipstein. *1946* studies under Mordecai
Ardon at Bezalel School of Arts and Crafts. *1949* studies under
Johannes Itten at Kunstgewerbeschule and Siegfried Gideon at the
Eidgenossische Technische Hochschule in Zurich. *1951* settles in
Paris. *1953* first "polyphonic" paintings. *1959-61* initial experience
with multiple-stage theater and sound sculpture. *1967* begins to
sculpt. *1968* lectures at Carpenter Center for the Visual Arts,
Harvard University. *1970* Sandberg Prize. *1971* first
"Agamographs"; monumental sculpture for Parc Floral, Bois de
Vincennes, Paris. *1972* monumental sculpture for presidential
mansion, Jerusalem; "environment" for antechamber of Elysée
Palace, Paris. *1974* murals for American Telephone and Telegraph
Company building, New York. *1975* honorary doctorate of
philosophy from Tel Aviv University; monumental water sculpture
for the Quartier de la Defense, Paris; innovator and pioneer in
kinetic art; the structure of his complex works, using intricate
computer technologies and acoustic and lighting effects, changes as
the spectator moves.

Selected Individual Exhibitions

Galerie Craven, Paris, 1953.
Galerie Denise René, Paris, 1956.
Galerie Aujourd'hui, Palais des
Beaux-Arts, Brussels, 1958.
The Tel Aviv Museum, 1958.
Galerie Denise René, Paris, 1958.
Galerie Suzanne Bollag, Zurich,
1962. Catalogue text by
S. Giedion.
Marlborough-Gerson Gallery,
New York, 1966. Catalogue
Introduction by Haim Gamzu.
Galerie Denise René, New York,
"Transformable
Transformables," 1966.
Catalogue Introduction by
Haim Gamzu.
Galerie Denise René, New York,
1971.
Musée National d'Art Moderne,
Paris, 1972-73. Circulated to
Stedelijk Museum, Amsterdam;
Städtische Kunsthalle,
Düsseldorf; The Tel Aviv
Museum.
The Tel Aviv Museum,
"Pictures-Sculptures," 1973.
Catalogue Foreword by Haim
Gamzu.
Maison de la Culture, Bourges,
France, 1973.
Hebrew Union College, Skirball
Museum, Los Angeles, 1973.
Centre Romi Goldmuntz,
Antwerp, 1973.
Galerie Attali, Paris, 1974.
The Jewish Museum, New York,
"Agam: Selected Suites," 1975.
Catalogue text by Paul Kaniel.

Instituto Nacional de Bellas
Artes, Mexico City, 1976.
Janus Gallery, Washington,
D.C., 1977.
South African National Gallery,
Capetown, 1977.
Pretoria Art Museum, 1977.
Philips Cultural Center,
Eindhoven, Holland, 1977.
Harcourts Gallery, San
Francisco, 1979.
Kolding Kunstforening,
Denmark, 1979.
Palm Springs Desert Museum,
1980.
Queen Victoria Museum and
Art Gallery, Launceston,
Tasmania, 1980.
Solomon R. Guggenheim
Museum, New York, "Agam:
Beyond the Visible,"
September 25-November 2,
1980.

Selected Group Exhibitions

Salon des Réalités Nouvelles,
Paris, 1954, 1955, 1956.
Musée des Beaux-Arts, Rouen,
"Architecture contemporaine.
Intégration des Arts," 1957.
Musée d'Art Moderne,
Charleroi, Belgium, "Art du
XXIe siècle," 1958.
Museum of Art, Carnegie
Institute, Pittsburgh,
"International," 1958, 1961,
1964, 1970.
Paris, "I Biennale," 1959.
Helmhaus, Zurich, "Konkrete
Kunst: 50 Jahre Entwicklung,"
1960.
Kunstgewerbemuseum, Zurich,
"Kinetisches Kunst," 1960,
1965.

Musée des Arts Décoratifs,
Paris, "Antagonismes," 1960.
Stedelijk Museum, Amsterdam,
"Bewogen Beweging
[Movements]," 1961. Circulated
to Moderna Museet, Stockholm;
Louisiana Museum, Copenhagen.
Musée d'Art Moderne de la
Ville de Paris, "Salon de Mai,"
1961, 1964, 1966.
Seibu Store, Tokyo, "Modern
Art of Israel," 1962. Circulated
to Osaka.
Musée des Arts Décoratifs,
Paris, "Antagonismes II:
L'objet," 1962.
São Paulo, Brazil, "VII Bienal,"
1963.
Musée Cantonal, Lausanne,
"Premier Salon International
des Galeries Pilotes," 1963.
The Tel Aviv Museum, "Art and
Movement," 1963.
Venice, "XXXII Biennale," 1964.
Kassel, Germany, "Documenta
III," 1964.
America-Israel Cultural
Foundation, and the
International Council of The
Museum of Modern Art, New
York, "Art Israel: 26 Painters
and Sculptors," 1964.
The Tel Aviv Museum,
Dizengoff House, "Art in
Israel," February 5-March 3,
1964.
The Museum of Modern Art,
New York, "The Responsive
Eye," 1965. Circulated to City
Art Museum, St. Louis; Seattle
Art Museum; Pasadena Art Mu-
seum; Baltimore Museum of Art.
Stedelijk van Abbemuseum,
Eindhoven, Holland,
"Kunst-Licht-Kunst," 1966.

Kunstmarkt 67, Cologne,
"Kölnischer Kunstverein +
Gürzenich," 1967.
Musée d'Art Moderne de la
Ville de Paris, "Art cinétique à
Paris: lumière et mouvement,"
1967.
National Gallery of Canada,
Ottawa, "Art and Movement,"
1967. Circulated.
Pavillion de la France, Montreal,
"Art Contemporain," 1967.
Musée du Petit Palais, Paris,
"Israel à travers les âges," 1968.
Albright-Knox Art Gallery,
Buffalo, "Plus by Minus:
Today's Half-Century," 1968.
National Gallery, Washington,
D.C., "Painting in France
1900-1967," 1968. Circulated.
Kunstnerns Hus, Oslo, "Moving
and Transformable Art," 1969.
Städtische Kunsthalle,
Recklinghausen, "Kunst als
Spiel/Spiel als Kunst/Kunst
zum Spiel," 1969.
University Art Gallery, State
University of New York at Al-
bany, "A Leap of Faith," 1969.
Whitechapel Art Gallery,
London, "Agam, Lifshitz,
Zaritsky: Three Israeli Artists,"
1969-70.
Centre Nationale d'Art
Contemporain, Paris, "Bilan et
problemes du 1%," 1970.
High Museum of Art, Atlanta,
"Israel on Paper," 1970.
Halles Centrales de Baltard,
Paris, "Salon Grands et Jeunes
d'Aujourd'hui," 1971.
The Tel Aviv Museum, "Art and
Science," 1971.

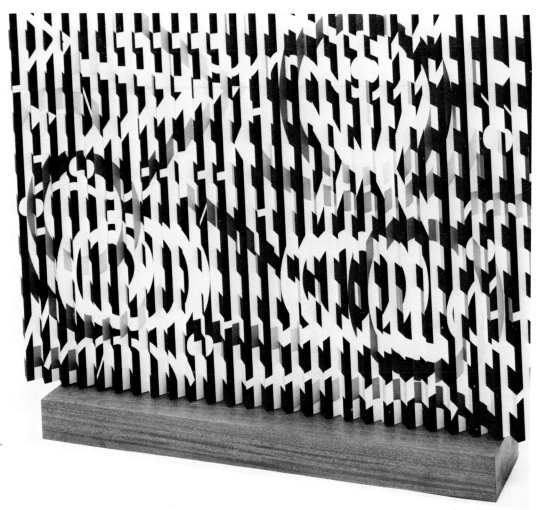

Central Museum, Utrecht, Holland, "Peter Stuyvesant Stichting," 1971.

National Museum, Seoul, Korea, "25 ans de peinture en France, 1945-1970," 1971.

Memorial Art Gallery of the University of Rochester, New York, "Looking Up . . . ," 1971.

Grand Palais, Paris, "72. Douze ans d'art contemporain en France, 1960-1972," 1972.

The Jewish Museum, New York, "Jewish Experience in the Art of the Twentieth Century," October 16, 1975-January 25, 1976. Catalogue text by Avram Kampf.

Grand Palais, Paris, "Grands et jeunes d'aujourd'hui," 1976, 1977.

Life Is a Passing Shadow, 1970, oil on aluminum, 28½ × 45 × 2¼ in. (72 × 104 × 6 cm.). Collection Museum of Art, Carnegie Institute, Pittsburgh; Gift of Mr. and Mrs. Harold J. Ruttenberg in commemoration of the opening of the Sarah Scaife Gallery, October 1974.

Selected Bibliography

Monographs
Reichardt, Jasia. *Yaacov Agam.* London: Methuen, 1966.
Bosquet, Alain. *Escape Agam I, Escape Agam II.* Zug: Pamela Verlag, 1972.
Popper, Frank. *Yaacov Agam.* Rev. ed. New York: Harry N. Abrams, 1980.
Jouffroy, Alain, ed. *Homage to Yaacov Agam.* New York: XXe Siècle Editions, Leon Amiel, 1980.

Articles and General References
Kolb, Eugene. "Agam." *Art International* 3 (Summer 1959):5-6.

Taillandier, Yvon. "Agam and the Realism of the Infinite." *Art International* 7 (May 1963):44-47.
Agam, Yaacov. "The Artist and His Credo." *Ariel* 9 (Winter 1964-65):42-43.
———. "On Two of My Recent Works." *Art International* 9 (September 1965):80.
Seitz, William. "Yaacov Agam's *Double Metamorphosis II.*" *Quadrum,* No. 19 (February 1965):47-58.
Agam, Yaacov. "A Flexible Theater." *Art in America* 54 (November-December 1966):30-33.

Popper, Frank. "Agam, the Perceptible Absence of the 'Image.'" *Studio International* 172 (July 1966):14-19.
———. *Origins and Development of Kinetic Art.* Greenwich: New York Graphic Society, 1968.
———. "Agam's Tele-Art." *Art and Artists* 4 (January 1970):44-47.

MORDECAI ARDON

Born (Bronstein) 1896 Tuchow, Poland;
lives in Israel and Paris

1919 moves from Poland to Berlin. *1920-25* studies with Johannes Itten, Lyonel Feininger, Wassily Kandinsky, and Paul Klee at Bauhaus, Weimar. *1926* studies with Max Doerner at Staatliche Kunstakademie, Munich. *1929* studies at Johannes Itten Art School, Berlin. *1933* emigrates to Palestine; settles in Jerusalem; combines Eastern European Jewish tradition with formal artistic approach of Bauhaus. *1935* teaches drawing at Bezalel School of Arts and Crafts; pupils include Avigdor Arikha, Naftali Bezem, and Moshe Tamir. *1940–52* as director of Bezalel School of Arts and Crafts changes its character, stressing fundamental and systematic training in the art professions. *1949-58* lecturer, Hebrew University, Jerusalem. *1950s* his painting moves from descriptive landscapes to semi-abstract symbolic and allegorical compositions in pure, luminous colors. *1952* artistic adviser to Israeli Ministry of Education and Culture. *1954* UNESCO Prize, Venice Biennale. *1963* Israel Prize. *1974* honorary doctorate of philosophy, Hebrew University, Jerusalem.

Individual Exhibitions
Stematsky Gallery, Jerusalem, 1936.
Bezalel National Museum, Jerusalem, September 26-October 31, 1942.
Bezalel National Museum, Jerusalem, April 5-May 31, 1947.
The Jewish Museum, New York, 1948.
Passedoit Gallery, New York, February 25-March 15, 1952.
Stedelijk Museum, Amsterdam, December 1, 1960-January 9, 1961. Exhibition catalogue no. 251.
Städtische Galerie, Munich, 1961.
Städtische Kunsthalle, Recklinghausen, 1961.
Marlborough Fine Art Ltd., London, 1962.
Bezalel National Museum, Jerusalem, 1963.
The Tel Aviv Museum, Spring-Summer 1963.
Marlborough-Gerson Gallery, New York, 1967.
Marlborough Fine Art Ltd., London, April-May 1973. Catalogue Preface by Francois-Joachim Beer.
Neuer Berliner Kunstverein, Berlin, October 1978.
Marlborough Gallery, New York, December 6, 1980-January 3, 1981.

Selected Group Exhibitions
Berlin, "Novembergruppe," 1928.
Berlin, "Juryfreie Kunstschau," 1930.
New York World's Fair, Palestine Pavilion, 1939.
Bezalel National Museum, Jerusalem, "Artistes de Jerusalem," 1949.
Institute of Contemporary Art, Boston, "Seven Painters of Israel," 1953.
Venice, "XXVII Biennale," 1954.
Galleria Nazionale d'Arte Moderna, Rome, "Arte moderna di Israel," 1954.
Stedelijk Museum, Amsterdam, "Israëlische kunst," 1955.
Palais des Beaux-Arts, Brussels, "Art Israélien," 1955.
Arts Council of Great Britain, London, "Modern Israeli Painting," 1958.
Venice, "XXIX Biennale," 1958.
Palais Internationale des Beaux-Arts, Brussels, "50 ans d'art moderne," April 17-October 19, 1958.
Kassel, Germany, "Documenta II: Malerei nach 1945," 1959.
Solomon R. Guggenheim Museum, New York, "Guggenheim International Award," 1960.
Musée National d'Art Moderne, Paris, "L'art Israélien contemporain," 1960.
Seattle World's Fair, "Art since 1950," 1962.
America-Israel Cultural Foundation, and the

International Council of The Museum of Modern Art, "Art Israel: 26 Painters and Sculptors," 1964.
The Israel Museum, Jerusalem, "Trends in Israeli Art," 1965.
Gemeentemuseum Arnhem, Holland, "Schilders uit Israel [Painters of Israel]," 1965.
Venice, "XXXIV Biennale," 1968.
Musée du Petit Palais, Paris, "Israël à travers les âges," 1968.
Royal Academy of Arts, London, "50 Years of Bauhaus," 1969.
The Tel Aviv Museum, "Israeli Art: Painting, Sculpture, Graphic Works," 1971.
The Israel Museum, Jerusalem, "From Landscape to Abstraction . . . ," 1972.
Museum of Modern Art, Haifa, "Self-Portrait in Israel Art," 1973.
The Jewish Museum, New York, "Jewish Experience in the Art of the Twentieth Century," October 16, 1975-January 25, 1976. Catalogue text by Avram Kampf.
The Israel Museum, Jerusalem, "A Tribute to Sam Zacks," 1976. Circulated to The Tel Aviv Museum.
The Tel Aviv Museum, "Israel Art 30 + 30," 1978.
Canada-Israel Cultural Foundation, Ottawa, "Israel Art Festival . . . ," 1978.
University of Haifa Art Gallery, "The Myth of Canaan . . . ," 1980.

Selected Bibliography
Monograph
Vishny, Michele. *Mordecai Ardon*. New York: Harry N. Abrams, 1973.

Articles and General References
"Reviews and Previews: Ardon-Bronstein." *Art News* 47 (March 1948):44.
Greenberg, Clement. "Art." *Nation* 166 (March 1948):284.
Schwarz, Karl. *Jewish Artists of the Nineteenth and Twentieth Centuries*. New York: Philosophical Library, 1949. Pp. 163, 263.
Politzer, Heinz. "Two Artists and the Hills of Judea." *Commentary* 6 (December 1948):539-41.
Plaut, James S. "Seven Painters of Israel." *Carnegie Magazine* 27 (March 1953):86-89.
Gamzu, Haim. *Painting and Sculpture in Israel*. Tel Aviv: Dvir, 1958. P. 62.
Shepherd, Michael. "Ardon." *Arts Review* 14 (February 1962):6-7.
Graham, Hugh. "Ardon." *Spectator*, February 23, 1962. P. 243.
Spencer, Charles S. "Ardon's Paintings: A Challenge to Israel's Art Establishment." *Jewish Observer and Middle East Review*, February 23, 1962. P. 10.
Reichardt, Jasia. "Ardon at Marlborough Fine Art." *Apollo* 76 (March 1962):71-72.
Spencer, Charles S. "Ardon, Doyen of Israeli Painters." *Studio* 163 (May 1962):174-75.

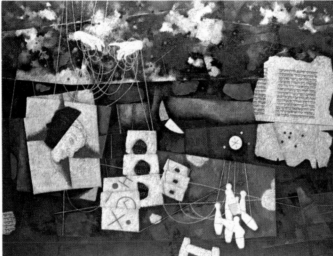

Missa Dura, 1958-59, oil on canvas, triptych: *left, The Knight*, 76¾ × 51¼ in. (195 × 130 cm.); *center, Kristallnacht*, 76¾ × 102¼ in. (195 × 203 cm.); *right, House No. 5*, 76¾ × 51¼ in. (195 × 130 cm.). Collection Trustees of The Tate Gallery, London.

"Jews in Creative Arts." *Congress Bi-Weekly* 29 (September 1962):32-43.

Katz, Karl. "Ardon." *Ariel* 5 (Summer 1963):4-28.

Tammuz, Benjamin, and Wykes-Joyce, Max, eds. *Art in Israel*. Tel Aviv: Massada, 1965. Pp. 25, 26, 37, 39, 291.

Ardon, Mordecai. "Whither Israel Art?" *Ariel* 10 (Spring 1965):33-38.

Werner, Alfred. "Mordecai Ardon: Metaphor-Maker." *Congress Bi-Weekly* 34 (May 8, 1967):22.

Fischer, Yona. "From 'New Horizons' to 'Ten Plus.' " *Ariel* 22 (Spring 1968): 63-67.

Vishny, Michele. "Mordecai Ardon: Recent Works." *Art International* 17 (April 1973):23-27.

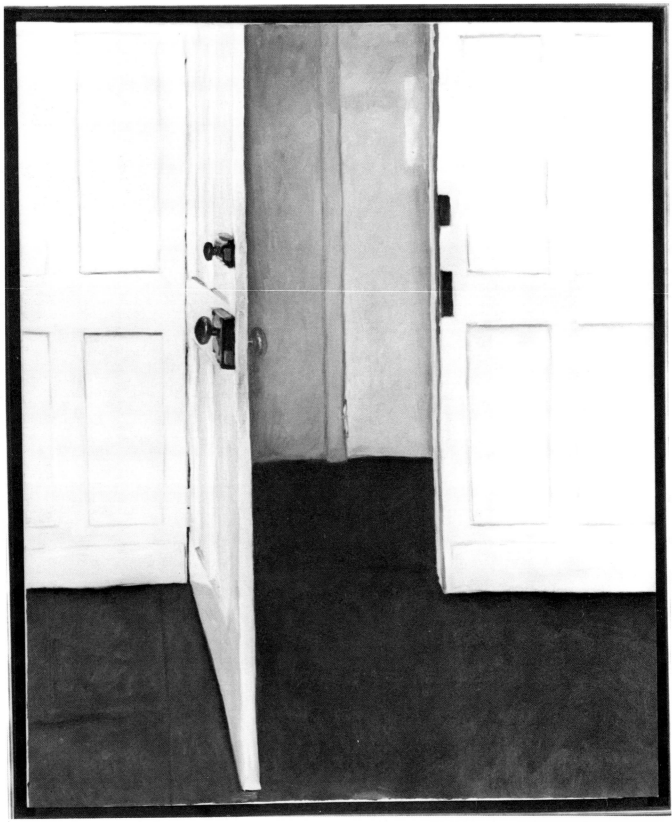

Open Door in the Visitor's Studio, 1976, oil on canvas, 72 × 60 in. (183 × 152 cm.). Collection Jane Bradley Pettit, Milwaukee.

AVIGDOR ARIKHA

Born 1929 Bukovina, Romania;
lives in Paris and Jerusalem

first portraits from life at age 9; continues drawing in Nazi deportation. *1944* rescued from concentration camp and emigrates to Palestine; youth spent in Kibbutz Maaleh-Hahamisha doing farmwork, military training, and academic and art studies (at Bezalel School of Arts and Crafts). *1948* critically wounded in Israel's War of Independence. *1949-51* studies art at École des Beaux-Arts and philosophy at the Sorbonne, Paris. *1954* travels in England and Scandinavia; returns to Paris. *ca. 1957* moves from figurative to abstract style; dark, abstract forms create a mystical ambience and tension which emphasize the play of light and shadow.
1965-73 draws only from nature; studies art history. *1971* teaches curatorial course on drawing at Cabinet des Dessins, Louvre. *1973* returns to painting; subjects are persons around him and everyday objects disposed on a flat canvas. *1978-79* mounts exhibition at Louvre on Nicolas Poussin's *Rape of the Sabine Women*. Author of numerous essays and art-historical studies.

Individual Exhibitions

Zeira Gallery, Tel Aviv, 1952.
Artists' House, Jerusalem, 1953.
Bezalel National Museum, Jerusalem, "Peintures, dessins, bois," 1953.
Galerie Moderne, Stockholm, 1954.
Athenaeum Kunsthandel, Copenhagen, 1955. Catalogue Introduction by Peter P. Rohde.
Galerie Furstenberg, Paris, 1955.
Matthiesen Gallery, London, 1956.
Galerie Furstenberg, Paris, "Peintures recentes," 1957. Catalogue Introduction by Jean Wahl.
Matthiesen Gallery, London, "Paintings, Gouaches, Drawings," 1958. Catalogue Introduction by Samuel Beckett.
Stedelijk Museum, Amsterdam, "Paintings and Watercolors," 1960.
Galerie Karl Flinker, Paris, 1961.
The Israel Museum, Jerusalem, "Paintings 1963-1966; Drawings 1947-1966," September-October 1966. Catalogue Introduction by Yona Fischer.
Galerie Claude Bernard, Paris, 1967. Catalogue Introduction by Samuel Beckett.
Centre National d'Art Contemporain, Paris, "Dessins 1965-1970," 1970. Catalogue text by Barbara Rose; Preface by Samuel Beckett.
Los Angeles County Museum of Art, "39 Ink Drawings 1965-1972," April-May 1972. Catalogue Introduction by Barbara Rose; Preface by Samuel Beckett. Circulated to

Fort Worth Art Center Museum, Texas, 1973; Everson Museum of Art, Syracuse, New York, 1973.
Marlborough Gallery, New York, 1972.
Gordon Gallery, Tel Aviv, 1972.
The Tel Aviv Museum, "Paintings 1957-1965 and 1968," 1973. Catalogue Introduction by Haim Gamzu.
Marlborough Fine Art Ltd., London, "Inks, Drawings and Etchings," 1974. Catalogue Introduction by Robert Hughes.
Janie C. Lee Gallery, Houston, 1974.
Musée National d'Art Moderne, Centre Pompidou, Paris, "39 Gravures 1970-73," 1974. Catalogue Introduction by André Fermigier; interview by Germain Viatte. Circulated to 28 French and three German cities, 1974-79.
Marlborough Gallery, New York, "Paintings and Watercolors," 1975. Catalogue text by the artist.
Bibliothèque Nationale, Cabinet des Estampes, Paris, 1975.
Victoria and Albert Museum, London, "Samuel Beckett by Avigdor Arikha," February-May 1976. Catalogue Introduction by Mordecai Omer.
Marlborough Gallery, Zurich, "Paintings, Drawings and Watercolors," 1977. Catalogue Introduction by Samuel Beckett.
Galerie Amstutz, Zurich, "Eight prints," 1977.
Marlborough Fine Art Ltd., London, "Paintings, Watercolors and Drawings,"

1979. Catalogue interview with the artist by Barbara Rose.
New 57 Gallery, Edinburgh, 1978.
Janie C. Lee Gallery, Houston, "Paintings and Watercolors," 1979. Catalogue text by Barbara Rose.
Corcoran Gallery of Art, Washington, D.C., "Twenty-Two Paintings 1974-1978," June 15-August 26, 1978. Catalogue Preface by Jane Livingston.
Berggruen & Cie., Paris, "Dessins et gravures," 1980. Catalogue text by the artist.
Marlborough Gallery, New York, "Recent Works," October 1980.

Selected Group Exhibitions

Milan, "X Triennial," 1954.
Paris, I Biennale, 1959.
Venice, "XXXI Biennale," 1962.
America-Israel Cultural Foundation, "Art Israel: 26 Painters and Sculptors," 1964.
São Paulo, Brazil, "IX Bienal: Israel-Arikha, Tumarkin," 1967.
Musée du Petit Palais, Paris, "Israel à travers les âges," 1968.
Los Angeles County Museum of Art, "European Painting in the Seventies," 1975. Circulated to St. Louis Art Museum; Elvehjem Art Center, Madison, Wisconsin.
Musée National d'Art Moderne, Centre Pompidou, Paris, "Cabinet Graphique," 1977.
National Portrait Gallery, London, "New Acquisitions," 1977.
Musée National d'Art Moderne, Centre Pompidou, Paris, "Le regard du peintre," 1978-79.

Selected Bibliography

Monographs
Beckett, Samuel. *Avigdor Arikha Drawings 1965-1966.* Jerusalem-Tel Aviv: Tarshish and Dvir, 1967.
Avigdor Arikha Boyhood Drawings Made in Deportation. Paris: Daniel Jacomet, 1971.

Articles and General References
Hughes, Robert. "Feedback from Life." *Time*, May 7, 1973.
Rose, Barbara. "Art." *New York Magazine*, January 1, 1973.
Seldis, Henry. "A Conversation with Arikha." *Arts Magazine* 50 (October 1975):53-56.
McCorquodale, Charles. "Samuel Beckett by Avigdor Arikha." *Art International* 20 (April-May 1976):41-42.
Tuchman, Maurice. "A Talk with Avigdor Arikha." *Art International* 21 (May-June 1977):12-16.
Forgey, Benjamin. "The Lonely Intensity of Avigdor Arikha Glows at Corcoran Exhibition." *Washington Star*, June 17, 1979.
Stevens, Mark. "The Art of Ambush." *Newsweek*, July 2, 1979. Pp. 84-85.
Hughes, Robert. "Arikha's Elliptical Identity." *Time*, July 30, 1979.
Channin, Richard. "The Paintings of Avigdor Arikha, Composition and Meaning." *Art International* 24 (September-October 1980):141-52.

ARIE AROCH

Born 1908 Kharkov, Ukraine;
died 1974 Jerusalem

1924 emigrates to Palestine and studies at the Bezalel School of Arts and Crafts, Jerusalem, where he meets Castel, Stematsky and Streichman. *1934-35* studies at the Academie Colarossi, Paris, under Léger and others. *1937* creates stage designs for the Habimah and Ohel Theaters, Tel Aviv. *1942* works with Mairovich at Zichron Yaacov. *1948* among co-founders of the New Horizons group; attempts to free himself of a specific style and to attain a fresh, elemental expression by stressing the scribbled, spontaneous line in his work; compositions of random line, symbolic personal images along with the written word give the appearance of naive, primitive elements yet are highly deliberate and refined.
1948 travels to Argentina. *1950* enters the diplomatic service.
1950-53 serves with the Israeli embassay in Moscow.
1956-59 Ambassador to Brazil. *1959-62* Ambassador to Sweden.
1963 returns to Israel and settles in Jerusalem. *1968* Sandberg Prize. *1971* retires from Ministry of Foreign Affairs; Israel Prize.

Individual Exhibitions

Santee Landweer Gallery, Amsterdam, 1938.
Katz Gallery, Tel Aviv, 1939.
Viau Gallery, Buenos Aires, 1949.
Bezalel National Museum, Jerusalem, "Arie Aroch. Oil Paintings," November 1955.
Massada Gallery, Tel Aviv, 1966.
The Israel Museum, Jerusalem, " Arie Aroch, Paintings 1953-1968," October-December 1968. Catalogue text by Yona Fischer.
Dvora Schocken Gallery, Tel Aviv, 1972.
The Israel Museum, Jerusalem, "Arie Aroch: Itineraries and Forms," March-April 1976; circulated to The Tel Aviv Museum. Catalogue text by Yona Fischer.

Major Group Exhibitions

The Tel Aviv Museum, "Group of Seven," 1947.
Venice, "XXVII Biennale," 1954.
The Tel Aviv Museum, "New Horizons," May 1956.
Museum of Art (Mishkan Leomanut), Ein Harod, "New Horizons," July 1963.
Venice, "XXXII Biennale," 1964.
Musée du Petit Palais, Paris, "Israel à travers les âges," 1968.

University Art Gallery, State University of New York at Albany, "A Leap of Faith," 1969.
High Museum of Art, Atlanta, "Israel on Paper," 1970.
The Tel Aviv Museum, "Israeli Art: Painting, Sculpture, Graphic Works," 1971.
Memorial Art Gallery, The University of Rochester, New York, "Looking Up . . . ," 1971.
The Israel Museum, Jerusalem, "Expressionism in Eretz-Israel in the Thirties . . . ," 1971.
The Israel Museum, Jerusalem, "From Landscape to Abstraction . . . ," 1972.
The Israel Museum, Jerusalem, "Beyond Drawing," 1974.
The Tel Aviv Museum, "Israel Art 30 + 30," 1978.
Los Angeles County Museum of Art, "Seven Artists in Israel, 1948-1978," 1978-79.
The Israel Museum, Jerusalem, "From the Collection of Dr. Moshe Spitzer, Jerusalem," March 1978. Catalogue text by Moshe Spitzer, no. 172.
Tel Aviv University, University Gallery, "Graphic Works by 30 Israeli Artists," 1978.

Selected Bibliography

Articles and General References
Gamzu, Haim. *Painting and Sculpture in Israel.* Tel Aviv: Dvir, 1958. P. 44.
Tammuz, Benjamin, and Wykes-Joyce, Max, eds. *Art in Israel.* Tel Aviv: Massada, 1965. P. 42.
Spencer, Charles. "Israel, The Surrealist and Fantastic Factor in the New Art." *Studio International* 174 (October 1967):162.
Tal, Miriam. "Israel Art Comes of Age." *Ariel* 29 (Winter 1971):15.
Encyclopaedia Judaica. Jerusalem: Keter Publishing Ltd., 1972.
Fischer, Yona. "Aroch or the Attempt at Dialogue." *Ariel* 30 (Spring 1972):33-41.
Shechori, Ran. *Art in Israel.* New York: Schocken Books, 1976. Pp. 24, 189.
Rahmani, L. Y. *The Museums of Israel.* London: Secker and Warburg, 1976. Pp. 84, n. 97, 133, n. 159.
Ronnen, Meir. "An Ancient Land's Newborn Art." *Art News* 77 (May 1978):47-48, 49, 50.
Larsen, Susan C. "The New Prominence of Israeli Art." *Art News* (March 1979):92.
Kasher, Steven. "Seven Artists of Israel." *Artforum* 17 (Summer 1979):51.

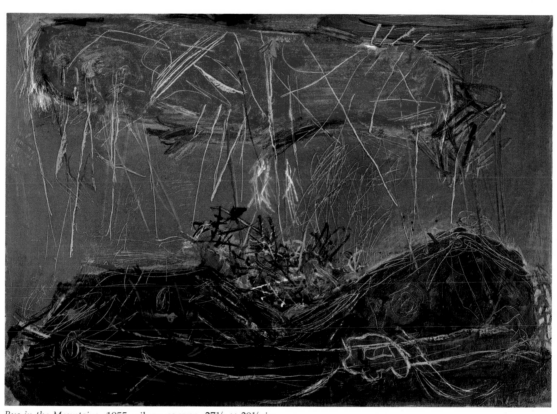

Bus in the Mountains, 1955, oil on canvas, 27½ × 39½ in.
(70 × 100 cm.). Collection The Tel Aviv Museum.

SAMUEL BAK

Born 1933 Vilna, Poland;
lives in Israel and Paris

1940 forced into Vilna ghetto with his mother; both escape but are
recaptured. *1942* first exhibition of drawings, held in Vilna
ghetto. *1943* in concentration camp near Vilna. *1945* attends art
classes at Vilna Academy. *1946-48* studies painting with Professor
Blocherer in Munich. *1948* settles in Tel Aviv. *1952* studies at
Bezalel School of Arts and Crafts. *1956* studies painting with Jean
Souverbie at Beaux-Arts Atelier, Paris. *1957* studies theater design
in England and France. *1959-66* works in Rome. *1964* designs
scenery for theaters in Israel and Germany. *from 1965* work
evolves from abstraction to figuration in present style,
"metaphysical painting," drawing on the surrealism of Dali and
Magritte to depict objects with precision and descriptive skill.
1975-77 lives in New York.

Individual Exhibitions
Galleria Schneider, Rome, 1959,
1961, 1965, 1966.
Galleria Liguria, Rome, 1963.
Bezalel National Museum,
Jerusalem, 1963.
The Tel Aviv Museum,
November-December 1963.
Catalogue Introduction by
Haim Gamzu.
L'Angle Aigu, Brussels, 1965.
Alwin Gallery, London, 1965.
Gordon Gallery, Tel Aviv, 1966.
Roma Gallery, Chicago, 1967.
Ministry of Defense, Jerusalem,
"Jerusalem Poems (Twelve
Drawings)," 1968.
Modern Art Gallery, Jaffa, 1968.
Pucker-Safrai Gallery, Boston,
November-December 1969.
Catalogue Introduction by Paul
T. Nagano.
Bronfman Cultural Center,
Montreal, 1970.
Pucker-Safrai Gallery, Boston,
"Bak The Eternal Enigma,"
October 1971. Catalogue
Introduction by Paul T.
Nagano.

Hadassah "K" Gallery, Tel
Aviv, 1971, 1973, 1978.
Pucker-Safrai Gallery, Boston,
1972, 1975, 1979.
Aberbach Fine Art, New York,
1974, 1975, 1978.
Rose Art Museum, Brandeis
University, Waltham, Massa-
chusetts, "Retrospective," 1976.
Berger Gallery, Pittsburgh, 1976.
Ketterer Gallery, Munich, 1977.
Heidelberg Museum, Germany,
1977.
Kunstverein Esslingen,
Germany, 1977.
Germanisches National
Museum, Nuremberg, 1977.
Kunstmuseum der Städt,
Dusseldorf, "Retrospective,"
1978.
Rheinisches Landesmuseum,
Bonn, "Retrospective," 1978.
Amstutz Gallery, Zurich, 1978.
Vonderbank Gallery, Frankfurt,
1978.
Debel Gallery, Ein Kerem, 1978.
Goldman Gallery, Haifa, 1978.
University of Haifa,
"Retrospective," 1978.
Kunstverein Braunschweig,
"Retrospective," 1979.

Major Group Exhibitions
Museum of Art, Carnegie
Institute, Pittsburgh,
"International," 1961.
Bezalel National Museum,
Jerusalem, "Today's Forms,"
April 1963.
The Tel Aviv Museum, "Image
and Imagination," 1967.
The Tel Aviv Museum, "Israeli
Art: Painting, Sculpture,
Graphic Works," 1971.
Maurice Spertus Museum of
Judaica, Chicago, "Israeli Art
in Chicago Collections," 1974.
The Jewish Museum, New York,
"Jewish Experience in the Art
of the Twentieth Century,"
October 16, 1975-January 25,
1976. Catalogue text by Avram
Kampf.
Canada-Israel Cultural
Foundation, Ottawa, "Israel
Art Festival . . . ," 1978.
Hannover Museum, Germany,
"Artists on Art," 1978.
The Tel Aviv Museum, "Artist
and Society . . . ," 1978.
The Tel Aviv Museum, "Artist's
Choice," 1979.

Selected Bibliography
Monograph
Nagano, Paul T., and Kaufman,
A. *Bak Paintings of the Last
Decade.* New York: Aberbach,
1974.

Articles and General References
Spencer, Charles. "Israel, the
Surrealist and Fantastic Factor
in the New Art." *Studio
International* 174 (October
1967):162.
Berman, Reuven. "The Organiza-
tion of Other Worlds." *Jeru-
salem Post*, April 18, 1968.
Tal, Miriam. "Israel Art Comes
of Age." *Ariel* 29 (Winter
1971):13.
Singer, Isaac Bashevis. "The
Humanscape of Destruction."
National Jewish Monthly,
September, 1974.
Shechori, Ran. *Art in Israel.*
New York: Schocken Books,
1976. Pp. 38, 190.
Rahmani, L. Y. *The Museums of
Israel.* London: Secker and
Warburg, 1976. P. 138, n. 177.
Debel, Ruth. "What Does It
Mean To Be an Israeli Artist?"
Art News 77 (May 1978):54, 55.
Ronnen, Meir. "An Ancient
Land's Newborn Art." *Art
News* 77 (May 1978):47.

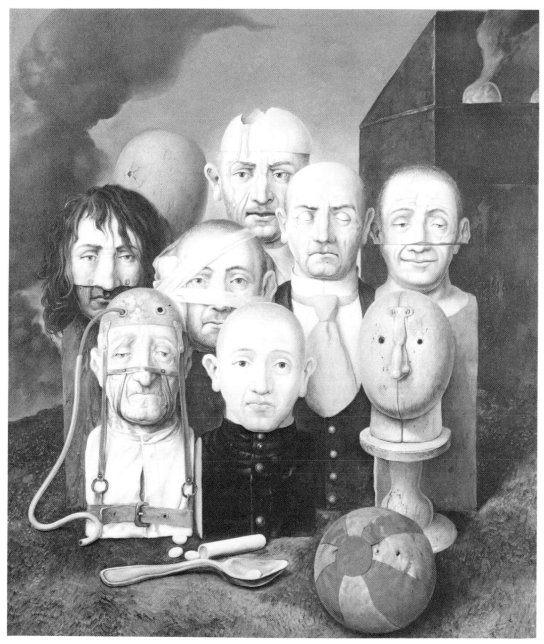

Personal Data, 1972, oil on canvas, 31½ × 25¼ in. (81× 65 cm.). Brandeis University Art Collection, Rose Art Museum; Gift of Mr. and Mrs. Donald Robinson, Pittsburgh, Pennsylvania.

YOSL BERGNER

Born 1920 Vienna;
lives in Tel Aviv

son of Melech Ravitch, Yiddish poet and essayist; spent childhood in Warsaw. *1937* emigrates to Australia; studies painting; joins Australian Army during World War II. *1940s* exhibits with Association of Contemporary Art, Australia, with such artists as Sidney Nolan and Albert Tucker. *1948-50* travels and exhibits in Paris, Montreal, and New York. *1950* emigrates to Israel. *1950-57* lives in Safed. *1957* settles in Tel Aviv; subjects are kitchen utensils — figures and spaces symbolizing a destroyed community. *1970s* produces stage designs and illustrates books, including Kafka; subjects are toys, flowers, and Palestinian pioneers in expressionistic, painterly style. *1980* Israel Prize.

Individual Exhibitions
Kadima Hall, Melbourne, Australia, 1941.
Galerie Gentilehomme, Paris, 1949.
Workmen's Circle, Montreal, 1950.
Katz Gallery, Tel Aviv, 1950.
Bezalel National Museum, Jerusalem, "Oil Paintings and Pen Drawings," February-March 1955.
The Tel Aviv Museum, 1957.
Museum of Modern Art, Haifa, March 1959.
Gallery One, London, 1960.
The Tel Aviv Museum, "Paintings 1960," February 1961.
Bineth Gallery, Jerusalem, "Paintings," October 1963.
Bineth Gallery, Jerusalem, 1964.
Bineth Gallery, Jerusalem, "Oil Painting," April 1965.
Bineth Gallery, Tel Aviv, 1969.
The Tel Aviv Museum, "Paintings 1955-1975," November 1975-January 1976. Catalogue text by Haim Gamzu.
Galerie Hardy, Paris, "Peintures d'aprés Franz Kafka," 1976.
Bineth Gallery, Tel Aviv, "Paintings of Toys," May 1977.
Bineth Gallery, Tel Aviv, "Paintings of Flowers," May-June 1979.
Aberbach Fine Art, New York, "Pioneers and Flowers," March 1980.

Major Group Exhibitions
Venice, "XXVIII Biennale," 1956.
São Paulo, Brazil, "IV Bienal," 1957.
Venice, "XXIX Biennale," 1958.
Arts Council of Great Britain, London, "Modern Israeli Paintings," 1958.
Bezalel National Museum, Jerusalem, "Twelve Artists," 1958.
Bezalel National Museum, Jerusalem, "Israel: Watercolors, Drawings, Graphics, 1948-1958," 1958.
Musée National d'Art Moderne, Paris, "L'art Israélien contemporain," 1960.
National Gallery of Victoria, Melbourne, Australia, "Rebels and Precursors," 1962.
Venice, "XXXI Biennale," 1962.
Museum of Modern Art, Haifa, "Israeli Drawings," 1965.
The Tel Aviv Museum, "Image-Imagination: 12 Israeli Artists," 1967.
The Tel Aviv Museum, "Israeli Art: Painting, Sculpture, Graphic Art," 1971.
The Israel Museum, Jerusalem, "From Landscape to Abstraction . . . ," 1972.
The Jewish Museum, New York, "Jewish Experience in the Art of the Twentieth Century," October 16, 1975-January 25, 1976. Catalogue text by Avram Kampf.

The Israel Museum, Jerusalem, "A Tribute to Sam Zacks: Selected Paintings, Drawings, and Sculpture from the Sam and Ayala Zacks Collection," Summer 1976. Catalogue no. 146. Circulated to The Tel Aviv Museum.
Canada-Israel Cultural Foundation, Ottawa, "Israel Art Festival . . . ," 1978.
The Israel Museum, Jerusalem, "From the Collection of Dr. Moshe Spitzer, Jerusalem," March 1978. Catalogue text by Moshe Spitzer, no. 172.
The Tel Aviv Museum, "Israel Art 30 + 30," 1978.
The Tel Aviv Museum, "Artist and Society . . . ," 1978.

Selected Bibliography

Articles and General References
Gamzu, Haim. *Painting and Sculpture in Israel.* Tel Aviv: Dvir, 1958. P. 45.
Tammuz, Benjamin, and Wykes-Joyce, Max, eds. *Art in Israel.* Tel Aviv: Massada, 1965. Pp. 36, 37.
Tal, Miriam. "Israel Art Comes of Age." *Ariel* 29 (Winter 1971):13.
Encyclopaedia Judaica. Jerusalem: Keter Publishing Ltd., 1972.
Shechori, Ran. *Art in Israel.* New York: Schocken Books, 1976. Pp. 27, 190.
Rahmani, L. Y. *The Museums of Israel.* London: Secker and Warburg, 1976. P. 133, n. 160.
Ronnen, Meir, "An Ancient Land's Newborn Art. "*Art News* 77 (May 1978):44, 48.
———. "The Jewish Outback." *Jerusalem Post,* September 14, 1979. P. 20.

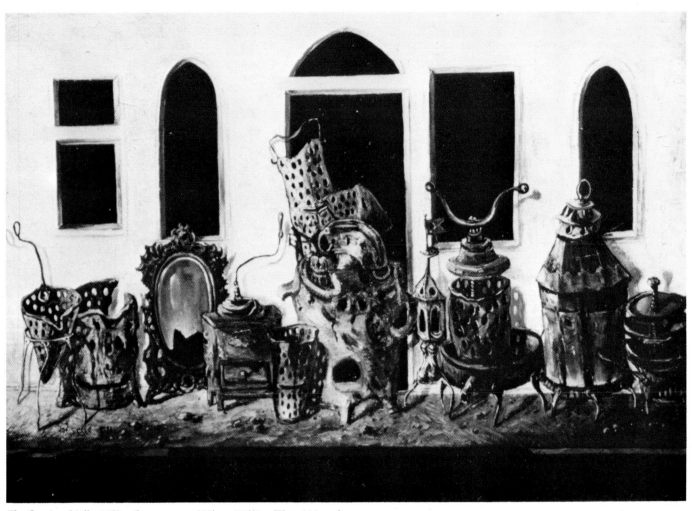

The Gypsies of Jaffa, 1972, oil on canvas, 28¾ × 45⅔ in. (73 × 116 cm.).
Lent by Bineth Gallery, Tel Aviv.

MOSHE CASTEL

Born 1909 Jerusalem; lives
in Tel Aviv, New York, and Paris

born into a Castilian Sephardic family resident in Palestine for five centuries. *1922-25* studies at Bezalel School of Arts and Crafts. *1927-40* attends Academie Julien and École du Louvre in Paris; subjects and technique reflect that of Jewish artists of the School of Paris. *1940* settles in Safed. *1946* Dizengoff Prize. *1948* moves to Tel Aviv; among founders of New Horizons group. *1952* visits Paris and New York. *1953* returns to Israel; moves from expressionism to abstraction; uses local antiquities (steles, inscriptions, ancient manuscripts) as inspirations for imaginary relief elements resembling Hebrew and Arabic. *1955* large murals for Hotel Accadia, Herzliya, Israel, and El Al Airlines, Rockefeller Center, New York. *from 1959* lives between Paris, New York, Israel. *1963* visits Spain. *1966* mural for Knesset. *1970-71* murals for ceremonial hall of presidential mansion, Jerusalem.

Individual Exhibitions

Galerie Zak, Paris, October 1931.
Haifa Technion, 1933.
The Tel Aviv Museum, December 1942.
The Tel Aviv Museum, December 1946.
Katz Gallery, Tel Aviv, March-April 1950.
Feigl Gallery, New York, May-June 1952.
The Tel Aviv Museum, January 1955.
Galerie Karl Flinker, Paris, June-July 1963.
Lefebre Gallery, New York, January 1964. Catalogue Introduction by Abram Sachar.
Galerie Karl Flinker, Paris, October-November 1965.
Lefebre Gallery, New York, April-May 1966. Catalogue text by Michel Tapié de Celeyran.
J. L. Hudson Gallery, Detroit, "Recent Works," March 1967.
Lefebre Gallery, New York, "Recent Works," January 1969, May 1971.
The Tel Aviv Museum, "Retrospective Exhibition 1928-1973," December 1973. Catalogue Introduction by Haim Gamzu.
Janus Gallery, Washington, D.C., 1977.
Galerie Dresdnere, Toronto, "Recent Paintings and Graphics," October 16-November 3, 1979.
Engel Gallery, New York, October 1980.

Major Group Exhibitions

Migdal David (Tower of David), Jerusalem, 1926.
Salon des Indépendants, Paris, "Salon d'Automne," 1928-31.
Salon Doroczny, Warsaw, 1931.
The Tel Aviv Museum, "Jewish Painters of Paris," 1937.
Venice, "XXIV Biennale," 1948.
The Tel Aviv Museum, "New Horizons," 1948, 1949, 1955, 1956, 1959.
Museum of Art, Carnegie Institute, Pittsburgh, "International," 1952.
Institute of Contemporary Art, Boston, "Seven Painters of Israel," 1953.
Metropolitan Museum of Art, New York, "From the Land of the Bible: An Archaeological Exhibition," 1953. Circulated to Museum of Art, Carnegie Institute, Pittsburgh; Institute of Contemporary Art, Boston; Tucson Art Center, Arizona.
Smith College Museum, Northampton, Massachusetts, 1954.
Cincinnati Art Museum, "Recent Acquisitions," 1958.
São Paulo, Brazil, "V Bienal," 1959. Catalogue text by Haim Gamzu.
Salon des Réalités Nouvelles, Paris, 1960.
Galerie Charpentier, École de Paris "Peintres Israéliens," 1963.
America-Israel Cultural Foundation and the International Council of The Museum of Modern Art, New York, "Art Israel: 26 Painters and Sculptors," 1964.

Museum of Art, Carnegie Institute, Pittsburgh, "International," 1964, 1967.
Lausanne, Switzerland, "Salon International des Galeries Pilotes," 1966.
The Israel Museum, Jerusalem, "New Horizons 1949-1963," 1966.
Palais des Beaux-Arts, Charleroi, Belgium, 1966.
Expo 67, Montreal, "Pavilion of Judaism," 1967.
The Tel Aviv Museum, "Israeli Art: Painting, Sculpture, Graphic Works," 1971.
The Israel Museum, Jerusalem, "Expressionism in Eretz-Israel in the Thirties . . . ," 1971.
Maurice Spertus Museum of Judaica, Chicago, "Israeli Art in Chicago Collections," 1974.
The Jewish Museum, New York, "Jewish Experience in the Art of the Twentieth Century," October 16, 1975-January 25, 1976. Catalogue text by Avram Kampf.
Canada-Israel Cultural Foundation, Ottawa, "Israel Art Festival . . . ," 1978.
The Tel Aviv Museum, "Israel Art 30 + 30," 1978.
Museum of Modern Art, Haifa, "30 Years to New Horizons, 1948-1978 . . . ," 1979.
University of Haifa Art Gallery. "The Myth of Canaan . . . ," 1980.

Selected Bibliography

Monograph
Sachar, Howard Morley. *Castel*. Neuchatel: Editions du Griffon, 1968. Introduction by Michel Tapie du Celeyran.

Articles and General References
Gamzu, Haim. *Painting and Sculpture in Israel*. Tel Aviv: Dvir, 1958. P. 32.
Tammuz, Benjamin, and Wykes-Joyce, Max, eds. *Art in Israel*. Tel Aviv: Massada, 1965. Pp. 22, 28, 30-33.
Tal, Miriam. "Israel Art Comes of Age." *Ariel* 29 (Winter 1971):12-13.
Encyclopaedia Judaica. Jerusalem: Keter Publishing Ltd., 1972.
Shechori, Ran. *Art in Israel*. New York: Schocken Books, 1976. Pp. 14, 191.
Rahmani, L. Y. *The Museums of Israel*. London: Secker and Warburg, 1976. P. 136, n. 168.
Werner, Alfred. "Israeli Art and the Americans." *American Zionist* 68 (May 1978):24-26.
Megged, Matti. "The Old-New Land: Israel." *Arts Canada* (December-January 1979-80):34.

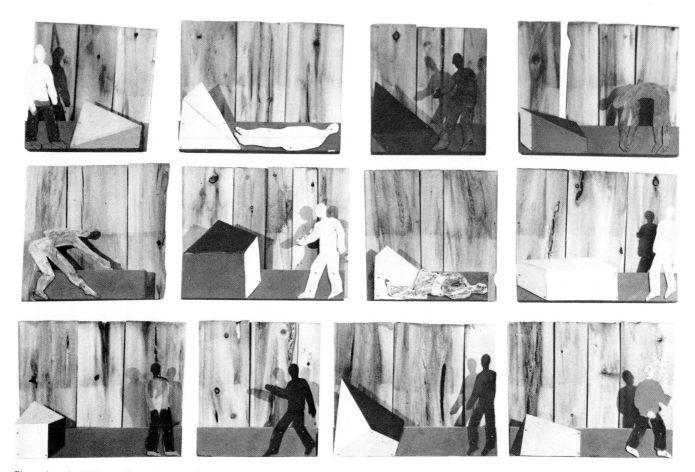

Figuration 12, 1978, cardboard mounted on wood, 12 panels, ca. 16 × 18 in.
each, 53 × 78 in. (135 × 198 cm.) overall. Collection Jud and Vivian
Ebersman, New York.

Kasher, Steven. "The Substance
 of Paper." *Artforum* 16 (March
 1978):27-28.
Ronnen, Meir. "An Ancient
 Land's Newborn Art." *Art
 News* 77 (May 1978):50, 51.
Omer, Mordecai. "Pinchas
 Cohen Gan." *Tarbut* 37 (Fall
 1978):5-7.
Rosenthal, Mark. "From
 Primary Structures to Primary
 Imagery." *Arts Magazine* 53
 (October 1978):106-7.
Frank, Peter. "Israelism and
 Abstraction." *Village Voice*,
 August 20, 1979. P. 79.
Larsen, Susan C. "The New
 Prominence of Israeli Art." *Art
 News* 78 (March 1979):92, 93.
Kasher, Steven, "Seven Artists
 of Israel." *Artforum* 17
 (Summer 1979):54.
Staniszewski, Mary Anne.
 "New York Reviews." *Art
 News* 79 (May 1980):181.

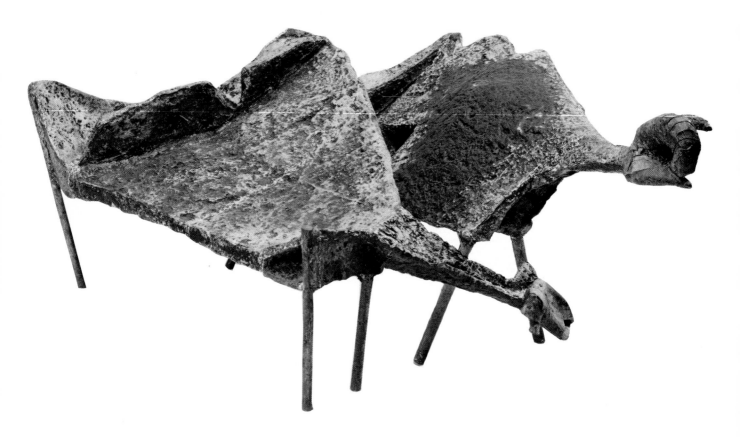

The Lord Is My Shepherd (Negev Sheep), 1964, bronze, 33¾ × 90 × 67¾ in.
(85 × 260 × 204 cm.). Collection Hirshhorn Museum and Sculpture Garden,
Smithsonian Institution.

YITZHAK DANZIGER

Born 1916 Berlin;
died 1977 Israel

1923 emigrates with family to Jerusalem. *1929-33* studies sculpture at Bezalel School of Arts and Crafts with Zeev Ben Zvi.
1934-38 attends Slade School of Fine Arts, University of London.
1939 establishes studio in Tel Aviv; first important sculptures (*Shabazya* and *Nimrod*) inspired by ancient Near Eastern sources; early style combines figurative and abstract elements.
1945 Dizengoff Prize. *1946* works with Ossip Zadkine in Paris.
1949-50 teaches environmental design at Haifa Technion. *1958* Milo Prize. *1960s* moves toward total abstraction, using both geometric and organic forms. *1968* commissioned to execute monumental sculpture for Olympic Games in Mexico City; Israel Prize.
1969 Sandberg Prize. *1970s* moves from sculpture to town planning and ecological and environmental projects; most ambitious is experimental *Rehabilitation of the Nesher Quarry* near Haifa in 1971; his work and bold conceptual thinking make him one of the most influential sculptors in Israel.

Individual Exhibitions

Mabat Gallery, Tel Aviv, "40 Drawings," 1970.
The Israel Museum, Jerusalem, "The Rehabilitation of the Nesher Quarry," 1971. Catalogue text by Yona Fischer.
The Israel Museum, Jerusalem, "Memorial Exhibition," 1977.

Major Group Exhibitions

America-Israel Cultural Foundation, and the International Council of The Museum of Modern Art, "Art Israel: 26 Painters and Sculptors," 1964.
The Israel Museum, Jerusalem, "Trends in Israeli Art," 1965.
The Israel Museum, Jerusalem, "Labyrinth . . . ," 1967.
Museum of Modern Art, Haifa, "Michael Gross, Yitzhak Danziger, Yehiel Shemi: Sculptures," 1969-70.
The Israel Museum, Jerusalem, "Concepts + Information," 1971.
Memorial Art Gallery of The University of Rochester, New York, "Looking Up . . . ," 1971.
The Tel Aviv Museum, "Israeli Art: Painting, Sculpture, Graphic Works," 1971.
The Israel Museum, Jerusalem, "From Landscape to Abstraction . . . ," 1972.
Louisiana Museum, Copenhagen, "10 Kunstnere fra Israel [10 Israeli Artists]," 1977.
Tel Aviv University, University Gallery, "Graphic Works by 30 Israeli Artists," 1978.
The Tel Aviv Museum, "Israel Art 30 + 30," 1978.
Museum of Modern Art, Haifa, "30 Years to New Horizons, 1948-1978 . . . ," 1979.
University of Haifa Art Gallery, "The Myth of Canaan . . . ," 1980.

Selected Bibliography

Articles and General References
Tammuz, Benjamin, and Wykes-Joyce, Max, eds. *Art in Israel*. Tel Aviv: Massada, 1965. Pp. 144, 149, 150.
Fischer, Yona. "A Tale of One Quarry." *Ariel* 31 (1972):52-65.
Encyclopaedia Judaica. Jerusalem: Keter Publishing Ltd., 1972.
Shechori, Ran. *Art in Israel*. New York: Schocken Books, 1976. Pp. 29, 191.
Ronnen, Meir. "An Ancient Land's Newborn Art." *Art News* 77 (May 1978):49-50.
————. "Preserving the Past, Securing the Future." *Art News* 77 (May 1978):59.
Megged, Matti. "The Old-New Land: Israel." *Arts Canada* (December-January 1979-80):32, 34.

BENNI EFRAT

Born 1936 Beirut;
lives in New York

1947 emigrates to Palestine. *1959-61* studies under Yeheskel Streichman at Avni Art Institute, Tel Aviv. *1964-65* works in Europe. *1966-76* settles in London; creates sculptures that bring materials together in unexpected contexts, using geometric forms that are visually improbable and ambiguous to the viewer. *1970* travels extensively in Israel, Europe, and the United States. *1971* Sandberg Prize. *1977* settles in New York; recent works define interrelationships between an object and its shadows; light is central to the theme of a work, as in his "shadow pieces" and conceptual films documenting his performances.

Individual Exhibitions

Chemerinsky Gallery, Tel Aviv, November-December 1965.
Grabowski Gallery, London, 1969.
Mayfair Gallery, London, 1970.
Gordon Gallery, Tel Aviv, 1972.
Israel Gallery, Jerusalem, 1972.
Gordon Gallery, Tel Aviv, 1973.
Bertha Urdang Gallery, New York, 1973.
Stedelijk Museum, Amsterdam, December 6, 1974-January 4, 1975. Exhibition catalogue no. 573.
Gordon Gallery, Tel Aviv, 1975.
Bertha Urdang Gallery, New York, 1975.
Paleis voor Schone Kunsten, Brussels, 1976.
Internationaal Cultureel Centrum, Antwerp, "Benni Efrat," September 24-October 30, 1977.
Whitney Museum of American Art, New York, "Benni Efrat: Films," January 18-30, 1977.
Bertha Urdang Gallery, New York, January 18-February 25, 1977.
Richard Foncke Galerij, Ghent, Belgium, 1977.
Galerie Schmela, Düsseldorf, 1978.
Galerie Oppenheim, Cologne, West Germany, September 17-October 15, 1978.
P. S. 1 (Project Studios One), New York, March 1978.
Ohio State University Gallery of Fine Art, Columbus, "Benni Efrat: Extrapolations," April 1978.

Wadsworth Atheneum, Matrix 37, Hartford, Connecticut, "Benni Efrat," January-March 1978.
The Tel Aviv Museum, Summer 1979.
Galerij A. Baronian, Brussels, 1980.
Galerie Schmela, Düsseldorf, 1980.

Major Group Exhibitions

Art Council Gallery, Tel Aviv, "10+," 1965.
Paris, "IV Biennale," 1965.
Artists' House, Tel Aviv, "10+," February 1966.
City of London Festival, "Sculpture in the City," 1968.
Edinburgh Festival, Scotland, "Sculpture in the Open Air," 1968.
Paris, "VI Biennale," 1969.
University Art Gallery, State University of New York at Albany, "A Leap of Faith," 1969.
High Museum of Art, Atlanta, "Israel on Paper," 1970.
Memorial Art Gallery of The University of Rochester, New York, "Looking Up . . . ," 1971.
The Israel Museum, Jerusalem, "Concepts + Information," 1971.
The Israel Museum, Jerusalem, "Beyond Drawing," 1974.
Bertha Urdang Gallery, Jerusalem, "Group Show," 1976.
Museum of Contemporary Art, Chicago, "Words at Liberty," 1977.

Kassel, Germany, "Documenta VI," 1977.
Tel Aviv University, University Gallery, "Graphic Works by 30 Israeli Artists," 1978.
Uri and Rami Nechushtan Museum, Kibbutz Ashdot Yaakov, "Location/Duration," 1978.
Musée National d'Art Moderne, Centre Pompidou, Paris, "Journées interdisciplinaires et performances," 1979.
Wright State University, Dayton, Ohio, "Pyramidal Influence in Art," 1979. Circulated to Midwest Museum of American Art, Elkhart, Indiana; Freedman Gallery, Albright College, Reading, Pennsylvania; Davidson Art Center, Wesleyan University, Middletown, Connecticut.
Internationaal Cultureel Centrum, Antwerp, Belgium, "Biennale van de Kritiek," 1979. Circulated to Palais des Beaux-Arts, Charleroi, 1980.
University of Hartford, Art School, 1980.
Internationaal Cultureel Centrum, Antwerp, "Beyond Surface," 1980.
Noemi Givon — Contemporary Art, Tel Aviv, "Opening Exhibition," September 1980.
P. S. 1 (Project Studios One), New York, "Film Installation," September 28-November 9, 1980. Catalogue interview with the artist by Leandro Katz.

Selected Bibliography

Articles and General References
Efrat, Benni. "Visual Dynamics." *Art and Artists* 4 (September 1969):20-21.
Reise, Barbara. "Benni Efrat: New York." *Studio International* 178 (September 1969):84-86.
Denvir, Bernard. "London Letter." *Art International* 15 (February 1971):45.
Russell, David. "London." *Arts Magazine* 45 (March 1971):50.
Frank, Peter. "Benni Efrat." *Art News* 74 (September 1975):112.
Ellenzweig, Allen. "Nir Bareket/Benni Efrat." *Arts Magazine* 50 (September 1975):99.
McFadden, Sarah. "Benni Efrat at Rina." *Art in America* 50 (September-October 1975):99.
Glueck, Grace. "Art People." *New York Times*, January 14, 1977. P. C-16.
Pincus-Witten, Robert. "The Sons of Light: An Observer's Notes in Jerusalem." *Arts Magazine* 50 (September 1975):64-74.
————. "Entries: The White Rectangle: Robert Ryman and Benni Efrat." *Arts Magazine* 51 (April 1977):93-95.
————. "Benni Efrat." *Arts Magazine* 54 (October 1979):145-153.
Naylor, Colin, and P-Orridge, Genesis, eds. *Contemporary Artists*. London: St. James Press, 1977. Pp. 274-75.

August, from *Undercover Blues* series, 1980, wood, latex, acrylic, and electric
light projection, 52 × 17 × 51 in. (135 × 43 × 130 cm.). Collection Selma and
Stanley I. Batkin, New York.

MICHAEL GROSS

Born 1920 Tiberias, Palestine;
lives in Haifa

1936-40 studies at Teachers' Seminary, Jerusalem. *1943-45* studies architecture at Haifa Technion and sculpture with Moshe Ziffer. *1951-54* studies with portraitist Marcel Gimond at École des Beaux-Arts, Paris. *1954* returns to Israel; sets up painting and sculpture studio in Ein Hod; works as both painter and sculptor; sources in painting are usually realistic but are condensed and reduced to boldly juxtaposed broad areas of color; mixed media and metal sculpture are in same Minimalist style. *1957-60* teaches sculpture at Bezalel School of Arts and Crafts. *1960-present* teaches at Art Institute of the Kibbutzim Seminary, Oranim. *1964* Struck Prize. *1967* Dizengoff Prize. *1971* environmental sculpture for garden of Museum of Contemporary Art, São Paulo University. *1974* monumental concrete sculpture for Simon Bolivar Park, Jerusalem. *1977* Sandberg Prize.

Individual Exhibitions

Museum of Modern Art, Haifa, "Paintings and Sculptures," April-May 1964. Catalogue text by Z. Hrycak.
Museu de Arte Moderna, Rio de Janeiro, October-November 1971. Catalogue text by Walmir Ayala.
Rina Gallery, New York, November-December 1974.
Julie M. Gallery, Tel Aviv, October 1975.
The Israel Museum, Jerusalem, "Outdoor and Indoor Works," 1976-77. Catalogue text by Yona Fischer.
The Tel Aviv Museum, "Michael Gross: 1975-77," November-December 1977. Catalogue Introduction by Marc Scheps; text by Yona Fischer.
Printers' Gallery, Jerusalem, October 1978.
Museum of Art (Mishkan Leomanut), Ein Harod, "Encounters with Jerusalem, 1968-1980," Spring 1980. Catalogue Introduction by Mordecai Omer.

Major Group Exhibitions

Bezalel National Museum, Jerusalem, "Twelve Artists," 1958.
Venice, "XXX Biennale," 1960.
Museum of Art, Carnegie Institute, Pittsburgh, "International," 1961.
Galerie Charpentier, École de Paris, "Peintres Israéliens," 1963.

America-Israel Cultural Foundation, and the International Council of The Museum of Modern Art, "Art Israel: 26 Painters and Sculptors," 1964.
Museum Boymans van Beuningen, Rotterdam, "Grafiek uit Israël," 1968.
Florence, Italy, "Graphics Biennale," 1968.
Ljubljana, Yugoslavia, "Eighth Biennale of Graphic Art," 1968.
University Art Gallery, State University of New York at Albany, "A Leap of Faith," 1969.
Museum of Modern Art, Haifa, "Michael Gross, Yitzhak Danziger, Yehiel Shemi: Sculptures," 1969-70.
Rijeka, Yugoslavia, "Drawing Biennale," 1970.
High Museum of Art, Atlanta, "Israel on Paper," 1970.
São Paulo, Brazil, "XI Bienal: Michael Gross, Osias Hofstatter, Mordecai Moreh," 1971.
Memorial Art Gallery of The University of Rochester, New York, "Looking Up . . . ," 1971.
The Israel Museum, Jerusalem, "From Landscape to Abstraction . . . ," 1972.
Museum of Modern Art, Haifa, "Self-Portrait in Israel Art," 1973.
Museum of Modern Art, Haifa, "Aclim," 1974.
Worcester Art Museum, Massachusetts, "Three Israeli Artists: Gross, Neustein, Kupferman," 1975.

Florence, Italy, "Graphics Biennale," 1976.
The Israel Museum, Jerusalem, "From the Collection of Dr. Moshe Spitzer, Jerusalem," March 1978. Catalogue text by Moshe Spitzer, no. 172.
Tel Aviv University, University Gallery, "Graphic Works by 30 Israeli Artists," 1978.
Canada-Israel Cultural Foundation, Ottawa, "Israel Art Festival . . . ," 1978.
The Tel Aviv Museum, "Israel Art 30 + 30," 1978.
Jerusalem City Museum (David's Tower), "Jerusalem and the Israeli Printmaker," 1980.

Selected Bibliography

Articles and General References
Tammuz, Benjamin, and Wykes-Joyce, Max, eds. *Art in Israel.* Tel Aviv: Massada, 1965. Pp. 34, 38, 52.
Encyclopaedia Judaica. Jerusalem: Keter Publishing Ltd., 1972.
Tal, Miriam, "Michael Gross." *Israel Magazine* 5 (February 1973):39-42.
Frackman, Noel. "Michael Gross/Buky Schwartz." *Arts Magazine* 49 (January 1975):12.
Shechori, Ran. *Art in Israel.* New York: Schocken Books, 1976. P. 193.
Frank, Peter. "A Specifically Israeli Flavor." *Art News* 75 (January 1976):95-97.
Pincus-Witten, Robert. "The Neustein Papers." *Arts Magazine* 52 (October 1977):10.

Goldfine, Gil. "The Ultimate Landscape." *Jerusalem Post Magazine,* November 25, 1977. P. 17.
Debel, Ruth. "What Does It Mean To Be an Israeli Artist" *Art News* 77 (May 1978):52-53.
Ronnen, Meir. "An Ancient Land's Newborn Art." *Art News* 77 (May 1978):49-51.
Megged, Matti. "The Old-New Land: Israel." *Arts Canada* (December-January 1979-80):33.

Fields in Sunlight, 1970, oil on canvas, 2 hinged panels, 78 × 96 in.
(198 × 259 cm.). Collection Lee and Elizabeth Turner, Kansas.

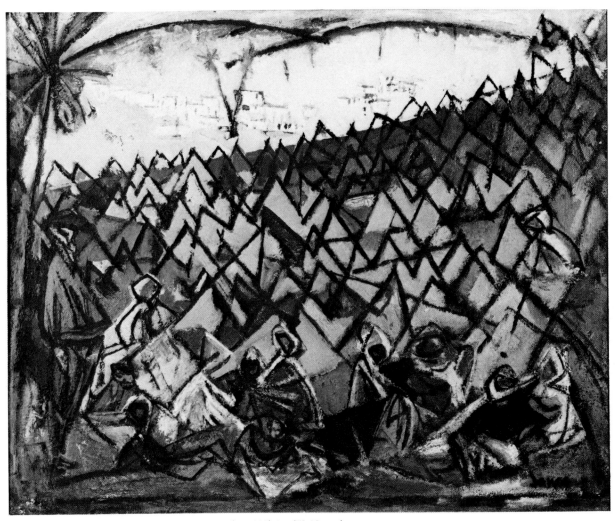

Ma'abarath in Grey, ca. 1950, oil on canvas, 30¾ × 38½ in. (78 98 cm.).
Collection The Jewish Museum, New York; Gift of Alan Stroock.

MARCEL JANCO

Born 1895 Bucharest;
lives in Ein Hod and Tel Aviv

1910-14 studies in Bucharest with the painter Iser-Josif.
1915 architectural degree at Polytechnique, Zurich; *1916* among
founders of Dada movement in Zurich. *1919* collaborates on Dada
magazine in Zurich; paints and makes abstract reliefs. *1921-22* in
Paris; meets young Surrealists. *1923* returns to Bucharest as
painter and architect; joins radical artists group Contemporanul and
co-edits its review. *1941* emigrates to Palestine; becomes influential
teacher; abandons early abstract style for bold, angular, and linear
expressionism based on abstraction and stylized figures and
landscapes. *1948* among founders of New Horizons group.
1951 Dizengoff Prize for Painting. *1953* among founders of artists'
village Ein Hod. *1967* Israel Prize.

Individual Exhibitions
Maison d'Art, Bucharest,
Romania, 1922.
The Tel Aviv Museum, Autumn
1942, 1948.
Feigl Gallery, New York, "Oils
and Watercolors," October
17-November 4, 1950.
The Tel Aviv Museum, April
1952.
Mikra Studio, Tel Aviv,
November-December 1953.
Sidney Janis Gallery, New York,
1954.
The Tel Aviv Museum,
"Retrospective 1916-1959,"
May-June 1959. Catalogue
Preface by Eugene Kolb.
Circulated to Artists' House,
Jerusalem, July 18-August 12,
1959.
Galerie Schwarz, Milan,
Autumn 1961.
Galerie Denise René, Paris,
October-November 1963.
Herzliya Museum, Israel,
"Retrospective 1942-1952,"
October 1964.
Museum of Modern Art, Haifa,
"Retrospective,"
Spring-Summer 1968.
Circulated to Ein Harod,
Petach Tikva, Beersheba.
The Tel Aviv Museum,
"Retrospective," June-July
1972. Catalogue text by Haim
Gamzu.

Major Group Exhibitions
Cabaret Voltaire, Zurich,
1916-17.
Galerie Wolfsberg, Zurich,
September 1917.
Kunstgewerbemuseum, Zurich,
October 1919.
Autumn Salon, Bucharest,
Romania, 1922-31.
Galerie Renaissance, Paris,
"Group 1940," 1931.
The Tel Aviv Museum,
Dizengoff House, "New
Horizons," 1948.
Galerie Maeght, Paris, 1949.
Venice, "XXVI Biennale," 1952.
Institute of Contemporary Art,
Boston, "Seven Painters of
Israel," 1953.
Galerie Creuze, Paris,
"Cinquante ans de peintures
abstraite," 1958.
Kunstmuseum der Städt
Düsseldorf, 1958.
Bezalel National Museum,
Jerusalem, "Israel: Watercolors,
Drawings, Graphics
1948-1958," 1958.
Musée du Louvre, Paris, "50
ans de collage," Autumn 1964.
The Israel Museum, Jerusalem,
"Trends in Israeli Art, " 1965.
Musée National d'Art Moderne,
Paris, "50th Anniversary of
Dada," 1965-66. Circulated to
Milan, Geneva.
Musée National d'Art Moderne,
Paris, "Salle Dada et New
York," 1967.
The Tel Aviv Museum, "Israeli
Art: Painting, Sculpture,
Graphic Works," 1971.
The Tel Aviv Museum, "Dada,"
June-July 1972.

Maurice Spertus Museum of
Judaica, Chicago, "Israeli Art
in Chicago Collections," 1974.
Maurice Spertus Museum of
Judaica, Chicago, "Jewish
Artists of the Twentieth
Century," October 5,
1975-January 30, 1976.
Catalogue text by Arthur M.
Feldman and Joseph Randall
Shapiro.
The Jewish Museum, New York,
"Jewish Experience in the Art
of the Twentieth Century,"
October 16, 1975-January 25,
1976. Catalogue text by Avram
Kampf.
The Israel Museum, Jerusalem,
"A Tribute to Sam Zacks:
Selected Paintings, Drawings,
and Sculptures from the Sam
and Ayala Zacks Collection,"
Summer 1976. Exhibition
catalogue no. 146. Circulated to
The Tel Aviv Museum.
The Tel Aviv Museum, "Artust
and Society . . . ," 1978.
Canada-Israel Cultural
Foundation, Ottawa, "Israel
Art Festival . . . ," 1978.
Museum of Modern Art, Haifa,
"30 Years to New Horizons,
1948-1978," 1979.

Selected Bibliography
Monographs
Kolb, Eugene. *Six Landscapes by
Marcel Janco*. Tel Aviv: Mikra
Studio, 1954.
Mendelson, Marcel. *Marcel
Janco*. Tel Aviv: Massada, 1963.
Seuphor, Michel. *Marcel Janco*.
Switzerland: Bodensee Verlag,
1963.

Articles and General References
Ball, Hugo. *Escape from Time*.
Munich: Dunker and Humbolt,
1927.
Barr, Alfred H. *Fantastic Art,
Dada, Surrealism*. New York:
Museum of Modern Art, 1936.
Motherwell, Robert. *Dada Poets
and Painters: An Anthology*.
New York: Wittenborn and
Schultz, 1950.
Verkauf, Willy; Janco, M.; and
Bollinger, H. *Dada Monograph of
a Movement*. Teufen: Niggli,
1957.
Gamzu, Haim. *Painting and
Sculpture in Israel*. Tel Aviv:
Dvir, 1958. P. 47.
Tammuz, Benjamin, and
Wykes-Joyce, Max, eds. *Art in
Israel*. Tel Aviv: Massada, 1965.
Pp. 29, 30, 38.
Tal, Miriam. "Israel Art Comes
of Age." *Ariel* 29 (Winter
1971):13.
Roth, Cecil, ed. *Jewish Art*. New
York: New York Graphic
Society, 1971.
Shechori, Ran. *Art in Israel*.
New York: Schocken Books,
1976. Pp. 23, 194.
Ronnen, Meir. "An Ancient
Land's Newborn Art." *Art
News* (May 1978):45.
Werner, Alfred. "Israeli Art and
the Americans." *American
Zionist* 68 (May 1978):25.
Larsen, Susan C. "The New
Prominence of Israeli Art." *Art
News* 78 (March 1979):93.

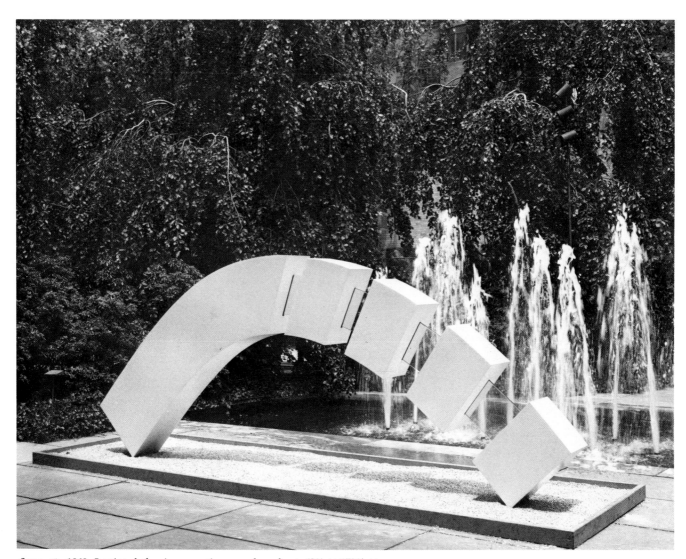

Segments, 1969, 5 painted aluminum sections on glass sheet, 62¼ × 172¼ ×
12 in. (152 × 437 × 30 cm.) overall. Collection The Museum of Modern Art,
New York; Gift of Mr. and Mrs. George M. Jaffin.

MENASHE KADISHMAN

Born 1932 Tel Aviv;
lives in Tel Aviv

studied with sculptors Rudi Lehmann and Moshe Sternschuss, Tel Aviv. *1959-60* studies at St. Martin's School of Art and Slade School of Fine Arts, University of London; sculpture uses glass and metal to create mass which challenges and defies gravity; massive blocks float in the air, next to seemingly weightless transparent bodies. *1972* returns to Israel; works on outdoor installations using trees, sheep, forests, and ocean in a dialogue with the more traditional art forms. *1978* Sandberg Prize.

Individual Exhibitions

Grosvenor Gallery, London, 1965.
Harlow Arts Festival, England, 1965.
Dunkelman Gallery, Toronto, 1967.
Goldberg Gallery, Edinburgh Festival, 1968.
The Jewish Museum, New York, May 13, 1970. Catalogue text by Edward F. Fry.
J. L. Hudson Gallery, Detroit, June-July 1971.
Museum Haus Lange, Krefeld, Germany, "Concepts and Their Realizations," January 23-March 5, 1972. Catalogue text by Paul Wember.
Julie M. Gallery, Tel Aviv, 1974.
The Israel Museum, Jerusalem, 1975.
Rina Gallery, New York, "M. Kadishman: Glass," January 13-February 7, 1976.
Obelisk Gallery, Copenhagen, 1977.
The Israel Museum, Jerusalem, "The Kadishman Connection," 1979. Catalogue text by Stephanie Rachum and Nurit Shilo-Cohen.
Sara Levi Gallery, Tel Aviv, 1979.

Major Group Exhibitions

Kentwood House, London, "Open Air Exhibition," 1964.
Grosvenor Gallery, London, "Fifty Years of Sculpture," 1965.
The Tel Aviv Museum, "Autumn Salon," 1967.
Toronto, "International Sculpture Symposium," 1967.
Paris, "V Biennale," 1967.
Kassel, Germany, "Documenta IV," 1968.
City of London, "Open Air Sculpture Exhibition," 1968.
Montevideo, Uruguay, "International Sculpture Symposium," 1969.
University Art Gallery, State University of New York at Albany, "A Leap of Faith," 1969.
High Museum of Art, Atlanta, "Israel on Paper," 1970.
Skopje, Yugoslavia, "Graphic Biennale," 1971.
Memorial Art Gallery of The University of Rochester, New York, "Looking Up . . . ," 1971.
The Tel Aviv Museum, "Israeli Art: Painting, Sculpture, Graphic Works," 1971.
Venice, "XXXVI Biennale," 1972.
The Israel Museum, Jerusalem, "From Landscape to Abstraction . . . ," 1972.
The Israel Museum, Jerusalem, "Beyond Drawing," Spring 1974.

Louisiana Museum, Copenhagen "10 Kunstnere fra Israel [10 Israeli Artists]," 1977.
The Israel Museum, Jerusalem, "From the Collection of Dr. Moshe Spitzer, Jerusalem," March 1978. Catalogue text by Moshe Spitzer, no. 172.
Tel Aviv University, The University Gallery, "Graphic Works by 30 Israeli Artists," 1978.
Venice, "XXXIX Biennale: Menashe Kadishman, Israel," 1978. Catalogue text by Amnon Barzel.
Canada-Israel Cultural Foundation, Ottawa, "Israel Art Festival . . . ," 1978.
The Tel Aviv Museum, "Artist and Society . . . ," 1978.
Tokyo, "Print Biennale," 1979.
Lehmbruck Museum der Stadt, Duisburg, Germany, 1979.
Jerusalem City Museum (David's Tower), "Jerusalem and the Israeli Printmaker," 1980.
The Israel Museum, Jerusalem, "Borders," 1980.
Constitution Garden, Washington, D.C., "Eleventh International Sculpture Conference," June 7, 1980.
Tel-Hai College Art Institute, "Tel-Hai 80, a Contemporary Art Meeting," September 1980.

Selected Bibliography

Articles and General References
Fry, Edward. "Menashe Kadishman: The Forest." *Studio International* 179 (June 1970):264-65.
Tal, Miriam. "Israel Art Comes of Age." *Ariel* 29 (Winter 1971):19.
Omer, Mordecai. "Concepts and Their Realization." *Studio International* 184 (December 1972):243-44.
Shechori, Ran. *Art in Israel.* New York: Schocken Books, 1976. P. 194.
Selz, Peter. "Menashe Kadishman: Planting Trees, Making Sculpture." *Arts Magazine* 51 (December 1976):95-97.
Ronnen, Meir. "Up in Arms." *Art News* 77 (January 1978):128.
———. "An Ancient Land's Newborn Art." *Art News* 77 (May 1978):45, 49, 50, 51.
———. "Preserving the Past, Securing the Future." *Art News* 77 (May 1978):59.
Hughes, Robert. "It's Biennale Time Again." *Time*, July 17, 1978.
Marck, Jan van der. "The Venice Biennale: Can It Rise Again?" *Artforum* 17 (September 1978):75-76.
Ronnen, Meir. "The Kadishman Connection." *Jerusalem Post Magazine*, February 23, 1979. P. 24.
Barzel, Amnon. "Review of the Kadishman Connection." *Flash Art*, Nos. 94-95 (February 1980):63.

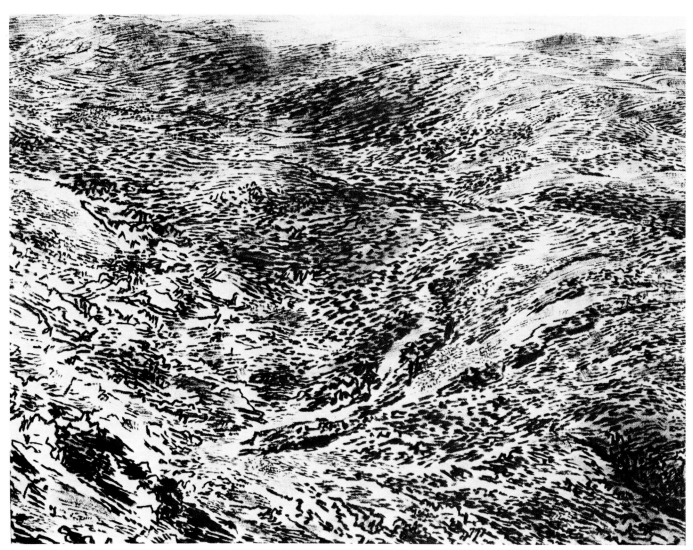

Barren Landscape, 1937, chalk on paper, 22 × 30 in. (56 × 76 cm.). Collection
Trude Dothan, Jerusalem.

LEOPOLD KRAKAUER

Born 1890 Vienna;
died 1954 Jerusalem

graduated from Imperial Academy of Fine Arts, Vienna, in engineering and architecture. *1924* emigrates to Palestine; settles in Jerusalem; plans architectural designs of kibbutzim. *1930s-54* large number of black-and-white chalk drawings which evoke a poetic interpretation of the trees, thistles, and landscape of Jerusalem. *1948-54* designs villages in Jerusalem for new immigrants.

Individual Exhibitions

The Tel Aviv Museum, "Drawings," December 1953.
Bezalel National Museum, Jerusalem, "Architect and Artist Memorial Exhibition 1890-1954," January-February 1955.
Artists' House, Jerusalem, "Memorial Exhibition." January 23-February 3, 1971.
The Israel Museum, Jerusalem, "Drawings," Summer 1974. Catalogue text by Elisheva Cohen.
Debel Gallery, Ein Kerem, "Leopold Krakauer — Thorns," 1979.

Major Group Exhibitions

Bezalel National Museum, Jerusalem, "Israel: Watercolors, Drawings, Graphics 1948-1958," 1958.
The Israel Museum, Jerusalem, "Trends in Israeli Art," 1965.
The Tel Aviv Museum, "Israeli Art: Painting, Sculpture, Graphic Works," 1971.
The Israel Museum, Jerusalem, "From Landscape to Abstraction . . . ," 1972.
Helmhaus, Zurich, "Jerusalemer Kunstler in Zurich," 1973.
The Jewish Museum, New York, "Jewish Experience in the Art of the Twentieth Century," October 16, 1975-January 25, 1976. Catalogue text by Avram Kampf.
The Israel Museum, Jerusalem, "From the Collection of Dr. Moshe Spitzer, Jerusalem," March 1978. Catalogue text by Moshe Spitzer, no. 172.

Selected Bibliography

Articles and General References
Buber, Martin. "The Anguish of Solitude: the Art of Leopold Krakauer." *Ariel* 9 (Winter 1964-65):5-10.
Tammuz, Benjamin, and Wykes-Joyce, Max, eds. *Art in Israel*. Tel Aviv: Massada, 1965. Pp. 25, 210, 212, 213.
Tal, Miriam. "Israel Art Comes of Age." *Ariel* 29 (Winter 1971):20-22.
Encyclopaedia Judaica. Jerusalem: Keter Publishing Ltd., 1972.
Shechori, Ran. *Art in Israel*. New York: Schocken Books, 1976. P. 195.
Rahmani, L. Y. *The Museums of Israel*. London: Secker and Warburg, 1976. P. 194, n. 252.

MOSHE KUPFERMAN

Born 1926 Jaroslav, Poland;
lives in Kibbutz Lohamai Ha'getaoth

refugee in U.S.S.R. during World War II. *1948* emigrates to Israel; among founders of Kibbutz Lohamai Ha'getaoth in western Galilee; attends art classes for settlers in the kibbutzim. *1950s* though influenced by the work of Avigdor Stematsky and Yosef Zaritsky, his own artistic style is mainly self-developed; participates in New Horizons, Tatzpit, and Autumn Salon exhibitions. *1963* visits Paris. *1971* Schiff Prize of Haifa Municipality. *1972* Sandberg Prize. *1975, 1980* visits United States; drawing and surface texture are the prominent elements in his grid paintings; numerous underlayers of paint and linear markings emerge from beneath the final surface paint.

Individual Exhibitions
Chemerinsky Gallery, Tel Aviv, January-February 1960.
The Israel Museum, Jerusalem, 1960.
The Israel Museum, Jerusalem, May-July 1969. Catalogue text by Yona Fischer, no. 59.
Mabat Gallery, Tel Aviv, "Drawings," 1971.
Museum of Modern Art, Haifa, "Recent Works," 1972. Catalogue text by Gabriel Tadmor.
Rina Gallery, New York, "Paintings and Drawings," May-June 1973.
Rina Gallery, New York, "Paintings and Drawings," 1974.
Kibbutz Painting and Sculpture Gallery, Tel Aviv, "Oil Paintings," March-April 1975.
Rina Gallery, New York, "Drawings," October-November 1975.
Bertha Urdang Gallery, New York, "Five Paintings Nine Drawings," October 18-November 12, 1977. Catalogue text by Robert Pincus-Witten.
Sara Levi Gallery, Tel Aviv, "Divided Pages," December 1978.
The Tel Aviv Museum, April-May 1978. Catalogue text by Sara Breitberg.
Sullivant Gallery, Ohio State University, Columbus, 1979.

Memorial Art Gallery of The University of Rochester, New York, January 19-March 2, 1980.
Bertha Urdang Gallery, New York, "Oils," April 8-May 3, 1980.
Bertha Urdang Gallery, New York, "Drawings," September 9-27, 1980.
Wadsworth Atheneum, Matrix Gallery, Hartford, Connecticut, October-December, 1980.
Stedelijk Museum, Amsterdam, "Drawings," February 15, 1981.

Major Group Exhibitions
Museum of Art (Mishkan Leomanut), Ein Harod, "New Horizons," 1963.
The Tel Aviv Museum, "Autumn Salon," 1964, 1965, 1966, 1968, 1969.
University Art Gallery, State University of New York at Albany, "A Leap of Faith," 1969.
Yad Lebanim, Petach Tikva, Israel, "The Five," 1973.
Ministry of Exterior, Jerusalem, "Works on Paper . . . ," 1973-74.
The Israel Museum, Jerusalem, "Beyond Drawing," 1974.
Worcester Art Museum, Massachusetts, "Three Israeli Artists: Gross, Neustein, Kupferman," 1975.
Louisiana Museum, Copenhagen, "10 Kunstnere fra Israel [10 Israeli Artists]," 1977.

The Israel Museum, Jerusalem, "From the Collection of Dr. Moshe Spitzer, Jerusalem." March 1978. Catalogue text by Moshe Spitzer, no. 172.
Tel Aviv University, University Gallery, "Graphic Works by 30 Israeli Artists," 1978.
The Tel Aviv Museum, "Israel Art 30+30," 1978.
Illinois Bell, Chicago, "Print-making in Israel Today," 1978.
Ohio State University Gallery of Fine Art, Columbus, "Sensible Explorations," February 7-May 15, 1978.
Los Angeles County Museum of Art, "Seven Artists in Israel, 1948-1978," 1978-79.
Uri and Rami Nechushtan Museum, Kibbutz Ashdot Yaakov, "Location/Duration," 1978.
Bronx Museum of the Arts. "Marking Black," 1980. Catalogue text by Jeanette Ingberman and Madeline Burnside.

Selected Bibliography
Articles and General References
Berman, Reuven. "Moshe Kupferman." *Jerusalem Post,* May 16, 1969.
Tal, Miriam. "Israel Art Comes of Age." *Ariel* 29 (Winter 1971):15.
Pincus-Witten, Robert. "Six Propositions on Jewish Art." *Arts Magazine* 50 (December 1975):69.
Frank, Peter. "Rina Gallery, New York, Exhibition." *Art in America* (May-June 1976):104.

Pincus-Witten, Robert. "The Neustein Papers." *Arts Magazine* 52 (October 1977):71-72.
Cardozo, Judith Lopes. "Bertha Urdang Gallery, New York, Exhibition." *Artforum* 16 (January 1978):71-72.
Goldfine, Gil. "Moshe Kupferman: The Message of the Medium." *Jerusalem Post Magazine,* April 27, 1978. P. 21.
Ronnen, Meir. "An Ancient Land's Newborn Art." *Art News* 77 (May 1978):46-47, 50.
Larsen, Susan C. "The New Prominence of Israeli Art." *Art News* 78 (March 1979):92-94.
Kasher, Steven. "Seven Artists of Israel." *Artforum* 17 (Summer 1979):51-53.
Hamm, Donna. "Moshe Kupferman: Painting and Drawing." *Dialogue* (November-December 1979):40.
Cardozo, Judith Lopes. "Marking Black, Bronx Museum of the Arts." *Artforum* 18 (April 1980):83-84.
Rickey, Carrie. "Review." *Village Voice,* April 28, 1980. Pp. 79-80.
Burnside, Madeleine. "Group Show: Bertha Urdang Gallery, New York." *Arts Magazine,* 54 (June 1980):41-42.
———. "Moshe Kupferman at Bertha Urdang." *New York Arts Journal* 18 (June 1980):24-26.

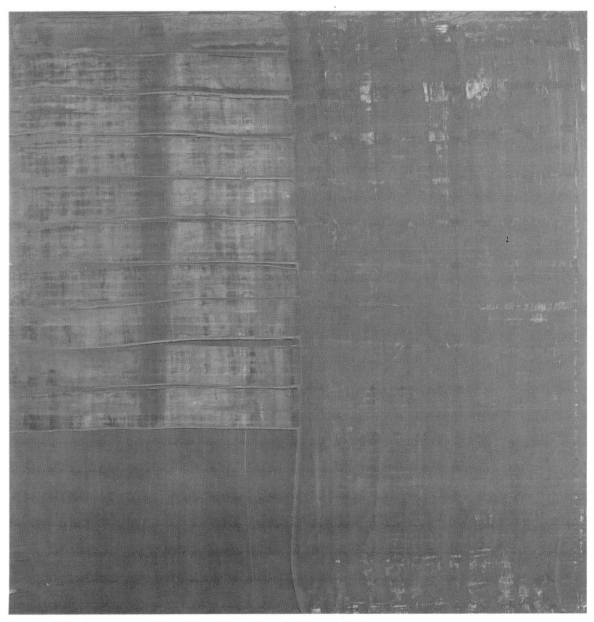

Untitled, 1980, oil on canvas, 39½ × 42 in. (100 × 107 cm.). Collection Judd
Hammack, Santa Monica; courtesy Bertha Urdang Gallery, New York.

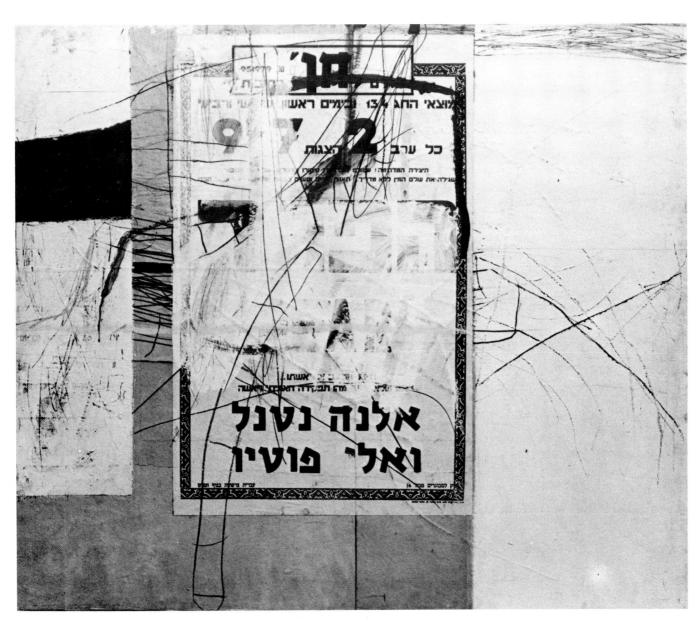

Composition, 1968, mixed media on plywood, 47¾ × 55 in. (120 × 140 cm.).
Collection The Tel Aviv Museum.

RAFFI LAVIE

Born 1937 Tel Aviv;
lives in Tel Aviv

studied painting with the academic painter Ludwig Moos, then with sculptor Kosso Elul, at State Art Teachers Training College, Tel Aviv. *1960s* follows direction established by artists Arie Aroch and Aviva Uri to place unrestrained scribbling on or into raw paint. *1966* among founders of 10+ group of young artists reacting against New Horizons influence; utilizing precisely calculated, spontaneously generated elements. *1970s* teaches at State Art Teachers Training College, Ramat Gan; influences many young artists like Tamar Getter, Michal Na'aman, and Benni Efrat.

Individual Exhibitions
Rina Gallery, Jerusalem, 1960.
Gordon Gallery, Tel Aviv, "Experiments in Sculpture and Objects, Sketch for a Film," January 1970.
Gordon Gallery, "Paintings," December 1970-January 1971.
Gordon Gallery, Tel Aviv, 1972.
The Israel Museum, Jerusalem, "Raffi Lavie: 21 Paintings, 1962-1972," January-February 1973.
Gordon Gallery, Tel Aviv, "New Paintings," February 1974.
Gordon Gallery, Tel Aviv, January-February 1975.
Sara Gilat Gallery, Jerusalem, 1977.
Gordon Gallery, Tel Aviv, April-May 1978.
Debel Gallery, Ein Kerem, "Early Works 1960-61," November-December 1978.
Gordon Gallery, Tel Aviv, "The Recent Works," May 1979.
The Tel Aviv Museum, "A Selection of Paintings," 1979.

Major Group Exhibitions
Museum of Art (Mishkan Leomanut), Ein Harod, "New Horizons," 1963.
Bezalel National Museum, Jerusalem, "Today's Forms," April 1963.
Stedelijk Museum, Amsterdam, "Schrift und Bild [Writing and Pictures]," 1963.
The Tel Aviv Museum, "Tatzpit," April-May 1964.
America-Israel Cultural Foundation and the International Council of The Museum of Modern Art, New York, "Art Israel: 26 Painters and Sculptors," 1964.
The Israel Museum, Jerusalem, "Trends in Israeli Art," 1965.
Maskit, Tel Aviv, "Painting on Textiles," 1965.
Artists' House, Tel Aviv, "10+," February 1966.
University Art Gallery, State University of New York at Albany, "A Leap of Faith," 1969.
Ateneul Roman, Bucharest, Romania, "Expozitia de pictura contemporana din Israel," 1969.
High Museum of Art, Atlanta, "Israel on Paper," 1970.
The Tel Aviv Museum, "Israeli Art: Painting, Sculpture, Graphic Works," 1971.
The Israel Museum, Jerusalem, "From Landscape to Abstraction . . . ," 1972.
Museum of Modern Art, Haifa, "Self-Portrait in Israel Art," 1973.
Louisiana Museum, Copenhagen, "10 Kunstnere fra Israel [10 Israeli Artists]," 1977.
Canada-Israel Cultural Foundation, Ottawa, "Israel Art Festival . . . ," 1978.
The Tel Aviv Museum, "Israel Art 30+30," 1978.
The Tel Aviv Museum, "Artist and Society . . . ," 1978.
The Israel Museum, Jerusalem, "From the Collection of Dr. Moshe Spitzer, Jerusalem," March 1978. Catalogue text by Moshe Spitzer, no. 172.

Selected Bibliography
Articles and General References
Tammuz, Benjamin, and Wykes-Joyce, Max, eds. *Art in Israel*. Tel Aviv: Massada, 1965. P. 43.
Spencer, Charles. "Israel, the Surrealist and Fantastic Factor in the New Art." *Studio International* 174 (October 1967):162.
Encyclopaedia Judaica. Jerusalem: Keter Publishing Ltd., 1972.
Shechori, Ran. *Art in Israel*. New York: Schocken Books, 1976. Pp. 33, 195.
Baruch, Adam. "Young Israeli Artists. Part II: The Artists." *Studio International* 193 (March-April 1977):143.
Goldfine, Gil. "Alternative Path." *Jerusalem Post Magazine*, April 29, 1978.
Ronnen, Meir. "An Ancient Land's Newborn Art." *Art News* 77 (May 1978):48, 49, 51.
Debel, Ruth. "What Does It Mean To Be an Israeli Artist?" *Art News* 77 (May 1978):55.
Goldfine, Gil. "Raffi at Midway." *Jerusalem Post Magazine*. December 21, 1979, P. 20.

MORDECAI LEVANON

Born 1901 Transylvania;
died 1968 Jerusalem

1921 emigrates to Palestine. *1922* studies briefly at Bezalel School of Arts and Crafts; works as agricultural laborer. *1925* studies with Yitzhak Frenkel at Histadrut Studio of Painting. *1938* settles in Jerusalem; paints landscapes in watercolor for about ten years. *1938, 1948, 1960* Dizengoff Prize. *1940* Struck Prize. *1948, 1968* Jerusalem Prize. *1963-68* works in Jerusalem and Safed; paints both cities as mystical lands of the spirit in expressionistic style and shimmering color.

Individual Exhibitions
Hess Gallery, Tel Aviv, 1936.
Katz Gallery, Tel Aviv, 1939, 1946.
Pevsner House, Haifa, 1940.
Habimah House Gallery, Tel Aviv, 1944.
Artists' House, Haifa, 1948.
The Tel Aviv Museum, 1949.
Artists' House, Jerusalem, "Retrospective", 1950.
San Marco Galleria D'Art, Rome, "Levanon", 1950-51.
Artists' Guild, Haifa, 1953.
Artists' House, Tel Aviv, 1953.
Chemerinsky Gallery, Tel Aviv, 1954.
Traklin Gallery, Haifa, 1956.
Nora Gallery, Jerusalem, 1957.
Rina Gallery, Jerusalem, 1957, 1960.
The Tel Aviv Museum, 1958.
Katz Gallery, Tel Aviv, "Watercolors", 1958.
Bezalel National Museum, Jerusalem, 1960.
Rivere Gallery, Paris, 1960.
De Beer Gallery, Amsterdam, 1960.
The Tel Aviv Museum, Dizengoff House, 1961.
Rosner Gallery, Tel Aviv, 1966.
Museum of Art (Mishkan Leomanut), Ein Harod, 1966.
Museum of Modern Art, Haifa, 1966.
The Israel Museum, Jerusalem, 1968. Catalogue text by Miriam Tal.
Artists' House, Jerusalem, "Mordecai Levanon," 1968.

The Tel Aviv Museum, Helena Rubinstein Pavilion, "Mordecai Levanon 1901-1968: Oil Paintings-Gouaches-Watercolors-Drawings," 1971. Catalogue Introduction by Haim Gamzu.

Major Group Exhibitions
Venice, "XXI Biennale," 1938.
New York World's Fair, Israel Pavilion, 1939.
Venice, "XXV Biennale," 1949-50.
São Paulo, Brazil, "IV Bienal," 1957.
Bezalel National Museum, Jerusalem, "Israel: Watercolors, Drawings, Graphics, 1948-1958," 1958.
Venice, "XXIX Biennale," 1958.
Bezalel National Museum, Jerusalem, 1963.
Monaco, "International Exhibition of Modern Art," 1965.
Gemeentemuseum Arnhem, Holland, "Schilders uit Israël [Painters of Israel]," 1965.
Rijksmuseum, Amsterdam, "Aharon Giladi, Aharon Kahana, Yehiel Krize, Mordecai Levanon, Zvi Mairovich," 1969-70. Circulated to Twenthe, Enschede, The Netherlands.
The Israel Museum, Jerusalem, "Expressionism in Eretz-Israel in the Thirties . . . ," 1971.
The Tel Aviv Museum, "Israeli Art: Painting, Sculpture, Graphic Works," 1971.

The Israel Museum, Jerusalem, "From Landscape to Abstraction . . . ," 1972.
Museum of Modern Art, Haifa, "Self-Portrait in Israel Art," 1973.

Selected Bibliography
Monograph
Giladi, David. *Levanon: Artist and His Work.* Jerusalem: E.M. Levanon, 1970.

Articles and General References
Newman, Elias. *Art in Palestine.* New York: Siebel, 1939 Pp. 64-65.
Gamzu, Haim. *Painting and Sculpture in Israel.* Tel Aviv: Dvir, 1958. P. 35.
Berman, Reuven. "New Gallery Opens with Levanon." *Jerusalem Post*, November 8. 1963.
Ronnen, Meir. "Levanon's Soul Cities." *Jerusalem Post* 1, August 2, 1968.
———. "Mordecai Levanon." *Israel Magazine* 1, no. 7 (1968):70-71.
Tal, Miriam. "Israel Art Comes of Age." *Ariel* 29 (Winter 1971):9.
Encyclopaedia Judaica. Jerusalem: Keter Publishing Ltd., 1972.
Schechori, Ran. *Art in Israel.* New York: Schocken Books, 1976. P. 195.

Rahmani, L. Y. *The Museums of Israel.* London: Secker and Warburg 1976. P. 134, n. 162.
Ronnen, Meir. "An Ancient Land's Newborn Art." *Art News* 77 (May 1978):48.

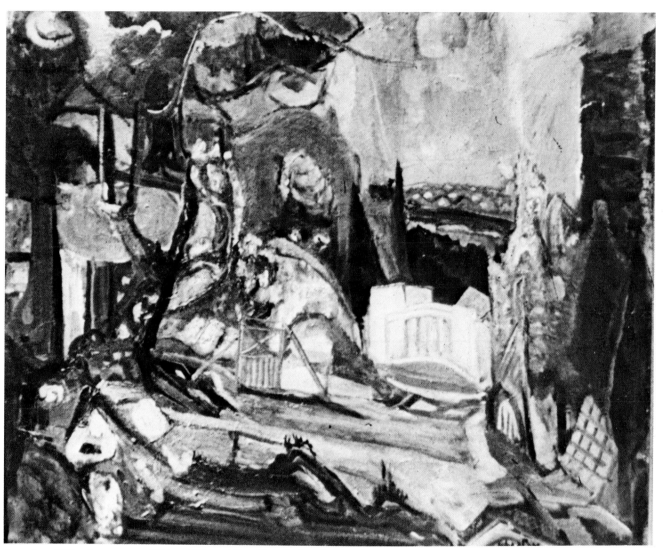

Jerusalem, 1956, oil on canvas, 25½ × 30¼ in. (65 × 77 cm.). Lent by Engel Gallery, Jerusalem.

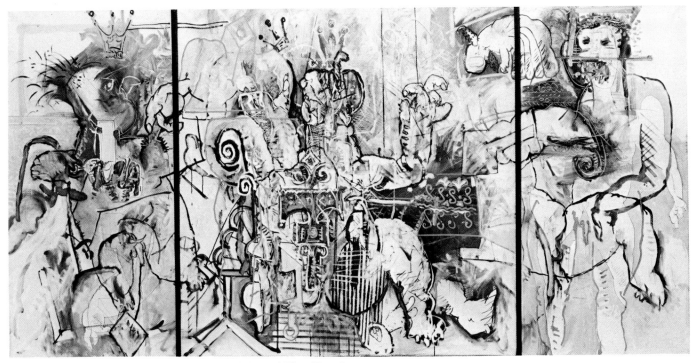

Triptych, 1967, oil on canvas, *left and right*, 59 × 29½ in. (150 × 75 cm.),
center, 59 × 59 in. (150 × 150 cm.). Collection The Israel Museum, Jerusalem.

URI LIFSHITZ

Born 1936 Kibbutz Givat Hashlosha,
Palestine; lives in Jaffa

self-taught painter who exhibited Abstract Expressionist works with New Horizons, Tatzpit, and 10+ groups. *1964* first figurative paintings are filled with contorted and grotesque figures expressed through nervous, sensitive line. *1965* awarded youth prize in exhibition of young Israeli artists. *1966* Marc Chagall Fellowship from Erasmus Fund Prize; Kolb Prize of Tel Aviv Museum. *1971, 1973, 1978* works in Spain.

Individual Exhibitions

Ekked Gallery, Tel Aviv, 1961.
220 Gallery, Tel Aviv, 1962, 1963, 1964.
Rina Gallery, Jerusalem, 1965.
Constant Munt Gallery, Amsterdam, 1966.
America-Israel Culture House, New York, "Paintings," January-February 1967.
Gordon Gallery, Tel Aviv, "Recent Works," April 1967.
Gordon Gallery, Tel Aviv, "Recent Works," April-May 1968.
The Israel Museum, "Paintings and Sculpture," March-April 1969. Catalogue text by Yona Fischer.
Bineth Gallery, Tel Aviv, "A Man With A Mirror," July 1969.
Gordon Gallery, Tel Aviv, 1969.
Gordon Gallery, Tel Aviv, "Drawings," September-October 1970.
Goldman Gallery, Haifa, "On Mr. Rabinowitz," November 1970.
Gordon Gallery, Tel Aviv, 1971.
Gordon Gallery, Tel Aviv, "Paintings & Etchings from Spain," January 15-September 19, 1972. Catalogue text by Adam Baruch.

The Tel Aviv Museum, "Paintings, Drawings, Etchings," May 1974. Catalogue Foreword by Haim Gamzu.
Bineth Gallery, Tel Aviv, "Etchings," May 1974.
Gordon Gallery, Tel Aviv, "Recent Works," 1976.
Gordon Gallery, Tel Aviv, "Back From Spain," 1978.
Museum of Art (Mishkan Leomanut), Ein Harod, "Paintings and Etchings," 1978.
Gallery 13½, Old Jaffa, "Uri Lifshitz: Drawing," July 1978.
Givon Fine Art, Tel Aviv, "My Family," 1979.
Givon Fine Art, Tel Aviv, "From Sam's House," May-June 1980.

Major Group Exhibitions

Musée du Petit Palais, Paris, "Israël à travers les âges," 1968.
University Art Gallery, State University of New York at Albany, "A Leap of Faith," 1969.
Whitechapel Art Gallery, London, "Agam, Lifshitz, Zaritsky: Three Israeli Artists," 1969-70.
High Museum of Art, Atlanta, "Israel on Paper," 1970.
The Tel Aviv Museum, "Israeli Art: Painting, Sculpture, Graphic Works," 1971.
Memorial Art Gallery of The University of Rochester, New York, "Looking Up . . . ," 1971.
São Paulo, Brazil, "XI Bienal," 1971.
The Israel Museum, Jerusalem, "From Landscape to Abstraction . . . ," 1972.
Maurice Spertus Museum of Judaica, Chicago, "Israeli Art in Chicago Collections," March 1974.
Tel Aviv University, University Gallery, "Graphic Works by 30 Israeli Artists," 1978.
The Tel Aviv Museum, "Israel Art 30+30," 1978.
The Tel Aviv Museum, "Artist and Society . . . ," 1978.

Selected Bibliography

Articles and General References
Spencer, Charles. "Israel, The Surrealist and Fantastic Factor in the New Art." *Studio International* 174 (October 1967):162.
Tal, Miriam. "Israel Art Comes of Age." *Ariel* 29 (Winter 1971):17.
Encyclopaedia Judaica. Jerusalem: Keter Publishing Ltd., 1972.
Shechori, Ran. *Art in Israel*. New York: Schocken Books, 1976. Pp. 34, 196.
Rahmani, L. Y. *The Museums of Israel*. London: Secker and Warburg, 1976. P. 140, n. 181.
Goldfine, Gil. "Lifshitz in Retreat." *Jerusalem Post Magazine*, July 14, 1978. P. 21.
———. "Uri Lifshitz on the Rebound." *Jerusalem Post Magazine*, June 6, 1980. P. 20.

ZVI MAIROVICH

Born 1911 Krosno, Poland;
died 1974 Haifa

1929 studies in Berlin with Karl Hofer at Institute for Jewish Studies
and Akademie der Kunst in Berlin. *1934* settles in Haifa.
1942 lives with Arie Aroch in Zichron Yaacov where they paint
together. *1942, 1951, 1961* Dizengoff Prize. *1948* among founders
of New Horizons group which he left in 1959. *1949-50* lives in
Paris. *1953* comes to abstract language through landscape.
1966 first Panda paintings marked by rich color and rhythmic line.

Individual Exhibitions
Galerie du Siècle, Paris, 1950.
Parma Gallery, New York,
December 1956.
Antoine Gallery, Los Angeles,
1957.
Museum of Modern Art, Haifa,
"Gouaches," Winter 1961.
Santee Landweer Gallery,
Amsterdam, 1962, 1964.
The Israel Museum, Jerusalem,
1976. Catalogue text by Yona
Fischer.
Gordon Gallery, Tel Aviv,
December 1976.
The Tel Aviv Museum,
September 19-November 27,
1979. Catalogue Introduction
by Marc Scheps; biographical
notes by Yhudit Hendel.
Gallery Gimel, Jerusalem,
"Pandas", February 29-March
17, 1980.

Major Group Exhibitions
The Tel Aviv Museum,
Habimah House, "Group of
Seven," 1947.
The Tel Aviv Museum, "New
Horizons," 1948, 1949, 1950,
1952, 1953, 1955.
Paris, "Salon de Mai," 1950,
1959.
Paris, "Salon d'Automne," 1950,
1959.
São Paulo, Brazil, "II Bienal,"
1953.
Museu de Arte Moderna, Rio de
Janeiro, "Modern Artists in
Israel," 1954.

Venice, "XXVIII Biennale,"
1956.
Venice, "XXIX Biennale," 1958.
Arts Council of Great Britain,
London, "Modern Israeli
Painting," 1958.
Kunstmuseum, Bern,
Switzerland, "Modern Painting
from Israel," 1958.
São Paulo, Brazil, "V Bienal,"
1959.
Musée National d'Art Moderne,
Paris, "L'art Israélien
contemporain," 1960.
Museu de Arte Moderna de São
Paulo, Brazil, "Twenty Israeli
Artists." 1960.
Museu de Arte Moderna de São
Paulo, Brazil, "Twenty Israeli
Artists," 1960.
Venice, "XXXI Biennale," 1962.
Galerie Charpentier, École de
Paris, "Peintres Israéliens,"
1963.
Museum of Art (Mishkan
Leomanut), Ein Harod, "New
Horizons," 1963.
America-Israel Cultural
Foundation and the
International Council of the
Museum of Modern Art, New
York, "Art Israel: 26 Painters
and Sculptors," 1964.
The Israel Museum, Jerusalem,
"Trends in Israeli Art," 1965.
Gemeentemuseum Arnhem,
Holland, "Schilders uit Israël,
[Painters of Israel]" 1965.
The Israel Museum, Jerusalem,
"New Horizons," 1966.

University Art Gallery, State
University of New York at
Albany, "A Leap of Faith,"
1969.
Rijksmuseum, Amsterdam,
"Aharon Giladi, Aharon
Kahana, Yehiel Krize, Mordecai
Levanon, Zvi Mairovich,"
1969-70. Circulated to
Twenthe, Enschede,
Netherlands.
High Museum of Art, Atlanta,
"Israel on Paper," 1970.
Das Städtische Museum,
Wiesbaden, "20 Israelische
Kunstler," 1971.
The Tel Aviv Museum, "Israeli
Art: Painting, Sculpture,
Graphic Works," 1971.
Museum of Modern Art, Haifa,
"Self-Portrait in Israel Art,"
1973.
Yad Lebanim, Petach Tikva,
Israel, "The Five," 1973.
Maurice Spertus Museum of
Judaica, Chicago, "Israeli Art
in Chicago Collections," 1974.
Canada-Israel Cultural
Foundation, Ottawa, "Israel
Art Festival . . . ," 1978.
The Tel Aviv Museum, "Israel
Art 30+30," 1978.
Museum of Modern Art, Haifa,
"30 Years to New Horizons,
1948-1978," 1979.

Selected Bibliography

Articles and General References
Coates, Robert M. "Israel's
Young Artists." *New Yorker*,
December 8, 1956.
Gamzu, Haim. *Painting and
Sculpture in Israel*. Tel Aviv:
Dvir, 1958. P. 51.
Wilkinson, Sarah. "Israelis Go
Abstract — Mairovich
Outstanding." *Jerusalem Post*,
January 1, 1959.
Tammuz, Benjamin, and
Wykes-Joyce, Max, eds. *Art in
Israel*. Tel Aviv: Massada, 1965.
P. 34.
Tal, Miriam. "Israel Art Comes
of Age." *Ariel* 29 (Winter
1971):14.
Encyclopaedia Judaica. Jerusalem:
Keter Publishing Ltd., 1972.
Ronnen, Meir. "Personal
Mythologies." *Jerusalem Post*,
April 4, 1976.
Shechori, Ran. *Art in Israel*.
New York: Schocken Books,
1976. Pp. 23, 196.
Rahmani, L. Y. *The Museums of
Israel*. London: Secker and
Warburg, 1976. P. 137, n. 170.
Ronnen, Meir. "An Ancient
Land's Newborn Art." *Art
News* 77 (May 1978):45.

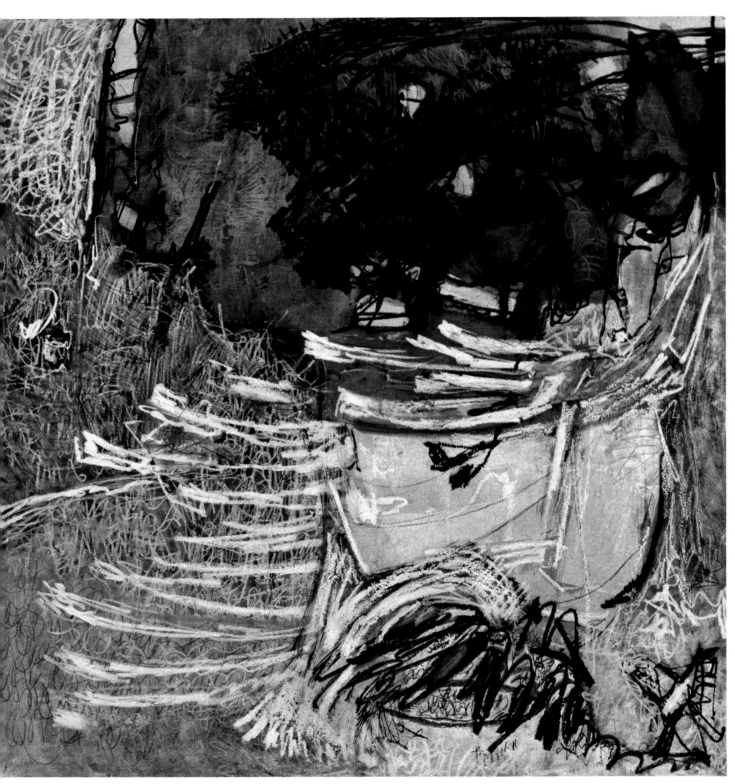

Blue Cloud over a Brown Mountain, 1969, Panda (oil, oil pastel, pencil, graphite, and collage), 39 × 39 in. (99 × 99 cm.). Collection Yhudit Hendel, Haifa.

JOSHUA NEUSTEIN

Born 1940 Danzig, Poland;
lives in New York and Jerusalem

1940-44 refugee in Europe. *1951-56* studies at Yeshiva Rabbi Jacob Joseph, New York. *1959-61* studies at Art Students League, New York. *1960-63* studies at Pratt Institute, Brooklyn. *1961* B.A. from the College of the City of New York. *1964* settles in Israel. *1964-68* studies with Zvi Mairovich and Arie Aroch in Jerusalem. *1971* Jerusalem Prize. *1973* Sandberg Prize. *1974* teaches at Bezalel Academy of Art. *1975* editor of *Art en Garde*, Jerusalem; performs certain "operations" on materials (tearing, folding, removing, replacing, marking, spraying) using layers of edges to create texture, depth, and shadow in compositions which fold out from the wall.

Individual Exhibitions
Rina Gallery, Jerusalem, 1966.
Artists' House, Jerusalem, "Boots," 1969.
The Israel Museum, Jerusalem, "Jerusalem River Project," October 13-27, 1970.
The Tel Aviv Museum, "Road-Piece," September 26-November 5, 1970.
Gallery House, London, 1971.
Yodfat Gallery, Jerusalem, 1972, 1973.
Rina Gallery, New York, "Drawings 1970-1973," October 1973. Catalogue Introduction by Yona Fischer.
Yodfat Gallery, Tel Aviv, "The Sound of Pine Cones Opening in the Sun," 1974.
Golan Heights, Israel, "Territorial Imperative," 1975-76. Circulated to Krusa, Denmark, 1976-77; Belfast, Ireland, 1978.
Pollock Gallery, Toronto, 1977.
Gallery Birch, Copenhagen, 1977.
The Tel Aviv Museum, Summer 1977. Catalogue text by Robert Pincus-Witten.
Velar Gallery, Carnegie-Mellon University, Pittsburgh, "Recent Works," 1978. Catalogue text by Jeremy Gilbert-Rolfe.
Mary Boone Gallery, New York, 1979.
Givon Fine Arts, Tel Aviv, 1980.
Dayton, Ohio, "Quintessence," April 1980. Public sculpture.

Major Group Exhibitions
High Museum of Art, Atlanta, "Israel on Paper," 1970.
The Israel Museum, Jerusalem, "Concepts + Information," 1971.

Museum of Fine Arts, Boston, "Earth, Air, Fire, Water: Elements of Art," 1971.
Museum of Modern Art, Oxford, "Travel Art, " September 1971. Catalogue text by Jacque Caumont.
Memorial Art Gallery of the University of Rochester, New York, "Looking Up . . . ," 1971.
The Israel Museum, Jerusalem, "From Landscape to Abstraction . . . ," 1972.
Gallery House, London, "Affadavit . . . ," November 1972.
Kassel, Germany, "Documenta V," 1972.
Museum of Modern Art, Haifa, "Self-Portrait in Israel Art," 1973.
Ministry of Exterior, Jerusalem, "Works on Paper . . . ," 1973-74.
The Israel Museum, Jerusalem, "Beyond Drawing," 1974.
Artists' House, Tel Aviv, "Performance '76," June 20-25, 1976. Catalogue text by Gideon Ofrat.
Worcester Art Museum, Massachusetts, "Three Israeli Artists: Gross, Neustein, Kupferman," 1975.
Artists' House, Tel Aviv, "Words," 1976. Catalogue Introduction by Miriam Tuvia.
The Israel Museum, Jerusalem, "Photography Triennale," 1976.
Louisiana Museum, Copenhagen, "10 Kunstnere fra Israel [10 Israeli Artists]," 1977.
Tel Aviv University, University Gallery, "Graphic Works by 30 Israeli Artists," 1978.

The Tel Aviv Museum, "Israel Art 30+30," 1978.
Ohio State University Gallery of Fine Art, Columbus, "Sensible Explorations," February 7-May 15, 1978.
Illinois Bell, Chicago, "Printmaking in Israel Today," 1978.
Uri and Rami Nechushtan Museum, Kibbutz Ashdot Yaakov, "Location/Duration," 1978.
Los Angeles County Museum of Art, "Seven Artists in Israel, 1948-1978," 1978-79.
Tokyo, "Print Biennale," 1979.
The Israel Museum, Jerusalem, Bronx Museum of the Arts, "Marking Black," 1980. Catalogue text by Jeanette Ingberman and Madeleine Burnside.
Tel-Hai College Art Institute, "Tel-Hai 80, a Contemporary Art Meeting," September 1980.
Albright-Knox Art Gallery, Buffalo, "With Paper, About Paper," September 12-October 26, 1980. Catalogue text by Charlotta Kotik.
Münchner Stadtmuseum, Munich, "Israelische Künstler Heute [Israeli Artists Today]," 1980.

Selected Bibliography
Articles and General References
Ronnen, Meir. "The Happening That Didn't Happen." *Jerusalem Post*, October 19, 1969.
Fischer, Yona. "New Trends among Young Israeli Artists." *Studio International* 183 (March 1972):122-25.

Neustein, Joshua. "I Remember George Grosz." *Flash Art* No. 37 (November 1972):22.
Gilbert-Rolfe, Jeremy. "Review." *Artforum* 12 (April 1974):72.
Frackman, Noel. "Joshua Neustein." *Arts Magazine* 49 (June 1975):33-34.
Pincus-Witten, Robert. "The Sons of Light: An Observer's Notes in Jerusalem." *Arts Magazine* 50 (September 1975):64-74.
———. "Six Propositions on Jewish Art." *Arts Magazine* 50 (September 1975):66-69.
Goldfine, Gil. "Neustein Now." *Jerusalem Post*, August 5, 1977.
Pincus-Witten, Robert. "The Neustein Papers." *Arts Magazine* 52 (October 1977):102-15.
Naylor, Colin, and P-Orridge, Genesis, eds. *Contemporary Artists*. London: St. James Press, 1977. Pp. 693-94.
Ronnen, Meir. "Report from Jerusalem." *Art News* 77 (January 1978):129.
———. "An Ancient Land's Newborn Art." *Art News* 77 (May 1978):49, 50.
Gilbert-Rolfe, Jeremy. "Static, Fragile, Massive, Gray, Torn, Impermanent." *Artforum* 16 (Summer 1978): 54-56.
Larsen, Susan C. "The New Prominence of Israeli Art." *Art News* 78 (March 1979):92, 93.
Kasher, Steven. "Seven Artists of Israel." *Artforum* 17 (Summer 1979):53-54.
Ronnen, Meir. "Grappling with Ambivalent Feelings." *Art News* 79 (Summer 1980):216-18.

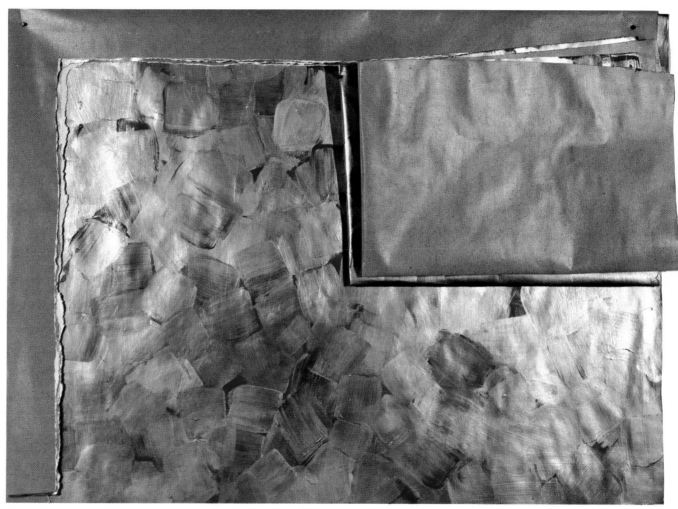

Second Bully Straps, 1979, acrylic on paper, 52 × 74 in. (132 × 188 cm.).
Collection Albright-Knox Art Gallery, Buffalo, New York.

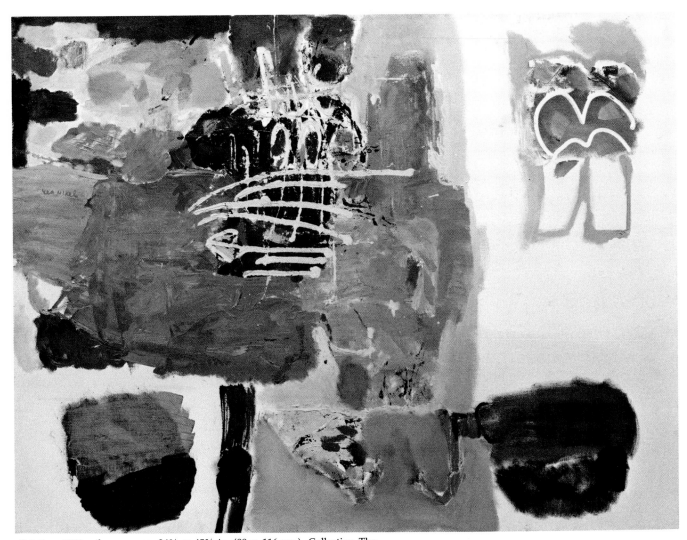

Painting, 1969, oil on canvas, 34²/₃ × 45²/₃ in. (88 × 116 cm.). Collection The Tel Aviv Museum.

LEA NIKEL

Born 1918, Zhitomir, Ukraine;
lives in Tel Aviv

1920 emigrates with family to Palestine. *1940s* studies in Tel Aviv
with Haim Gliksberg, Avigdor Stematsky, and Yeheskel
Streichman. *1950-61* works in Paris in bold, abstract style
dominated by rich, vibrant, emphatic color. *1961* works in Safed,
Ashdod, and Tel Aviv. *1963-64* lives in New York. *1968-70*
lives in Rome. *1972* Sandberg Prize. *1975-78* lives in New York.

Individual Exhibitions
Chemerinsky Gallery, Tel Aviv, 1954.
Galerie Espace, Amsterdam, 1957.
Galerie Colette Allendy, Paris, 1957.
Galleria Blu, Milan, 1958.
Galleria Salita, Rome, 1958.
Galerie Espace, Amsterdam, 1959.
Bezalel National Museum, Jerusalem, 1961.
The Tel Aviv Museum, 1961.
Chemerinsky Gallery, Tel Aviv, 1965.
Museum of Modern Art, Haifa, 1966.
Gordon Gallery, Tel Aviv, 1967.
Chemerinsky Gallery, Tel Aviv, 1970.
The Tel Aviv Museum, 1973.
America-Israel Cultural Foundation, New York, 1975.
Sara Gilat Gallery, Jerusalem, 1978, 1979, 1980.

Major Group Exhibitions
Ben-Uri Gallery, London, 1958.
Bezalel National Museum, Jerusalem, "Twelve Artists," 1958.
Paris, "I Biennale," 1959.
America-Israel Cultural Foundation, and the International Council of The Museum of Modern Art, New York, "Art Israel: 26 Painters and Sculptors," 1964.
Venice, "XXXII Biennale," 1964.
The Israel Museum, Jerusalem, "Trends in Israeli Art," 1965.
University Art Gallery, State University of New York at Albany, "A Leap of Faith," 1969.
Memorial Art Gallery of The University of Rochester, New York, "Looking Up . . . ," 1971.
The Tel Aviv Museum, "Israeli Art: Painting, Sculpture, Graphic Works," 1971.
Museum of Modern Art, Haifa, "Self-Portrait in Israel Art," 1973.
Yad Lebanim, Petach Tikva, Israel, "The Five," 1973.
Tel Aviv University, University Gallery, "Graphic Works by 30 Israeli Artists," 1978.
Canada-Israel Cultural Foundation, Ottawa, "Israel Art Festival . . . ," 1978.
The Tel Aviv Museum, "Artist's Choice," 1979.
South African National Gallery, Capetown, 1980.
Pretoria Art Museum, 1980.

Selected Bibliography

Articles and General References
Tammuz, Benjamin, and Wykes-Joyce, Max, eds. *Art in Israel*. Tel Aviv: Massada, 1965. P. 42.
Tal, Miriam. "Lea Nikel." *Ariel* (Winter 1967-68):71-73.
———. "Israel Art Comes of Age." *Ariel* 29 (Winter 1971):14.
Encyclopaedia Judaica. Jerusalem: Keter Publishing Ltd., 1972.
Goldfine, Gil. "Nikel the Colourist." *Jerusalem Post*, May 18, 1973.
Shechori, Ran. *Art in Israel*. New York: Schocken Books, 1976. Pp. 26, 196.
Rahmani, L. Y. *The Museums of Israel*. London: Secker and Warburg, 1976. P. 137, n. 172.
Ronnen, Meir. "An Ancient Land's Newborn Art." *Art News* 77 (May 1978):48.
Breitberg, Sara. "Women's Art in Israel." *Ariel* 49 (1979):57-58.
Ronnen, Meir. "Hits and Missings." *Jerusalem Post*, February 22, 1980.

115

ISRAEL PALDI

Born (Feldman) 1892 Berdyansk, Ukraine;
died 1979 Tel Aviv

1900-1909 lives in Switzerland. *1909* emigrates to Palestine; attends
Bezalel School of Arts and Crafts; works as agricultural laborer.
1911-14 studies at Staatliche Kunstakademie, Munich. *1914* lives in
Turkey. *1920* returns to Palestine; teaches and paints in early
modern style. *1929, 1931* in Paris. *1936* paints "Oriental" genre
scenes. *1943, 1957* Dizengoff Prize. *ca. 1950* makes abstract reliefs
and assemblages. *1958-60* works in Paris. *mid-1960s* returns to
figuration in personal, naive style.

Individual Exhibitions
Habimah House, Tel Aviv, 1943.
Habimah House, Tel Aviv, 1948.
Katz Gallery, Tel Aviv, 1950.
Katz Gallery, Tel Aviv, 1951.
Katz Gallery, Tel Aviv, 1953.
Chemerinsky Gallery, Tel Aviv,
1954.
The Tel Aviv Museum, 1955.
Katz Gallery, Tel Aviv, 1959.
The Tel Aviv Museum, 1961.
The Israel Museum, Jerusalem,
1967.
Bineth Gallery, Tel Aviv, 1970.
The Tel Aviv Museum, 1972.
Goldman Gallery, Haifa, 1974.

Major Group Exhibitions
Migdal David (Tower of David),
Jerusalem, 1921.
Hebrew Artists' Association,
Jerusalem, 1922.
Migdal David (Tower of David),
Jerusalem, 1924.
Ohel, Tel Aviv, "Modern Art
Exhibition," 1926, 1927.
Massad, Tel Aviv, 1929.
São Paulo, Brazil, "IV Bienal,"
1957.
The Tel Aviv Museum,
"Modern Israel Art in its
Beginnings 1920-30," 1957.
Venice, "XXIX Biennale," 1958.
The Israel Museum, Jerusalem,
"Trends in Israeli Art," 1965.
The Israel Museum, Jerusalem,
"Migdal David . . . ," 1968.
The Tel Aviv Museum, "Israeli
Art: Painting, Sculpture,
Graphic Works," 1971.
The Israel Museum, Jerusalem,
"Expressionism in Eretz-Israel
in the Thirties . . . ," 1971.
Museum of Modern Art, Haifa,
"Self-Portrait in Israel Art,"
1973.
The Tel Aviv Museum, "Israel
Art 30+30," July 25, 1978.

Selected Bibliography
Articles and General References
Schack, William. "Our Painters.
Israel Paldi: Sincere and
Strong." *New Palestine*, April
20, 1928.
———. "Art in Modern
Palestine." *Arts* [Brooklyn,
New York] 14 (October 1928):
211-12.
Gamzu, Haim. *Painting and
Sculpture in Israel*. Tel Aviv:
Dvir, 1958. P. 53.
Tammuz, Benjamin, and
Wykes-Joyce, Max, eds. *Art in
Israel*. Tel Aviv: Massada, 1965.
Pp. 18, 20, 21, 28, 40.
Tal, Miriam. "Israel Art Comes
of Age." *Ariel* 29 (Winter
1971):15.
Berman, Reuven. "Israel Paldi:
Genre, Abstraction, Fantasy."
Jerusalem Post, March 3, 1972.
Barzel, Amnon. "Paldi." *Israel
Magazine* 5 (August 1974):41-45.
Encyclopaedia Judaica. Jerusalem:
Keter Publishing Ltd., 1972.
Shechori, Ran. *Art in Israel*.
New York: Schocken Books,
1976. P. 197.
Rahmani, L. Y. *The Museums of
Israel*. London: Secker and
Warburg, 1976. P. 132, n. 156.

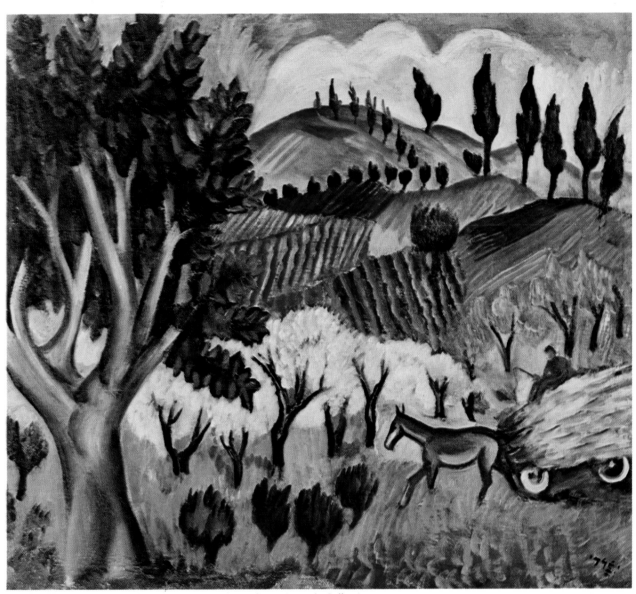

Jerusalem Landscape, 1928, oil on canvas, 24 × 30 in. (61 × 76 cm.). Collection
The Israel Museum, Jerusalem.

117

REUVEN RUBIN

Born 1893 Galatz, Romania;
died 1974 Caesarea

Photograph of Reuvin Rubin
© Arnold Newman.

1912 first visit to Jerusalem, attends Bezalel School of Arts and Crafts. *1913-14* studies at École des Beaux-Arts and Academie Colarossi, Paris. *1916-19* returns to Romania; works in Czernowitz. *1920* first visit to New York. *1922* establishes studio in Tel Aviv. *1924* chairman of Association of Painters and Sculptors of Palestine. *1928, 1930* visits New York. *1940-45* works in New York. *1948* in Tel Aviv; designs sets and costumes for Habimah and Ohel theaters; appointed Minister Plenipotentiary to Romania. *1950* returns to Israel from Romania; direct and representational paintings in romantic, pastoral style, convey deep affection for land and people. *1960s* travels and exhibits in United States and Europe. *1966* executes mural *Story of Galilee* for Knesset. *1970* Israel Prize.

Individual Exhibitions

Anderson Gallery, New York, 1921 (sponsored by Alfred Stieglitz).
Migdal David (Tower of David), Jerusalem, 1924.
Tooth Gallery, London, 1928, 1938.
The Tel Aviv Museum, 1932.
The Tel Aviv Museum, "Retrospective," 1947, 1955.
Grace Borgenicht Gallery, New York, "Paintings," May 1953; "Drawings," December 1953.
Hatfield Galleries, Los Angeles, 1954.
Mint Museum of Art, Charlotte, North Carolina, 1954.
Parthenon, Centennial Park, Nashville, Tennessee, 1954.
O'Hana Gallery, London, 1957.
Wildenstein & Co., Inc., New York, "Retrospective," 1962.
Hatfield Galleries, Los Angeles, "Retrospective," 1962.
Rosenquist Gallery, Tucson, 1962.
The Israel Museum, Jerusalem, "Retrospective," 1966. Circulated to The Tel Aviv Museum.
Galerie Motte, Geneva, 1966.
Norton Gallery of Art, Palm Beach, Florida, 1967.

Major Group Exhibitions

Bezalel National Museum, Jerusalem, 1938.
The Museum of Modern Art, New York, "Twentieth-Century Portraits," 1942.
Venice, "XXVI Biennale," 1952.

Institute of Contemporary Art, Boston, "Seven Painters of Israel," 1953.
The Tel Aviv Museum, "Modern Israel Art in its Beginnings 1920-1930," 1957.
Arts Council of Great Britain, London, "Modern Israeli Paintings," 1958.
Bezalel National Museum, Jerusalem, "Israel: Watercolors, Drawings, Graphics, 1948-1958," 1958.
Musée National d'Art Moderne, Paris, "L'art Israélien contemporain," 1960.
The Israel Museum, Jerusalem, "Trends in Israeli Art," 1965.
The Israel Museum, "Migdal David . . . ," 1968.
The Tel Aviv Museum, "Israeli Art: Painting, Sculpture, Graphic Works," 1971.
The Israel Museum, Jerusalem, "From Landscape to Abstraction . . . ," 1972.
Museum of Modern Art, Haifa, "Self-Portrait in Israel Art," 1973.
Maurice Spertus Museum of Judaica, Chicago, "Israeli Art in Chicago Collections," 1974.
The Jewish Museum, New York, "Jewish Experience in the Art of the Twentieth Century," October 16, 1975-January 25, 1976. Catalogue by Avram Kampf.
The Israel Museum, Jerusalem, "A Tribute to Sam Zacks: Selected Paintings, Drawings, and Sculptures from the Sam and Ayala Zacks Collection," Summer 1976. Exhibition catalogue no. 146. Circulated to The Tel Aviv Museum, Autumn 1976.

Tel Aviv University, University Gallery, "Graphic Works by 30 Israeli Artists," 1978.
Canada-Israel Cultural Foundation, Ottawa, "Israel Art Festival . . . ," 1978.
The Tel Aviv Museum, "Israel Art 30+30," 1978.

Selected Bibliography

Monographs
Werner, Alfred. *Rubin*. Tel Aviv: Massada, 1958.
Rubin, Reuven. *My Life, My Art*. New York: Funk and Wagnalls, Sabra Books, 1969.
Wilkinson, Sarah. *Reuven Rubin*. New York: Harry N. Abrams, 1971.
Articles and General References
Newman, Elias. *Art in Palestine*. New York: Siebel, 1939. Pp. 10, 90.
Fineman, Irving. "Rubin: Painter of Peace." *National Jewish Monthly*, June 1941.
Reed, Judith Kaye. "Rubin, Returning to Israel, Holds Exhibition." *Art Digest* 21 (May 1947):15.
St. John, Robert. *Shalom Means Peace*. New York: Doubleday, 1949. Pp. 262-66.
Schwarz, Karl. *Jewish Artists of the 19th and 20th Centuries*. New York: Philosophical Library, 1949. Pp. 258-60.
Plaut, James S. "Seven Painters of Israel." *Carnegie Magazine* 27 (March 1953):86-89.

Schack, William. "Israeli Painting after Twenty-Five Years." *Commentary* 5 (June 1953):593-601.
Coates, Robert M. "Galleries: Rubin." *New Yorker*, June 23, 1953.
Werner, Alfred. "Painting the Glory of Palestine." *Reconstructionist* 22 (June 29, 1956):22-30.
Gainsborough, Ralph. "Portrait of the Artist Rubin." *Art News and Review* 9 (May 1957):3.
Blakestone, Oswell. "Works from Israel." *Art News* 56 (June 1957):15-16.
———. "Israel Artist at the O'Hana." *Apollo* 65 (June 1957):200.
Gamzu, Haim. *Painting and Sculpture in Israel*. Tel Aviv: Dvir, 1958. Pp. 15, 19, 33-34, 38.
Werner, Alfred. "Reuven Rubin at Seventy." *Jewish Heritage* (Fall 1963):33-40.
Tammuz, Benjamin, and Wykes-Joyce, Max, eds. *Art in Israel*. Tel Aviv: Massada, 1965. Pp. 18-21, 23.
Wilkinson, Sarah. "Palette of a Poet." *Ariel* 13 (1966):53-63.
Werner, Alfred. "Reuven Rubin: Pioneer of Israeli Art." *Arts Magazine* 42 (April 1968):47-49.
Ronnen, Meir. "An Ancient Land's Newborn Art." *Art News* 77 (May 1978):45, 48.
Werner, Alfred. "Israeli Art and the Americans." *American Zionist*, May 1978. Pp. 15, 24.

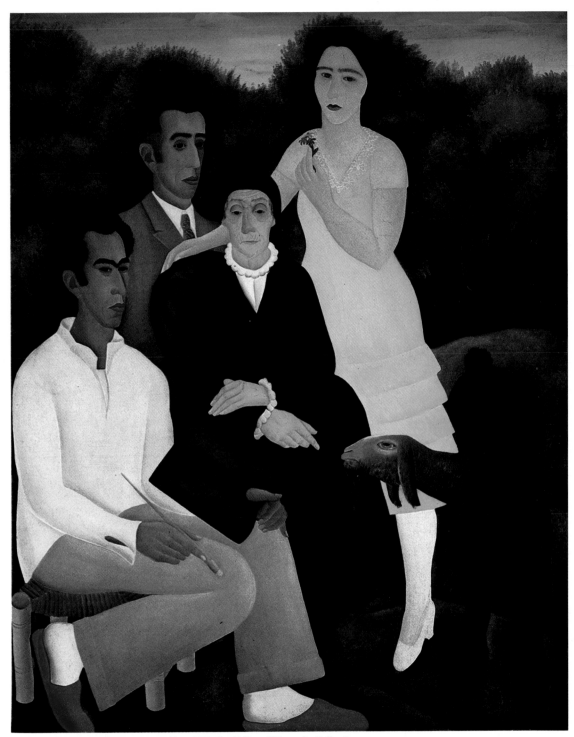

The Family, 1927, oil on canvas, 64 × 50¾ in. (163 × 129 cm.). Collection
The Tel Aviv Museum.

The Chair, 1980, color videotape. Lent by the artist.

BUKY SCHWARTZ

Born 1932 Jerusalem;
lives in New York

1956-58 studies at Avni Art Institute, Tel Aviv. *1958* works with Yitzhak Danziger. *1959-62* studies at St. Martin's School of Art, London; work marked by polychromatic contrasts, gravitational considerations, and interacting forms. *1961-63* participates in sculpture symposia in Germany and Austria. *1961, 1962* Sandberg Prize. *1963* returns from London to Israel; becomes active member of 10+ group; installations include *Pillar of Heroism*, sculpture and gates at Yad Vashem, Jerusalem; stainless steel installation at El Al Israel Airlines. *1965* Dizengoff Prize. *1967* teaches at St. Martin's School of Art, London. *1971* moves to New York; recent work records live images from various points of view using closed circuit video systems and monitors to explore the relationship of space in video and viewer's experience of that space.

Individual Exhibitions
Rina Gallery, Jerusalem, 1963.
Massada Gallery, Tel Aviv, 1965.
Hamilton Gallery, London, 1967.
The Tel Aviv Museum, "Sculptures," July 1969. Catalogue text by Haim Gamzu.
The Israel Museum, Jerusalem, 1970. Catalogue text by Martin Weyl.
Riebenfeld Gallery, Tel Aviv, 1970.
Mabat Gallery, Tel Aviv, 1971.
America-Israel Culture House, New York, 1972.
Deson-Zaks Gallery, Chicago, 1972.
New Illinois Center, Chicago, 1972.
Rina Gallery, New York, 1974.
OK Harris Gallery, New York, 1974.
OK Harris Gallery, New York, 1976. Catalogue text by the artist.
OK Harris Gallery, New York, 1977.
Julie M. Gallery, Tel Aviv, "Painted Projections 1977," September 1977.
Internationaal Cultureel Centrum, Antwerp, Belgium, "Box #1, A Corner Installation for a Closed-Circuit T.V.," May 27-June 25, 1978. Catalogue text by the artist.

OK Harris Gallery, New York, "Videoconstructions," 1978.
Akron Art Institute, Ohio, "Videocolorchart," 1979.
Lake Placid Hilton, New York, Winter Olympics, "Video-sculpture," February 2-24, 1980.
The Israel Museum, Jerusalem, "Buky Schwartz Videotapes 1978-80," Summer 1980. Catalogue text by John G. Hanhardt.

Major Group Exhibitions
Kircheim, Germany, "International Symposium of Sculpture," 1960.
Berlin, "International Symposium of Sculpture," 1962.
Bezalel National Museum, Jerusalem, "Today's Forms," 1963.
The Tel Aviv Museum, "Tatzpit," 1964.
Maskit, Tel Aviv, "Painting on Textiles," 1965.
Artists' House, Tel Aviv, "10+," 1966.
The Tel Aviv Museum, "Autumn Salon," 1966.
Venice, "XXXIII Biennale," 1966.
Nuremberg, Germany, "Symposium Urbanum," 1971.
The Tel Aviv Museum, "Israeli Art: Painting, Sculpture, Graphic Works," 1971.
The Israel Museum, Jerusalem, "Beyond Drawing," 1974.
Maurice Spertus Museum of Judaica, Chicago, "Israeli Art in Chicago Collections," 1974.

Indianapolis Museum of Art, Indiana, "Painting and Sculpture Today," June 9-July 18, 1976. Catalogue text by R. A. Yassin.
Potsdam, New York, "Sculpture Now," 1977.
Whitney Museum of American Art, New York, "Re-Visions: Projects and Proposals in Film and Video," April 19-May 13, 1979. Catalogue text by John G. Hanhardt.
Internationaal Cultureel Centrum, Antwerp, Belgium, "Biennale van de Kritiek," 1979. Circulated to Palais des Beaux-Arts, Charleroi.

Selected Bibliography
Articles and General References
Spencer, Charles. "Sculpture Dominates Venice." *Sculpture International* 1 (1966):52-53.
Tal, Miriam. "Israel Art Comes of Age." *Ariel* 29 (Winter 1971):18-19.
Encyclopaedia Judaica. Jerusalem: Keter Publishing Ltd., 1972.
Frackman, Noel. "Michael Gross/Buky Schwartz." *Arts Magazine* 49 (January 1975):12.
Shechori, Ran. *Art in Israel*. New York: Schocken Books, 1976. P. 198.
Rahmani, L. Y. *The Museums of Israel*. London: Secker and Warburg, 1976. P. 135, n. 166.

Ronnen, Meir. "An Ancient Land's Newborn Art." *Art News* 77 (May 1978):49, 50.
Locke, John. "Re-Visions at the Whitney Museum." *Parachute* 16 (Autumn 1979):53.
Pincus-Witten, Robert. "Video as Sculpture." *Arts Magazine* 53 (February 1979):93-95.
Carr, Carolyn. "Buky Schwartz Video Constructions: An Interview." *Dialogue* (September-October 1979):10-11.
Crary, Jonathan. "Re-Visions: Whitney Museum." *Flash Art*, No. 92-93 (October-November 1979):22.
Schwartz, Buky. "Video-constructions at OK Harris." *Criss Cross Art Communications* 7-9 (1979):50-55.
McFadden, Sarah. "Report from Lake Placid." *Art in America* 68 (April 1980):57.

1. First Generation
2. Expressionism

MENACHEM SHEMI

Born (Schmidt) 1897 Bobruisk, Byelorussia;
died 1951 Safed

1913 settles in Palestine; attends Bezalel School of Arts and Crafts;
one of the first students to rebel against its prevailing academicism.
1915 in Turkish army. *1918* in British army. *1920* paints and
teaches in Tiberias. *1922* settles in Haifa; dark, dramatic, and
expressive painting style. *1928, 1937* visits Paris. *1930s* paints
landscapes and portraits in Haifa and Akko. *1942-44* in British
army, North Africa and Italy. *1945* visits Paris. *1947-51* paints
Safed landscapes with animated rich textures, bright exuberant
colors.

Individual Exhibitions

The Tel Aviv Museum,
"Memorial Exhibition," 1952.
Circulated to Museum of
Modern Art, Haifa; Berl Com-
munity Centre, Kibbutz Na'an.
Glicenstein Museum, Zefat,
Israel, "Memorial Exhibition,"
1958.
Museum of Art (Mishkan
Leomanut), Ein Harod,
"Dedication of Shemi Room,
permanent installation," 1959.
Museum of Modern Art, Haifa,
"Memorial Exhibition," 1961.
The Israel Museum, Jerusalem,
"Memorial Exhibition," 1966.
Circulated to Artists' House,
Tel Aviv; Municipal Museum,
Beersheeba; Museum of
Modern Art, Haifa.
Museum of Modern Art, Haifa,
"Dedication of Shemi Room,
permanent installation," 1978.

Major Group Exhibitions

São Paulo, Brazil, "III Bienal: 7
Artistas de Israel," 1955.
The Tel Aviv Museum,
"Modern Israel Art in Its
Beginnings 1920-1930," 1957.
Bezalel National Museum,
Jerusalem, 1963.
The Israel Museum, Jerusalem,
"Trends in Israeli Art," 1965.
The Israel Museum, Jerusalem,
"Migdal David . . . ," 1968.
The Tel Aviv Museum, "Israeli
Art: Painting, Sculpture,
Graphic Works," 1971.
The Israel Museum, Jerusalem,
"Expressionism in Eretz-Israel
in the Thirties . . . ," 1971.
The Israel Museum, Jerusalem,
"From Landscape to
Abstraction . . . ," 1972.
Museum of Modern Art, Haifa,
"Self-Portrait in Israel Art,"
1973.
The Tel Aviv Museum, "Israel
Art 30+30," 1978.

Selected Bibliography

Articles and General References
Gamzu, Haim. *Painting and
Sculpture in Israel*. Tel Aviv:
Dvir, 1958. P. 39.
Tammuz, Benjamin, and
Wykes-Joyce, Max, eds. *Art in
Israel*. Tel Aviv: Massada, 1965.
Pp. 21-22.
Tal, Miriam. "Israel Art Comes
of Age." *Ariel* 29 (Winter
1971):10.
Encyclopaedia Judaica. Jerusalem:
Keter Publishing Ltd., 1972.
Shechori, Ran. *Art in Israel*.
New York: Schocken Books,
1976. P. 198.
Rahmani, L. Y. *The Museums of
Israel*. London: Secker and
Warburg, 1976. P. 133, n. 16l.

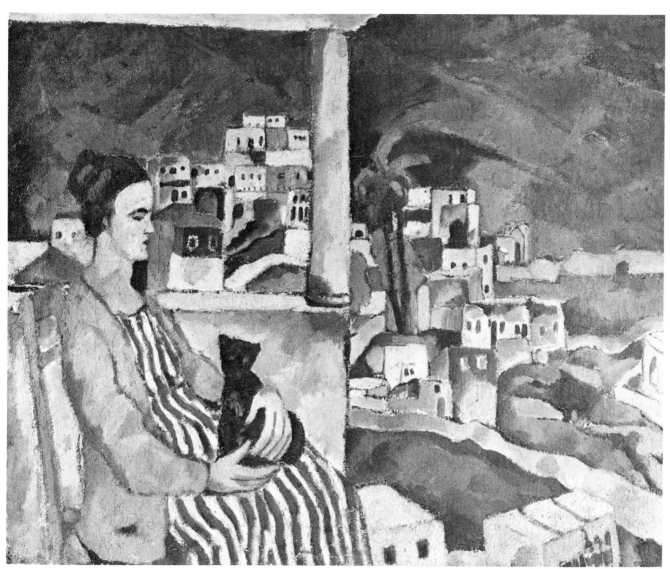

The Artist's Wife with Cat, 1928, oil on canvas, mounted on plywood,
23½ × 28⅜ in. (59 × 72 cm.). Collection Haifa Museum of Modern Art.

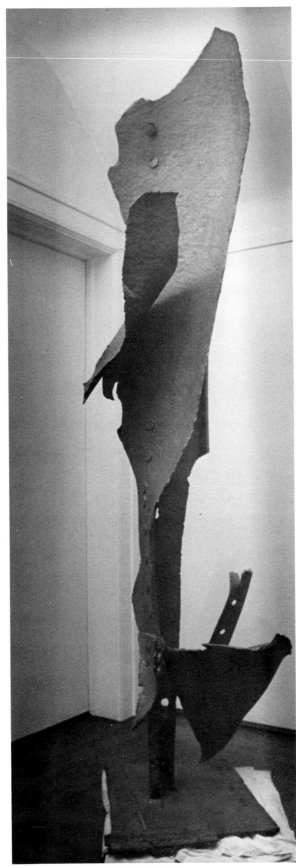

Untitled, 1966, steel, 97 × 24 × 24 in. (246 × 61 × 61 cm.).
Collection Mr. and Mrs. Stephen L. Singer, New York.

Photograph of Y. Shemi
© Arnold Newman.

YEHIEL SHEMI

Born 1922 Haifa, Palestine;
lives in Kibbutz Cabri.

1939-48 helps build and settles in Kibbutz Beit Ha'Arava on the Dead Sea. *1948* co-founder of Kibbutz Cabri, Western Galilee. *1949-50* visits Egypt, France, and Italy. *1950s* studies briefly with Chaim Gross at Art Students League in New York. *1954* Dizengoff Prize. *1955* exhibits with New Horizons group; begins working in welded iron; scrap metal constructions with twisting elements suggest plant forms. *1957-60* teaches at Art Institute of the Kibbutzim Seminary, Oranim. *1958* creates large sculpture for Binyenei Ha'Umah convention center, Jerusalem. *1959-61* works in Paris. *1964-65* creates monumental sculpture at Achziv. *1969-70* executes monumental concrete relief for Jerusalem Theater. *1970s* works in New York intermittently; develops clean-surfaced planar compositions of intersecting angles. *1977-79* teaches environmental design at Haifa Technion.

Individual Exhibitions

The Tel Aviv Museum, 1957.
Bezalel National Museum, Jerusalem, 1957.
Betty Parsons Section Eleven Gallery, New York, 1959.
Palais des Beaux-Arts, Brussels, 1964.
Gordon Gallery, Tel Aviv, 1966.
The Israel Museum, Jerusalem, "The Sea Sculpture," 1967.
Goldman Gallery, Haifa, 1971.
Betty Parsons Gallery, New York, 1973, 1975.
Gordon Gallery, Tel Aviv, 1976.
Debel Gallery, Ein Kerem, 1976.
Gordon Gallery, Tel Aviv, 1978.
Betty Parsons Gallery, New York, April 8-26, 1980.

Major Group Exhibitions

The Tel Aviv Museum, "New Horizons," May 1956.
The Museum of Modern Art, New York, "New Acquisitions," 1958.
Salon des Réalités Nouvelles, Paris, "Second International Sculpture Exhibition," 1959.
America-Israel Cultural Foundation and the International Council of the Museum of Modern Art, New York, "Art Israel: 26 Painters and Sculptors," 1964.
The Tel Aviv Museum, Helena Rubinstein Pavilion, "Tatzpit," 1964.
The Israel Museum, Jerusalem, "Trends in Israeli Art," 1965.
Museum of Modern Art, Haifa, "Michael Gross, Yitzhak Danziger, Yehiel Shemi: Sculptures," 1969-70.
Canada-Israel Cultural Foundation, Ottawa, "Israel Art Festival . . . ," 1978.
Museum of Modern Art, Haifa, "30 Years to New Horizons, 1948-1978 . . . ," 1979.

Selected Bibliography

Articles and General References
Dypréau, Jean. "Yehiel Shemi." *Quadrum* 18 (1965):152-53.
Tammuz, Benjamin, and Wykes-Joyce, Max, eds. *Art in Israel*. Tel Aviv: Massada, 1965. Pp. 144, 151.
Tal, Miriam. "Israel Art Comes of Age." *Ariel* 29 (Winter 1971):18.
Encyclopaedia Judaica. Jerusalem: Keter Publishing Ltd., 1972.
Spencer, Charles. "Yehiel Shemi." *Jewish Quarterly* (Autumn 1974):28-29.
Shechori, Ran. *Art in Israel*. New York: Schocken Books, 1976. P. 198.
Rahmani, L. Y. *The Museums of Israel*. London: Secker and Warburg, 1976. P. 192, n. 250.
Debel, Ruth. "What Does It Mean To Be an Israeli Artist?" *Art News* (May 1978):53.
Ronnen, Meir. "An Ancient Land's Newborn Art." *Art News* 77 (May 1978):45.
Megged, Matti. "The Old-New Land: Israel." *Arts Canada* (December-January 1979-80):33.

YOHANAN SIMON

Born 1905 Berlin;
died 1976 Herzliya, Israel

1924 studies at Akademie der Kunst in Berlin and with Max Beckmann at Frankfurt. *1925* studies at Bauhaus. *1926* studies at Staatliche Kunstakademie, Munich. *1931* works in southern France; moves to Paris, joins circle of André Derain. *1935* visits New York, deeply impressed by Diego Rivera's work on murals for Rockefeller Center. *1936* emigrates to Palestine; joins Kibbutz Gan Shmuel and Association of Painters and Sculptors of Palestine; employs monumental realism to portray scenes of kibbutz life in paintings and wall murals for kibbutzim, factories, and public institutions. *1946, 1953, 1961* Dizengoff Prize. *1948* among founders of New Horizons group and participant in many of its early shows. *1950s-60s* often visits Latin America; portrays imaginary landscapes, often with bold colors and tropical vegetation.

Individual Exhibitions
The Tel Aviv Museum, "Oil Paintings and Decorative Panels," May 11-31, 1947.
The Tel Aviv Museum, March-April, 1953.
Museu de Arte Moderna de São Paulo, Brazil, August 1954.
O'Hana Gallery, London, "Oil Paintings and Gouaches," October 23-November 8, 1958.
Feingarten Galleries, San Francisco, February 13-26, 1962.
Miami Museum of Modern Art, Florida, "Paintings 1958-1963," January 29-February 24, 1963.
Herzliya Museum, Israel, April-May 1966.

Major Group Exhibitions
The Tel Aviv Museum, "New Horizons," May 1956.
The Tel Aviv Museum, "Israeli Art: Painting, Sculpture, Graphic Works," 1971.
Ministry of Education and Culture, America-Israel Cultural Foundation, Jerusalem, "'Itzuv' presents M. Avniel, J. Simon, J. Pins," 1971-72.
The Israel Museum, Jerusalem, "From Landscape to Abstraction . . . ," 1972.
Maurice Spertus Museum of Judaica, Chicago, "Israeli Art in Chicago Collections," 1974.
The Jewish Museum, New York, "Jewish Experience in the Art of the Twentieth Century," October 16, 1975-January 25, 1976. Catalogue text by Avram Kampf.
The Tel Aviv Museum, "Artist and Society . . . ," 1978.
Museum of Modern Art, Haifa, "30 Years to New Horizons, 1948-1978 . . . ," 1979.

Selected Bibliography
Articles and General References
Gamzu, Haim. *Painting and Sculpture in Israel*. Tel Aviv: Dvir, 1958. P. 41.
Tammuz, Benjamin, and Wykes-Joyce, Max, eds. *Art in Israel*. Tel Aviv: Massada, 1965. P. 30.
Tal, Miriam. "Israel Art Comes of Age." *Ariel* 29 (Winter 1971):12.
Encyclopaedia Judaica. Jerusalem: Keter Publishing Ltd., 1972.
Rahmani, L. Y. *The Museums of Israel*. London: Secker and Warburg, 1976. P. 136, n. 179.

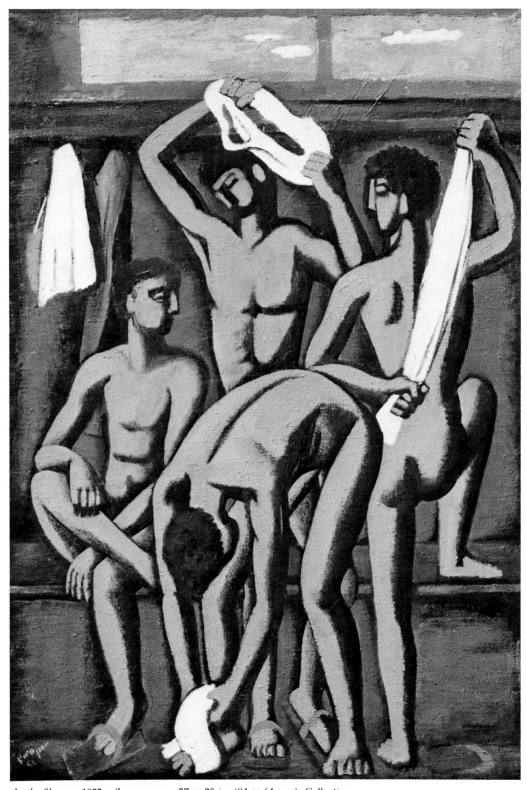

In the Shower, 1952, oil on canvas, 37 × 25 in. (94 × 64 cm.). Collection
The Tel Aviv Museum.

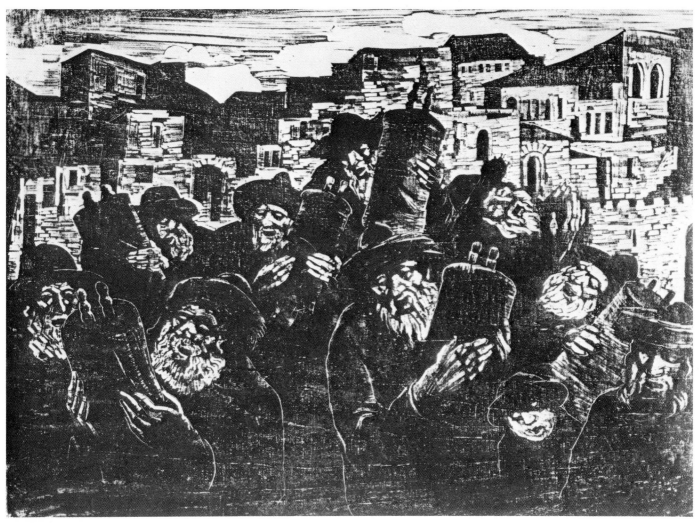

Simhat Torah, 1938, woodcut, 13¼ × 18¼ in. (34 × 46 cm.).
Collection The Israel Museum, Jerusalem.

JAKOB STEINHARDT

Born 1889 Zerkow, Poland;
died 1968 Naharyia, Israel

1906 moves to Berlin and studies with painter Lovis Corinth and engraver Hermann Struck. *1909* studies with Henri Laurens, Théophile Steinlen, and Henri Matisse in Paris. *1911* visits Italy. *1912* returns to Berlin; among founders of Expressionist group Pathetiker; exhibits with Die Sturmer group. *1917* exhibits drawings done while soldier in World War I at Berliner Sezession. *1925* visits Palestine. *1933* emigrates to Palestine and settles in Jerusalem; continues stark black-and-white woodcuts in German Expressionist tradition with social and biblical themes. *1949* heads graphic department of Bezalal School of Arts and Crafts. *1953-57* director, Bezalel School. *1955* international prize in graphic art São Paulo Bienal. *1960* liturgical prize for woodcuts, Venice Biennale.

Individual Exhibitions
Bezalel National Museum, Jerusalem, January 18-March 1, 1947.
The Tel Aviv Museum, "Retrospective Graphic Works," June 1-21, 1947.
Artists' House, Jerusalem, "Woodcuts," May 30-June 18, 1957.
Museum of Modern Art, Haifa, 1958.
Bezalel National Museum, Jerusalem, "Retrospective," February 1962. Catalogue Introduction by Elisheva Cohen.
Museum of Modern Art, Haifa, "Graphic Work," December 23, 1967-January 20, 1968.
Pucker-Safrai Gallery, Boston, April 7-May 4, 1968.
Engel Gallery, Jerusalem, December 20, 1977.

Major Group Exhibitions
The Tel Aviv Museum, "Jakob Steinhardt and Moshe Sternshus," November 1945.
São Paulo, Brazil, "III Bienal: 7 Artistas de Israel," 1955.
Bezalel National Museum, Jerusalem, "Israel: Watercolors, Drawings, Graphics 1948-1958," April 1958.
The Israel Museum, Jerusalem, "Trends in Israeli Art," 1965.
The Tel Aviv Museum, "Israeli Art: Painting, Sculpture, Graphic Works," 1971.
Museum of Modern Art, Haifa, "Self-Portrait in Israel Art," 1973.
Maurice Spertus Museum of Judaica, Chicago, "Israeli Art in Chicago Collections," 1974.
The Jewish Museum, New York, "Jewish Experience in the Art of the Twentieth Century," October 16, 1975-January 25, 1976. Catalogue text by Abram Kampf.
Tel Aviv University, University Gallery, "Graphic Works by 30 Israeli Artists," 1978.
Jerusalem City Museum (David's Tower), "Jerusalem and the Israeli Printmaker," 1980.

Selected Bibliography

Monographs
Schiff, F. *Jacob Steinhardt. Woodcuts*. Jerusalem: Art Publishing Society, 1952.
Kolb, Leon, ed. *The Woodcuts of Jacob Steinhardt*. San Francisco: Genuart, 1959.
Gamzu, Haim. *Steinhardt, Drawings and Graphic Work*. New York: Thomas Yosseloff, 1963.
Pfefferkorn, Rudolf. *Jacob Steinhardt*. Berlin: Stapp, 1967.
Jacob Steinhardt. Miami: International Book Corp., 1969; International Hebrew Heritage Library, Vol. 3.
Amishai-Maisels, Ziva. "Steinhardt's Call for Peace." *Journal of Jewish Art* 3-4 (1977):90-102.

Articles and General References
Gamzu, Haim. *Painting and Sculpture in Israel*. Tel Aviv: Dvir, 1958. P. 80.

Tammuz, Benjamin, and Wykes-Joyce, Max, eds. *Art in Israel*. Tel Aviv: Massada, 1965. Pp. 23, 24.
Werner, Alfred. "Jakob Steinhardt, Master of the Woodcut." *Jewish Heritage* (Summer 1968):9-15.
Tal, Miriam. "Israel Art Comes of Age." *Ariel* 29 (Winter 1971):22.
Roth, Cecil, ed. *Jewish Art*. New York: New York Graphic Society, 1971. Pp. 242, 294.
Ronnen, Meir. "An Ancient Land's Newborn Art." *Art News* 77 (May 1978):45.

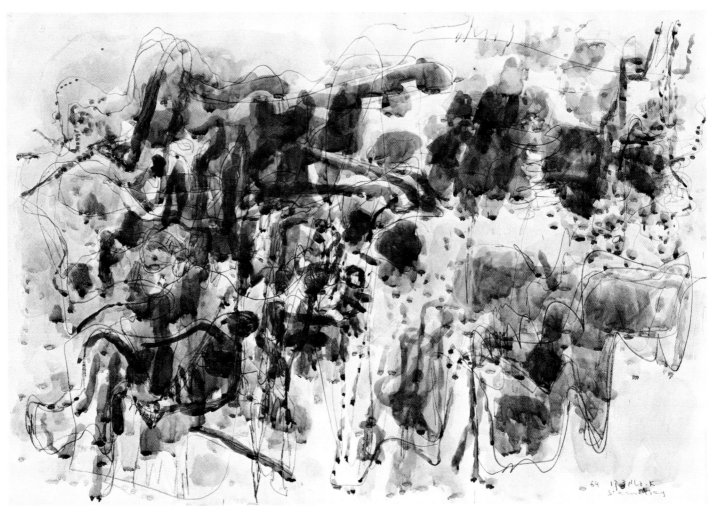

Composition, 1964, watercolor, 27½ × 39⅓ in. (70 × 100 cm.).
Collection Mr. and Mrs. Israel Zafrir, Tel Aviv.

AVIGDOR STEMATSKY

Born 1908 Odessa, Russia;
lives in Tel Aviv

1922 emigrates to Palestine. *1926-28* attends Bezalel School of Arts and Crafts. *1929* joins Massad group in Tel Aviv. *1930-31* studies at Academie de la Grande Chaumière and Academie Colarossi, Paris. *1941, 1956* Dizengoff Prize. *1948* among founders of New Horizons group. *1950s* adopts Abstract Lyricism; employs splashes of interacting vibrant color to create expressive abstract composition. *1950-51, 1960-61* works in Paris. *1976* Sandberg Prize; teaches at Avni Art Institute.

Individual Exhibitions
The Tel Aviv Museum, 1939.
The Tel Aviv Museum, 1946.
Galerie Henri Béranger, Paris, "Stematsky peintures aquarelles," April 1951.
The Tel Aviv Museum, "Paintings 1949-1958," February 1958.
SDS-Hallen, Malmö, Stockholm, March 1962.
Rosner Gallery, Tel Aviv, 1964.
Gordon Gallery, Tel Aviv, "Paintings," May 1970.
The Israel Museum, Jerusalem, "Paintings 1939-1972," June-July 1972. Catalogue text by Yona Fischer.
Printers' Gallery, Jerusalem, 1978.

Major Group Exhibitions
Venice, "XXX Biennale," 1948.
Salon de Mai, Paris, 1951.
São Paulo, Brazil, "III Bienal: 7 Artistas de Israel," 1955.
Venice, "XXVIII Biennale," 1956.
The Tel Aviv Museum, "New Horizons," 1953, 1955.
Arts Council of Great Britain, London, "Modern Israeli Painting," 1958.
Bezalel National Museum, Jerusalem, "Israel: Watercolors, Drawings, Graphics, 1948-1958," April 1958.
Musée National d'Art Moderne, Paris, "L'Art Israélien contemporain," 1960.
Museum of Art (Mishkan Leomanut), Ein Harod, "New Horizons," 1963.
America-Israel Cultural Foundation, and the International Council of The Museum of Modern Art, New York, "Art Israel: 26 Painters and Sculptors," 1964.
The Israel Museum, Jerusalem, "Trends in Israeli Art," 1965.
University Art Gallery, State University of New York at Albany, "A Leap of Faith," 1969.

High Museum of Art, Atlanta, "Israel on Paper," 1970.
Memorial Art Gallery of The University of Rochester, New York, "Looking Up . . . ," 1971.
The Tel Aviv Museum, "Israeli Art: Painting, Sculpture, Graphic Works," 1971.
The Israel Museum, Jerusalem, "Expressionism in Eretz-Israel in the Thirties . . . ," 1971.
The Israel Museum, Jerusalem, "From Landscape to Abstraction . . . ," 1972.
Museum of Modern Art, Haifa, "Self-Portrait in Israel Art," 1973.
Yad Lebanim, Petach Tikva, Israel, "The Five," 1973.
Canada-Israel Cultural Foundation, Ottawa, "Israel Art Festival . . . ," 1978.
The Israel Museum, Jerusalem, "From the Collection of Dr. Moshe Spitzer, Jerusalem," March 1978. Catalogue text by Moshe Spitzer, no. 172.
The Tel Aviv Museum, "Israel Art 30 + 30," 1978.
Museum of Modern Art, Haifa, "30 Years to New Horizons, 1948-1978 . . . ," 1979.

Selected Bibliography
Articles and General References
Gamzu, Haim. *Painting and Sculpture in Israel.* Tel Aviv: Dvir, 1958. P. 56.
Tammuz, Benjamin, and Wykes-Joyce, Max, eds. *Art in Israel.* Tel Aviv: Massada, 1965. Pp. 23, 30, 32, 33, 42.
Tal, Miriam. "Israel Art Comes of Age." *Ariel* 29 (Winter 1971):14.
Encyclopaedia Judaica. Jerusalem: Keter Publishing Ltd., 1972.
Shechori, Ran. *Art in Israel.* New York: Schocken Books, 1976. P. 198.
Rahmani, L. Y. *The Museums of Israel.* London: Secker and Warburg, 1976. P. 138, n. 178.
Ronnen, Meir. "An Ancient Land's Newborn Art." *Art News* 77 (May 1978):45, 48.

YEHESKEL STREICHMAN

Born 1906 Kovno, Lithuania;
lives in Tel Aviv

1924 emigrates to Palestine. *1924-26* studies at Bezalel School of
Arts and Crafts. *1926* studies at École Speciale d'Architecture in
Paris. *1928* attends Accademia di Belle Arti, Florence.
1931 returns to Kovno. *1936* returns to Palestine; joins Kibbutz
Ashdot Yaakov and works there during World War II. *1941, 1944,
1954, 1969* Dizengoff Prize. *1944* settles in Tel Aviv. *1948* among
founders of New Horizons group. *1950s* teaches at Avni Art
Institute, Tel Aviv; influential in developing Lyrical Abstraction as
dominant local style; abstract work delicately blends rich color and
shading, still tied to landscape and figure. *1956* Ramat Gan
Municipality Prize. *1968* Milo Prize. *1974* Sandberg Prize.

Individual Exhibitions
The Tel Aviv Museum,
Dizengoff House, 1945.
The Tel Aviv Museum,
Dizengoff House, "Oil
Paintings," May-June 1953.
The Tel Aviv Museum, Helena
Rubinstein Pavilion, 1960.
Israel Gallery, Tel Aviv, 1961.
Riebenfield Gallery, Jaffa, 1969.
Yodfat Gallery, Tel Aviv,
"Paintings," March-April 1974.
Catalogue text by Yona Fischer.
The Israel Museum, Jerusalem,
"Paintings," March-April 1974.
The Tel Aviv Museum,
"Paintings 1942-1975,"
April-May 1975. Catalogue
Introduction by Haim Gamzu.

Major Group Exhibitions
The Tel Aviv Museum, "Group
of Seven," 1947.
Venice, "XXIV Biennale," 1948.
The Tel Aviv Museum,
Dizengoff House, "New
Horizons," 1949, 1966.
Venice, "XXVI Biennale," 1952.
Venice, "XXVII Biennale," 1954.
São Paulo, Brazil, "III Bienal: 7
Artistas de Israel," 1955.
Museum of Art, Carnegie
Institute, Pittsburgh,
"International," 1961.
Seibu Store, Tokyo, "Modern
Art of Israel," 1962.
America-Israel Cultural
Foundation, and the
International Council of The
Museum of Modern Art, New
York, "Art Israel: 26 Painters
and Sculptors," 1964.
Solomon R. Guggenheim
Museum, New York,
"Guggenheim International
Award," 1964.
The Tel Aviv Museum,
"Tatzpit," 1964.
The Israel Museum, Jerusalem,
"Trends in Israeli Art," 1965.
Gemeentemuseum Arnhem,
Holland, "Schilders uit Isräel
[Painters of Israel]," 1965.

Venice, "XXXIII Biennale," 1966.
The Tel Aviv Museum,
"Autumn Salon," 1968, 1969.
The Israel Museum, Jerusalem,
"Expressionism in Eretz-Israel
in the Thirties . . . ," 1971.
The Tel Aviv Museum, "Israeli
Art: Painting, Sculpture,
Graphic Works," 1971.
The Israel Museum, Jerusalem,
"From Landscape to
Abstraction . . . ," 1972.
Yad Lebanim, Petach Tikva,
"The Five," 1973.
The Israel Museum, Jerusalem,
"A Tribute to Sam Zacks:
Selected Paintings, Drawings,
and Sculptures from the Sam
and Ayala Zacks Collection,"
Summer 1976. Circulated to
The Tel Aviv Museum,
Autumn 1976. Exhibition
catalogue no. 146.
The Tel Aviv Museum, "Israel
Art 30+30," 1978.
Museum of Modern Art, Haifa,
"30 Years to New Horizons,
1948-1978," 1979.
The Tel Aviv Museum, "Artist's
Choice," 1979.

Selected Bibliography

Articles and General References
Gamzu, Haim. *Painting and
Sculpture in Israel.* Tel Aviv:
Dvir, 1958. P. 56.
Tammuz, Benjamin and
Wykes-Joyce, Max, eds. *Art in
Israel.* Tel Aviv: Massada, 1965.
Pp. 30, 32, 33.
Tal, Miriam. "Israel Art Comes
of Age." *Ariel* 29 (Winter
1971):14.
Encyclopaedia Judaica. Jerusalem:
Keter Publishing Ltd., 1972.
Goldfine, Gil. "Streichman."
The Jerusalem Post, June 18,
1975.
Shechori, Ran. *Art in Israel.*
New York: Schocken Books,
1976. P. 198.
Rahmani, L. Y. *The Museums of
Israel.* London: Secker and
Warburg, 1976. P. 132, n. 157.
Ronnen, Meir. "An Ancient
Land's Newborn Art." *Art
News* 77 (May 1978):45, 48.
Megged, Matti. "The Old-New
Land: Israel." *Arts Canada*
(December-January 1979-80):
31, 33.

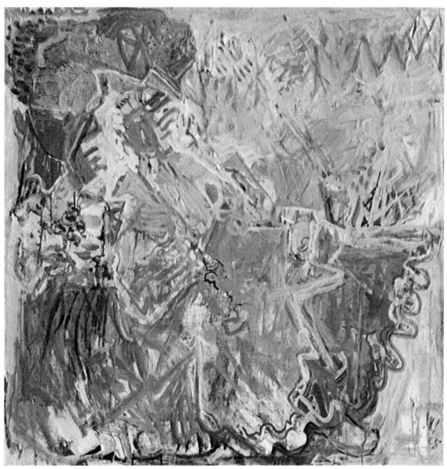

Zila, 1965, oil on canvas, 39½ × 39½ in. (100 × 100 cm.). Collection
Selma and Stanley I. Batkin, New York.

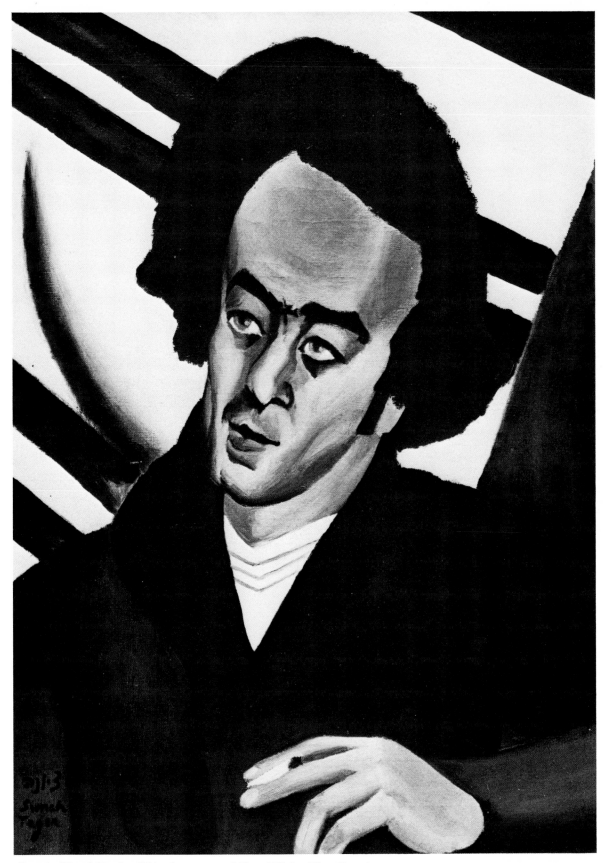

Portrait of Poet Schlonsky, 1924, oil on canvas, 24¾ × 17½ in. (63 × 44 cm.).
Collection The Tel Aviv Museum.

TZIONA TAGGER

Born 1900 Jaffa, Palestine;
lives in Tel Aviv

1900 modern Israel's first native-born painter; parents among founders of Ahuzat Bayit (later Tel Aviv). Studies with sculptor Joseph Constant in Tel Aviv. *1921* studies at Bezalel School of Arts and Crafts. *1924-25* studies with André Lhote in Paris. *early 1920s* co-founder of Hebrew Artists' Association. *1936, 1937, 1938* exhibits in Egypt. *1937* Dizengoff Prize. World War II in British army. *1950-51* works in Paris; while remaining strongly linked to earlier concern with subject's likeness, she alters and stylizes portrait and landscape for expressive effect.

Individual Exhibitions
The Tel Aviv Museum, 1937.
Wizo Club, Tel Aviv, 1954.
Chagall House, Haifa, 1957.
The Tel Aviv Museum, "Retrospective," 1960.
Chemerinsky Gallery, Tel Aviv, 1968.

Major Group Exhibitions
Ohel, Tel Aviv, "Modern Art Exhibition," 1925, 1926.
Venice, "XXIV Biennale," 1948.
The Tel Aviv Museum, "Modern Israel Art in Its Beginnings 1920-1930," 1957.
The Israel Museum, Jerusalem, "Migdal David . . . ," 1968.
The Tel Aviv Museum, "Israeli Art: Painting, Sculpture, Graphic Works," 1971.

Selected Bibliography

Articles and General References
Newman, Elias. *Art in Palestine.* New York: Seibel, 1935. Pp. 110-111.
Gamzu, Haim. *Painting and Sculpture in Israel.* Tel Aviv: Dvir, 1958. P. 73.
Tammuz, Benjamin, and Wykes-Joyce, Max, eds. *Art in Israel.* Tel Aviv: Massada, 1965. Pp. 18, 20, 21.
Encyclopaedia Judaica. Jerusalem: Keter Publishing Ltd., 1972.
Rahmani, L. Y. *The Museums of Israel.* London: Secker and Warburg, 1976. P. 128, n. 148.

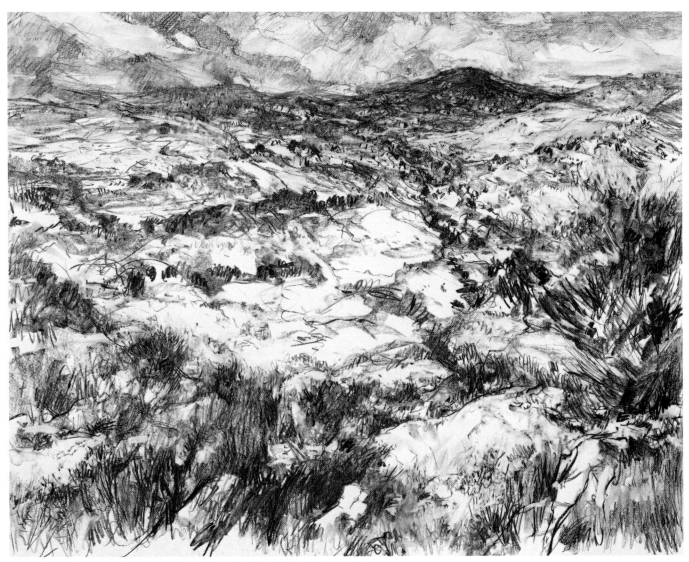

Jerusalem, 1969, charcoal on paper, 27⅝ × 39½ in. (70 × 100 cm.). Collection
The Museum of Modern Art, New York; Given anonymously.

ANNA TICHO

Born 1894 Brünn, Austria;
died 1980 Jerusalem

1904 family moves to Vienna. *1909* enrolls in art school.
1912 settles in Jerusalem. *1917* to Damascus with husband
Abraham Ticho, eye surgeon serving in Austrian army.
1919 returns to Jerusalem. *1930* visits Paris; early black-and-white
drawings of figures and Jerusalem landscape done from nature.
1960s-80 works on pastel imaginary landscapes but still draws on
the hills, rocks, and olive trees of Jerusalem as sources. *1965* art
prize of City of Jerusalem. *1975* Sandberg Prize. *1980* Israel Prize.

Individual Exhibitions
Stematsky Gallery, Jerusalem,
"Drawings and Watercolors,"
1934.
Passedoit Gallery, New York,
September-October 1953.
Bezalel National Museum,
Jerusalem, "Drawings and
Watercolors," May-June 1959.
Stedelijk Museum, Amsterdam,
October 1959.
Baltimore Museum of Art,
"Drawings," April-May 1962.
Museum of Modern Art, Haifa,
"Drawings," January-February
1962.
Bezalel National Museum,
Jerusalem, "Recent Drawings,"
December 1963.
Art Institute of Chicago, 1964.
Museum Boymans van
Beuningen, Rotterdam, 1964.
Poses Institute of Fine Arts,
Brandeis University, Waltham,
Massachusetts, "Landscape
Drawings of Israel," March
6-April 7, 1967. Catalogue
Introduction by Karl Katz and
Elisheva Cohen.
The Israel Museum, Jerusalem,
"Drawings," March-April 1968.
The Jewish Museum, New York,
"Drawings," November 19,
1969-January 4, 1970.
Ashmolean Museum of Art and
Archaeology, Oxford,
April-May 1972. Catalogue
Introduction by Philip Hendy.
The Israel Museum, Jerusalem,
1973.

The Tel Aviv Museum,
"Jerusalem Landscapes,"
July-August 1974.
The Israel Museum, Jerusalem
"Fifty Years of Drawing,"
March 1978.
The Tel Aviv Museum,
"Drawings and Photographs,"
Summer 1978.

Major Group Exhibitions
Bezalel National Museum,
Jerusalem, "Israel: Watercolors,
Drawings, Graphics
1948-1958," April 1958.
America-Israel Cultural
Foundation, and the
International Council of The
Museum of Modern Art, New
York, "Art Israel: 26 Painters
and Sculptors," 1964.
The Israel Museum, Jerusalem,
"Trends in Israeli Art," 1965.
Musée du Petit Palais, Paris,
"Israël à travers les âges," 1968.
High Museum of Art, Atlanta,
"Israel on Paper," 1970.
The Tel Aviv Museum, "Israeli
Art: Painting, Sculpture,
Graphic Works," 1971.
The Israel Museum, Jerusalem,
"From Landscape to
Abstraction . . . ," 1972.
Maurice Spertus Museum of
Judaica, Chicago, "Israeli Art
in Chicago Collections," 1974.
The Jewish Museum, New York,
"Jewish Experience in the Art
of the Twentieth Century,"
October 16, 1975-January 25,
1976. Catalogue text by Avram
Kampf.

The Israel Museum, Jerusalem,
"A Tribute to Sam Zacks:
Selected Paintings, Drawings
and Sculpture from the Sam
and Ayala Zacks Collection,"
Summer 1976. Circulated to
The Tel Aviv Museum,
Autumn 1976. Exhibition
catalogue no. 146.
Illinois Bell, Chicago, "Print-
making in Israel Today," 1978.
The Israel Museum, Jerusalem,
"From the Collection of Dr.
Moshe Spitzer, Jerusalem,"
March 1978. Catalogue text by
Moshe Spitzer, no. 172.
Los Angeles County Museum of
Art, "Seven Artists in Israel,
1948-1978," 1978-79.
Jerusalem City Museum (David's
Tower), "Jerusalem and the
Israeli Printmaker," 1980.

Selected Bibliography
Monographs and Books
Eisler, Max. *Anna Ticho, Jerusa-
lem, 12 Facsimile Plates.* Vienna:
Gerlach and Wiedling, 1951.
Cohen, Elisheva. *Anna Ticho,
Jerusalem Landscape, Drawings
and Watercolors.* London and
Tel Aviv: Lund Humphries and
Dvir, 1971.
Fischer, Yona, ed. *Anna Ticho:
Sketches 1918-1975.* Jerusalem:
The Israel Museum, 1976.

Cohen, Elisheva. "The Painter
of Jerusalem. A Glimpse into
Anna Ticho's Studio." *Ariel*
45-46 (1978):33-44.

Articles and General References
Gamzu, Haim. *Painting and
Sculpture in Israel.* Tel Aviv:
Dvir, 1958. P. 83.
Tammuz, Benjamin, and
Wykes-Joyce, Max, eds. *Art in
Israel.* Tel Aviv: Massada, 1965.
P. 25.
Tal, Miriam. "Israel Art Comes
of Age." *Ariel* 29 (Winter
1971):20.
Shechori, Ran. *Art in Israel.*
New York: Schocken Books,
1976. P. 199.
Rahmani, L. Y. *The Museums of
Israel.* London: Secker and
Warburg, 1976. P. 192, n. 249.
Ronnen, Meir. "An Ancient
Land's Newborn Art." *Art
News* 77 (May 1978):45, 51.
Larsen, Susan C. "The New
Prominence of Israeli Art." *Art
News* 78 (March 1979):92, 94.
Kasher, Steven. "Seven Artists
of Israel." *Artforum* 17
(Summer 1979):51.
Megged, Matti. "The Old-New
Land: Israel." *Arts Canada*
(December-January 1979-80):34.

IGAEL TUMARKIN

Born 1933 Dresden;
lives in Tel Aviv

1935 emigrates to Palestine with his mother. *1945* studies at Technical School, Tel Aviv. *1952-54* serves in Israeli Navy. *1954* studies with sculptor Rudi Lehmann at Ein Hod. *1955-57* assistant stage designer with Berliner Ensemble; designs stage sets for productions of Bertolt Brecht's plays in Germany, Holland, and Israel; attracted to strongly expressive, socially oriented art. *1957-61* paints and sculpts in Paris. *1961* returns to Israel. *1962-68* creates monumental sculptures *Window to the Sea*, Atlit, and *Panorama*, Arad. *1966-80* visits Europe, the United States, the Far East, Africa, and Australia; his protest against war, dehumanization, violence, and alienation continues to be expressed in geometric and organic abstract forms, which often have narrative significance. *1968* Sandberg Prize. *1971-75* monumental sculpture *Holocaust and Survival* for Tel Aviv. *1973* correspondent and photographer for October War.

Individual Exhibitions
Santee Landweer Gallery, Amsterdam, 1956.
Galerie Sisley, Brussels, 1958.
Galerie Het-Venster, Rotterdam, 1958.
Galerie Seide, Hanover, 1959.
Galerie Saint-Germain, Paris, 1959.
Savage Gallery, London, 1960.
Svenska Franska, Stockholm, 1960.
Galerie Espace, Haarlem, 1960.
Bezalel National Museum, Jerusalem, February 1961.
Galerie Saint-Germain, Paris, 1961.
Galerie Bonnier, Lausanne, 1962.
Gallery Israel, Tel Aviv, 1962.
The Tel Aviv Museum, Helena Rubinstein Pavilion, 1962.
Osgood Gallery, New York, 1963.
Galerie Saint-Germain, Paris, 1964.
Galerie Löhr, Frankfort, 1965.
The Tel Aviv Museum, Dizengoff House, 1966.
The Tel Aviv Museum, "Sculptures, Paintings," September-October 1966. Catalogue Preface by Haim Gamzu.
Gordon Gallery, Tel Aviv, "Gangsters," February 1967.
The Israel Museum, Jerusalem, "Sculptures, Assemblages, Plans for Monuments," July-August 1967.
Mabat Gallery, Tel Aviv, 1968.
Galerie Bonnier, Geneva, 1969.
Gordon Gallery, Tel Aviv, "Horns of Hattim," November 19-28, 1970.
Byron Gallery, New York, "Sculpture 1967-1970," April 15-May 10, 1970. Catalogue text by the artist.

Museum of Modern Art, Haifa, "Sculptures," Winter 1970-71.
Hopner Gallery, Hamburg, July-August 1971.
Bargera Gallery, Cologne, 1972.
Yodfat Gallery, Tel Aviv, 1972.
The Tel Aviv Museum, "War Impressions," February 1974. Circulated to The Jewish Museum, New York, September 1974-January 1975. Catalogue Introduction to New York exhibition by Susan T. Goodman.
Gilman Gallery, Chicago, 1975.
Queens Museum, Flushing Meadow, New York, "Outdoor Sculpture," September 1976-January 1977. Circulated to Fordham University at Lincoln Center, New York.
The Israel Museum, Jerusalem, "Five Variations on the Theme of Earth," Autumn 1978. Catalogue text by Yona Fischer.
The Tel Aviv Museum, "Journeys into Culture: Works on Paper 1956-1980." April-June 1980. Catalogue text by Sara Breitberg.

Major Group Exhibitions
Musée du Louvre, Musée des Arts Décoratifs, Paris, 1961.
The Museum of Modern Art, New York, "Art of Assemblage," 1961.
Ljubljana, Yugoslavia, "Fourth International Biennale for Graphic Art," 1962.
Museum of Art, Carnegie Institute, Pittsburgh, "International," 1963.
Venice, "XXXII Biennale," 1964.
America-Israel Cultural Foundation, and the International Council of The Museum

of Modern Art, New York, "Art Israel: 26 Painters and Sculptors," 1964.
The Israel Museum, Jerusalem, "Trends in Israeli Art," 1965.
The Israel Museum, Jerusalem, "Labyrinth . . . ," 1967.
Museum Boymans van Beuningen, Rotterdam, "Grafiek uit Israel," 1968.
São Paulo, Brazil, "IX Bienal, Israel — Arikha, Tumarkin," 1967.
Tokyo, "Graphic Biennale," 1968.
Ljubljana, Yugoslavia, "Eighth International Biennale for Graphic Art," 1969.
University Art Gallery, State University of New York at Albany, "A Leap of Faith," 1969.
High Museum of Art, Atlanta, "Israel on Paper," 1970.
Memorial Art Gallery of The University of Rochester, New York, "Looking Up . . . ," 1971.
Museum of Modern Art, Haifa, "Self-Portrait in Israel Art," 1973.
The Jewish Museum, New York, "Jewish Experience in the Art of the Twentieth Century," October 16, 1975-January 25, 1976. Catalogue text by Avram Kampf.
The Tel Aviv Museum, "Israel Art 30 + 30," 1978.
The Tel Aviv Museum, "Artist and Society . . . ," 1978.
Tel Aviv University, University Gallery, "Graphic Works by 30 Israeli Artists," 1978.
The Israel Museum, Jerusalem, "Borders," 1980.
Jerusalem City Museum (David's Tower), "Jerusalem and the Israeli Printmaker," 1980.
University of Haifa Art Gallery, "The Myth of Canaan . . . ," 1980.

Selected Bibliography

Monograph
Tumarkin, Igael. *Tumarkin by Tumarkin 1957-1970.* Hadera: American Israel Paper Mills, Ltd., 1970. Epilogue by W. Sandberg.

Articles and General References
Tammuz, Benjamin, and Wykes-Joyce, Max, eds. *Art in Israel.* Tel Aviv: Massada, 1965. Pp. 43, 144, 154, 155.
Spencer, Charles. "Israel, the Surrealist and Fantastic Factor in the New Art." *Studio International* 174 (October 1967):162-63.
Tal, Miriam. "Israel Art Comes of Age." *Ariel* 29 (Winter 1971):19.
Encyclopaedia Judaica. Jerusalem: Keter Publishing Ltd., 1972.
Runciman, Steven, and Tumarkin, Igael. "Tumarkin." *Israel Magazine* 6, No. 4 (1974):20-35.
Kohansky, Mendel. "Art Confronts War." *American Zionist* (May 1974):15-16.
Dresner, Sylvia. "Two Exhibitions by Igael Tumarkin." *Tarbut*, No. 29 (Fall 1974):12-13.
Shechori, Ran. *Art in Israel.* New York: Schocken Books, 1976. P. 199.
Rahmani, L. Y. *The Museums of Israel.* London: Secker and Warburg, 1976. P. 140, n. 182.
Ronnen, Meir. "Up in Arms." *Art News* 77 (January 1978):128.
———. "An Ancient Land's Newborn Art." *Art News* 77 (May 1978):45, 47, 51.
———. "Grappling with Ambivalent Feelings." *Art News* 79 (Summer 1980):216-18.

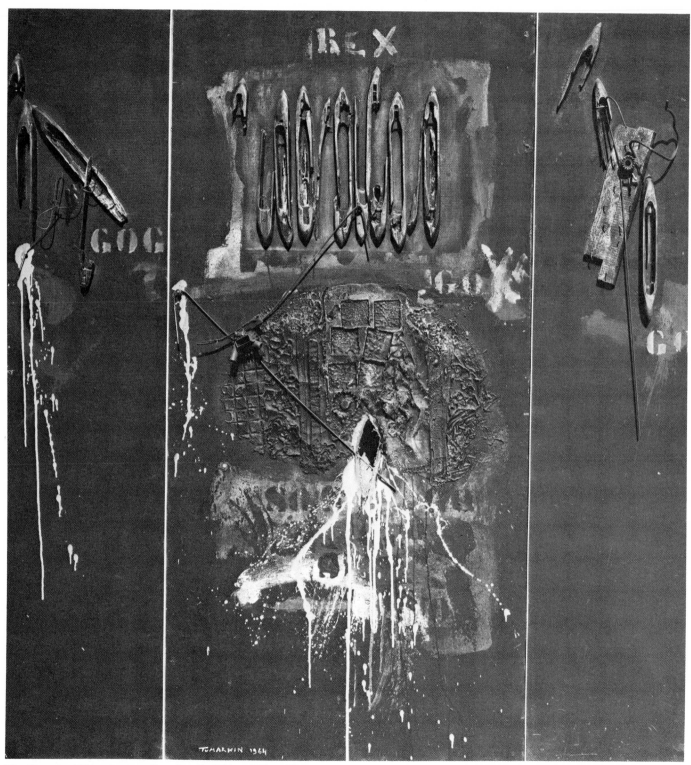

War Memories, 1964, mixed media, triptych, 77¼ × 76½ × 7 in.
(196 × 194 × 17 cm.). Collection Mr. and Mrs. Israel Zafrir, Tel Aviv.

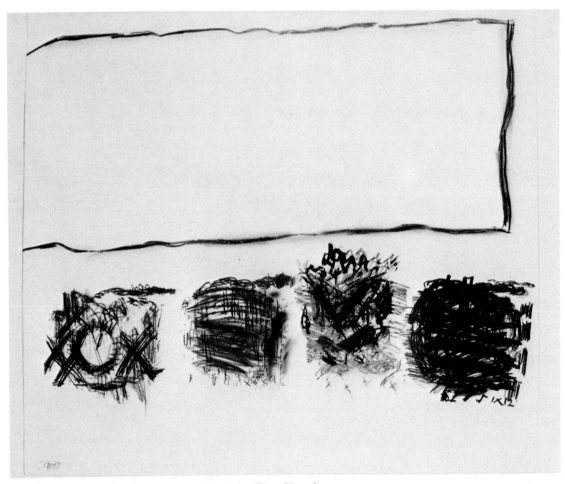

Untitled, 1976, color drawing on paper, 27 × 32 in. (71 × 81 cm.).
Collection Mrs. Sara Levi, Tel Aviv.

AVIVA URI

Born 1927, Safed, Palestine;
lives in Tel Aviv

studied drawing in Tel Aviv with David Hendler, whom she
married; restricts herself to drawing until late 1960s, bold and
expressive abstract sketches built on spontaneous and rhythmic
hand gestures. *1956* Dizengoff Prize. *1960* exhibits with 10+
group. *1976* Sandberg Prize.

Individual Exhibitions
The Tel Aviv Museum, 1957.
Rina Gallery, Jerusalem, 1960.
Gordon Gallery, Tel Aviv, April
1968.
The Israel Museum, Jerusalem,
"Drawings," February-March
1971. Catalogue text by Yona
Fischer.
The Tel Aviv Museum,
"Drawings," March-May 1977.
Catalogue text by Sara
Breitberg.

Major Group Exhibitions
Bezalel National Museum,
Jerusalem, "Israel: Watercolors,
Drawings, Graphics
1948-1958," April 1958.
Bezalel National Museum,
Jerusalem, "Twelve Artists,"
1958.
Lugano, Switzerland,
"Biennale," 1960.
Venice, "XXX Biennale," 1960.
Paris, "II Biennale," 1961.
The Israel Museum, Jerusalem,
"Trends in Israeli Art," 1965.

The Tel Aviv Museum, "Autumn
Salon," 1968, 1969, 1970.
University Art Gallery, State
University of New York at Al-
bany, "A Leap of Faith," 1969.
Florence, Italy, "Graphics
Biennale," 1970.
High Museum of Art, Atlanta,
"Israel on Paper," 1970.
The Tel Aviv Museum, "Israeli
Art: Painting, Sculpture,
Graphic Works," 1971.
The Israel Museum, Jerusalem,
"From Landscape to
Abstraction . . . ," 1972.
Ministry of Exterior, Jerusalem,
"Works on Paper . . . ,"
1973-74.
The Israel Museum, Jerusalem,
"Beyond Drawing," 1974.
Louisiana Museum,
Copenhagen, "10 Kunstnere
fra Israel [10 Israeli Artists],"
1977.
The Israel Museum, Jerusalem,
"From the Collection of Dr.
Moshe Spitzer, Jerusalem,"
March 1978. Catalogue text by
Moshe Spitzer, no. 172.
A.I.R. Gallery, New York,
"Artists from Israel,"
September 6-22, 1979.
Jerusalem City Museum (David's
Tower), "Jerusalem and the
Israeli Printmaker," 1980.

Selected Bibliography
Articles and General References
Tammuz, Benjamin, and
Wykes-Joyce, Max, eds. *Art in
Israel.* Tel Aviv: Massada, 1965.
Pp. 42, 43.
Tal, Miriam. "Israel Art Comes
of Age." *Ariel* 29 (Winter
1971):17.
Encyclopaedia Judaica. Jerusalem:
Keter Publishing Ltd., 1972.
Shechori, Ran. *Art in Israel.*
New York: Schocken Books,
1976. P. 199.
Debel, Ruth. "What Does It
Mean To Be an Israeli Artist?"
Art News 77 (May 1978):53-54.
"Art Notes: Aviva Uri." *Ariel*
45-46 (1978):237-38.
Ronnen, Meir. "An Ancient
Land's Newborn Art." *Art
News* 77 (May 1978):48, 50.
Breitberg, Sara. "Women's Art
in Israel." *Ariel* 49 (1979):58-63.
Lippard, Lucy R. "Artists from
Israel at A.I.R." *Art in America*
68 (January 1980):110.

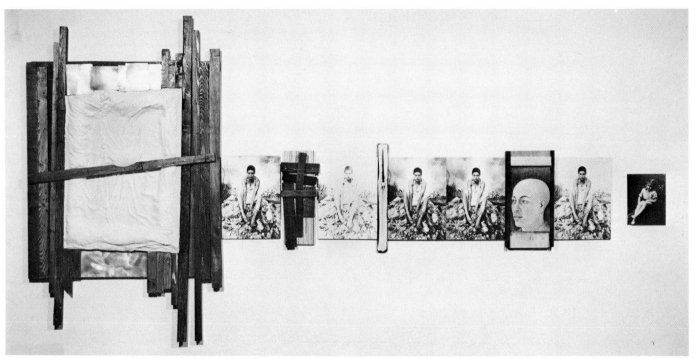

Visual Images #8, 1979, mixed media, 64 × 121½ in. (163 × 307 cm.).
Collection The Israel Museum, Jerusalem.

YOCHEVED WEINFELD

Born (Ernst) 1947 Legnica, Poland;
lives in New York and Israel

1957 emigrates to Israel. *1963-67* studies with Raffi Lavie in Ramat
Gan. *1966-67* studies at State Art Teachers Training College and
Tel Aviv University. *1967* settles in Jerusalem; artist and educator
at Israel Museum's youth wing; combines elements of painting
assemblage, body art, photography, and written messages to make
a conceptual as well as a visual statement; work employs the
element of exposure — personal, intimate situations related to
family and femaleness often expressed in the context of Jewish
experience. *1967-77* studies at Hebrew University, Jerusalem.
1976-77 works in South Africa; M.F.A. from University of
Capetown. *1979* New York and Israel.

Individual Exhibitions
Mabat Art Gallery, Tel Aviv,
"Paintings and Drawings,"
1969.
Little Gallery, Jerusalem,
"Drawings," 1971.
Bar-Kochba Gallery, Tel Aviv,
"Paintings," 1972.
Debel Gallery, Ein Kerem,
"Yocheved Weinfeld," 1974.
Debel Gallery, Ein Kerem,
"Pains," 1975.
Debel Gallery, Ein Kerem,
"Yocheved Weinfeld," 1976.
The Israel Museum, Jerusalem,
June-July 1979. Catalogue text
by Stephanie Rachum, no. 191.

Major Group Exhibitions
Gordon Gallery, Tel Aviv,
"10+," 1967, 1969, 1970.
Gan Haem, Haifa, "Contem-
porary Israeli Art," 1970.
Ramat Gan Museum, Israel,
"Contemporary Israeli Art,"
1971.
Artists Pavilion, Tel Aviv, "Sara
Gilat Presents," Summer 1972.
Ramat Gan Museum, Israel,
"Contemporary Israeli Art,"
1973.
The Israel Museum, Jerusalem,
"Beyond Drawing," 1974.
Artists' House, Tel Aviv,
"Performance '76," June 20-25,
1976. Catalogue text by Gideon
Ofrat.
Louisiana Museum, Copenhagen,
"10 Kunstnere fra Israel
[10 Israeli Artists]," 1977.
The Tel Aviv Museum, "Artist
and Society . . . ," 1978.
The Tel Aviv Museum, "Artist's
Choice," 1979.
A.I.R. Gallery, New York,
"Artists from Israel . . . ,"
1979.

Selected Bibliography
Articles and General References
Ronnen, Meir. "Mourning and
Menses." *Jerusalem Post*, May
14, 1976.
Ronnen, Meir. "Whimsey and
Poetry; Traumas and Taboos."
Art News 75 (September
1976):105.
Debel, Ruth. "What Does It
Mean To Be an Israeli Artist?"
Art News 77 (May 1978):55-56.
Ronnen, Meir. "An Ancient
Land's Newborn Art." *Art
News* 77 (May 1978):47, 50.
Breitberg, Sarah. "Women's Art
in Israel." *Ariel* 49 (1979):55,
64-65.
Ronnen, Meir. "Portrait of the
Artist as a Very Young
Persecuted Jewish Female."
Jerusalem Post, June 8, 1979.
Lippard, Lucy R. "Artists from
Israel at A.I.R." *Art in America*
68 (January 1980):109.

YOSEF ZARITSKY

Born 1891 Borispol, Ukraine;
lives in Tel Aviv and Kibbutz Tsova

1914 graduates from Academy of Arts, Kiev. *1923* emigrates to
Palestine; watercolors of Jerusalem where he lived and Safed.
1927 settles in Tel Aviv. *1927-29* studies and works in Paris.
1927-45 watercolor landscapes and still lifes in free, dynamic brush
strokes and delicate, lyrical color. *1947-48* dismissed as chairman
of Association of Painters and Sculptors of Palestine; among
founders and later leader of New Horizons group; great influence
on younger artists. *1950s* moves to total abstraction; largely
responsible for Lyrical Abstraction, carefully composed and
balanced paintings built in thick splashes of color, suffused with
light. *1954-56* lives and works in Paris and Amsterdam.
1960 Israel Prize. *1967* Sandberg Prize.

Individual Exhibitions
Bezalel National Museum,
Jerusalem, March-April 1930.
The Tel Aviv Museum,
Dizengoff House, 1951.
Bezalel National Museum,
Jerusalem, "Retrospective,"
1952.
Stedelijk Museum, Amsterdam,
September-October 1955.
Gordon Gallery, Tel Aviv,
"Watercolors 1920-1975," May
1976.

Major Group Exhibitions
The Tel Aviv Museum, "Group
of Seven," 1947.
The Tel Aviv Museum,
Dizengoff House, "New
Horizons," 1948.
Institute of Contemporary Art,
Boston, "Seven Painters of
Israel," 1953.
Bezalel National Museum,
Jerusalem, "Israel: Watercolors,
Drawings, Graphics
1948-1958," 1958.
America-Israel Cultural
Foundation, and the
International Council of The
Museum of Modern Art, New
York, "Art Israel: 26 Painters
and Sculptors," 1964.
The Israel Museum, Jerusalem,
"Trends in Israeli Art," 1965.

Musée du Petit Palais, Paris,
"Israël à travers les âges," 1968.
The Israel Museum, Jerusalem,
"Migdal David . . . ," 1968.
Whitechapel Art Gallery,
London, "Agam, Lifshitz,
Zaritsky: Three Israeli Artists,"
1969-70.
University Art Gallery, State
University of New York at
Albany, "A Leap of Faith,"
1969.
High Museum of Art, Atlanta,
"Israel on Paper," 1970.
Memorial Art Gallery of The
University of Rochester, New
York "Looking Up . . . ,"
1971.
The Tel Aviv Museum, "Israeli
Art: Painting, Sculpture,
Graphic Works," 1971.
The Israel Museum, Jerusalem,
"From Landscape to
Abstraction . . . ," 1972.
Museum of Modern Art, Haifa,
"Self-Portrait in Israel Art,"
1973.
Maurice Spertus Museum of
Judaica, Chicago, "Israeli Art
in Chicago Collections," 1974.
The Jewish Museum, New York,
"Jewish Experience in the Art
of the Twentieth Century,"
October 16, 1975-January 25,
1976. Catalogue text by Avram
Kampf.

The Israel Museum, Jerusalem,
"A Tribute to Sam Zacks:
Selected Paintings, Drawings,
and Sculptures from the Sam
and Ayala Zacks Collection,"
Summer 1976. Circulated to
The Tel Aviv Museum,
Autumn 1976. Exhibition
catalogue no. 146.
The Israel Museum, Jerusalem,
"From the Collection of Dr.
Moshe Spitzer, Jerusalem,"
March 1978. Catalogue text by
Moshe Spitzer, no. 172.
The Tel Aviv Museum, "Israel
Art 30 + 30," 1978.
Canada-Israel Cultural
Foundation, Ottawa, "Israel
Art Festival . . . ," 1978.
Tel Aviv University, University
Gallery, "Graphic Works by 30
Israeli Artists," 1978.
Los Angeles County Museum of
Art, "Seven Artists in Israel,
1948-1978," 1978-79.
Museum of Modern Art, Haifa,
"30 Years to New Horizons,
1948-1978," 1979.

Selected Bibliography
Articles and General References
Gamzu, Haim. *Painting and
Sculpture in Israel.* Tel Aviv:
Dvir, 1958. P. 59.
Tammuz, Benjamin, and
Wykes-Joyce, Max, eds. *Art in
Israel.* Tel Aviv: Massada, 1965.
Pp. 28-30, 32-33, 35, 43.
Tal, Miriam. "Israel Art Comes
of Age." *Ariel* 29 (Winter
1971):14.
Encyclopaedia Judaica. Jerusalem:
Keter Publishing Ltd., 1972.
Shechori, Ran. *Art in Israel.*
New York: Schocken Books,
1976. P. 199.
Rahmani, L. Y. *The Museums of
Israel.* London: Secker and
Warburg, 1976. P. 138, n. 175.
Ronnen, Meir. "An Ancient
Land's Newborn Art." *Art
News* 77 (May 1978):45, 47, 51.
Larsen, Susan C. "The New
Prominence of Israeli Art." *Art
News* 78 (March 1979):92, 94.
Kasher, Steven. "Seven Artists
of Israel." *Artforum* 17
(Summer 1979):50-51.
Megged, Matti. "The Old-New
Land: Israel." *Arts Canada*
(December-January 1979-80):34.

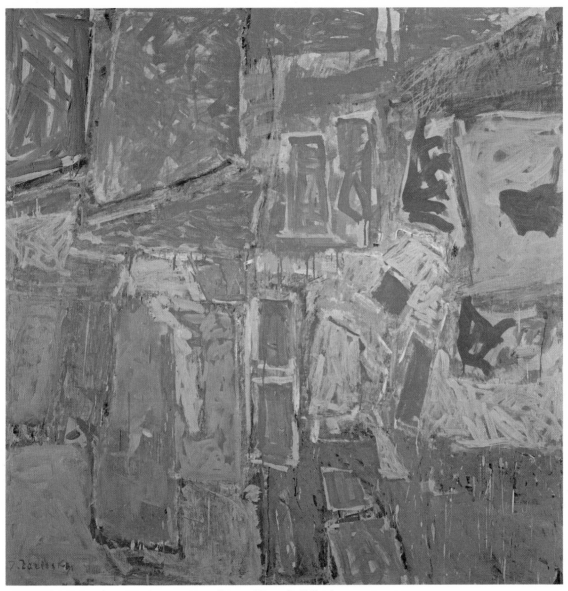

Composition, 1962, oil on canvas, 61 × 61 in. (155 × 155 cm.). Collection
Stedelijk Museum, Amsterdam.

Group Exhibitions of Israeli Art

The following exhibitions were devoted exclusively to Israeli artists. Only museum or special exhibitions are included here. The list is arranged chronologically, and alphabetically within the same year, beginning with the earliest dates.

When an Israeli artist was included in a group exhibition with artists of other nationalities, that exhibition is included in the "Major Group Exhibitions" section of the entry for that artist.

Migdal David (Tower of David), Jerusalem, 1921, 1922, 1924, 1925, 1926.

New York World's Fair, New York, Palestine Pavilion, 1939, 1940.

The Tel Aviv Museum, Habimah House, "Group of Seven," 1947.

The Tel Aviv Museum, Dizengoff House, "New Horizons," 1948, 1949, 1950.

Bezalel National Museum, Jerusalem, "Artistes de Jerusalem," August 1949.

Artists' House, Tel Aviv, "New Horizons," April 1952.

Institute of Contemporary Art, Boston, "Seven Painters of Israel," January 22-February 13, 1953. Circulated to Museum of Art, Carnegie Institute, Pittsburgh; Metropolitan Museum of Art, New York; Albright-Knox Art Gallery, Buffalo; Baltimore Museum of Art; Los Angeles County Museum of Art; Tucson Fine Arts Association; J. L. Hudson Company, Detroit.

The Tel Aviv Museum, "New Horizons," November 1953.

Galleria Nazionale d'Arte Moderna, Rome, "Arte Moderna di Israel," December 1954-January 1955.

Palais des Beaux-Arts, Brussels, "Art Israélien," April 26-May 19, 1955.

São Paulo, Brazil, "III Bienal: 7 Artistas de Israel," 1955.

Stedelijk Museum, Amsterdam, "Israëlische Kunst," January 20-February 20, 1955. Catalogue text [Dutch] by Theodor Ghort and Eugene Kolb.

The Tel Aviv Museum, Dizengoff House, "New Horizons," April 1955.

The Tel Aviv Museum, Dizengoff House, "New Horizons," May 1956.

Museum of Modern Art, Haifa, "New Horizons," December 1957.

The Tel Aviv Museum, "Modern Israel Art in Its Beginnings 1920-1930," May 1957. Catalogue text by Eugene Kolb.

Arts Council of Great Britain, London, "Modern Israeli Painting," 1958.

Bezalel National Museum, Jerusalem, "Israel: Watercolors, Drawings, Graphics 1948-1958," April 1958. Circulated to The Tel Aviv Museum; Museum of Modern Art, Haifa; Museum of Art (Mishkan Leomanut), Ein Harod. Catalogue text by Yona Fischer.

Bezalel National Museum, Jerusalem, "Twelve Artists," September 1958. Catalogue text by Yona Fischer.

Kunstmuseum, Bern, Switzerland, "Modern Painting from Israel," 1958. Circulated to Basel, Oslo, Athens.

São Paulo, Brazil, "V Bienal: Artistas de Israel," 1959.

New York Coliseum, "Forms from Israel," 1959.

The Tel Aviv Museum, Helena Rubinstein Pavilion, "New Horizons," April 1959.

Musée National d'Art Moderne, Paris, "L'art Israélien contemporain," April 7-May 1960.

Museu de Arte Moderna de São Paulo, Brazil, "Twenty Israeli Artists," April-May 8, 1960.

The Tel Aviv Museum, Helena Rubinstein Pavilion, "Modern Art in Israel," 1961.

Seibu Store, Tokyo, "Modern Art of Israel," April 10-17, 1962. Circulated to Osaka.

Bezalel National Museum, Jerusalem, "Today's Forms," April 1963.

Galerie Charpentier, École de Paris, "Peintres Israéliens," 1963.

Miami Museum of Modern Art, "Israeli Prints and Drawings," 1963. Catalogue text by Elisheva Cohen.

Museum of Art (Mishkan Leomanut), Ein Harod, "New Horizons," 1963.

America-Israel Cultural Foundation, New York, "23 Israel Artists," 1964. Circulated to Bezalel National Museum, Jerusalem; The Tel Aviv Museum, Helena Rubinstein Pavilion; Museum of Modern Art, Haifa; Negev Museum, Beersheba; Museum of Art (Mishkan Leomanut), Ein Harod. Catalogue text by William C. Seitz. (Later circulated, with new catalogue and three additional artists, as the exhibition listed next.)

America-Israel Cultural Foundation, and the International Council of The Museum of Modern Art, New York, "Art Israel: 26 Painters and Sculptors," 1964. Opened at The Jewish Museum, New York, December 9; circulated to Toledo Museum of Art; Contemporary Arts Center, Cincinnati; Rose Art Museum, Brandeis University, Waltham, Massachusetts; Art Institute of Chicago; Detroit Institute of Arts; Philadelphia Museum of Art; Museum of Art, Carnegie Institute, Pittsburgh; Montreal Museum of Fine Arts; Art Gallery of Ontario, Toronto; Winnipeg Art Gallery; Seattle Art Museum; San Francisco Art Museum; Los Angeles Municipal Art Gallery; Portland Museum of Art, Oregon. Catalogue text by William C. Seitz.

The Tel Aviv Museum, "Tatzpit," April-May 1964.

The Tel Aviv Museum, "Autumn Salon," October-November 1964, 1965, 1966, 1967, 1968, 1969, 1970.

Gemeentemuseum Arnhem, Holland, "Schilders uit Israël [Painters of Israel]," September 10-October 17, 1965.

The Israel Museum, Jerusalem, "Trends in Israeli Art," May 11-June 28, 1965. Catalogue text by Yona Fischer.

Museum of Modern Art, Haifa, "Israeli Drawings," 1965.

Artists' House, Tel Aviv, "10+," February 1966.

The Israel Museum, Jerusalem, "New Horizons 1949-1963," January 1966. Catalogue text by Yona Fischer.

The Israel Museum, Jerusalem, "Labyrinth: An Environment by Israeli Artists," February 28, 1967. Catalogue text by Yona Fischer.

The Tel Aviv Museum, "Image — Imagination: 12 Israeli Artists," January-February 1967. Catalogue Introduction by Haim Gamzu.

The Israel Museum, Jerusalem, "Migdal David: The Beginnings of Painting in Eretz-Israel," October 1968. Catalogue text by Yona Fischer.

Musée du Petit Palais, Paris, "Israel à travers les âges," May-September 1968. Catalogue text [French] by M. Avi Yonah.

Museum Boymans van Beuningen, Rotterdam, "Grafiek uit Israël," May 8-June 23, 1968. Catalogue Foreword by R. Hammacher-v.d. Brande; catalogue Introduction by Elisheva Cohen [Dutch].

Ateneul Roman, Bucharest, Romania, "Expozitia de Pictura Contemporana din Israel," 1969.

University Art Gallery, State University of New York at Albany, "A Leap of Faith," October 26-November 23, 1969. Catalogue Foreword by Donald Mochon; catalogue text by Bertha Urdang.

Museum of Modern Art, Haifa, "Michael Gross, Yitzhak Danziger, Yehiel Shemi: Sculptures," 1969-70. Catalogue text by the artists.

Whitechapel Art Gallery, London, "Agam, Lifshitz, Zaritsky: Three Israeli Artists," 1969-70.

High Museum of Art, Atlanta, "Israel on Paper," February 22-March 22, 1970. Catalogue text by Bertha Urdang.

The Israel Museum, Jerusalem, "Concepts + Information," February 1971. Exhibition catalogue no. 76.

The Israel Museum, Jerusalem, "Expressionism in Eretz-Israel in the Thirties and Its Ties with the École de Paris," Autumn 1971. Catalogue text by Yona Fischer.

Memorial Art Gallery of The University of Rochester, New York, "Looking Up . . . Paintings, Graphics, and Sculptures, Israel, 1971," April 1971. Catalogue text by Bertha Urdang.

The Tel Aviv Museum, "Israeli Art: Painting, Sculpture, Graphic Works," April 1971. Catalogue Introduction by Haim Gamzu.

Gallery House, London, "Affidavit, Idea-Process Document by Six Israeli Artists," November 30-December 1972.

The Israel Museum, Jerusalem, "From Landscape to Abstraction — From Abstraction to Nature," October-November 1972. Catalogue text by Yona Fischer.

Museum of Modern Art, Haifa, "Self-Portrait in Israel Art," Autumn 1973. Catalogue text by Gabriel Tadmor.

Yad Lebanim, Petach Tikva, "The Five," March-April 1973.

Ministry of Exterior, Jerusalem, "Works on Paper: Travelling Exhibition of Four Israeli Artists," October 1973-74. Circulated to Antwerp, Helsinki, Milan, Rome, The Hague. Catalogue Introduction by Amnon Barzel.

The Israel Museum, Jerusalem, "Beyond Drawing," Spring 1974. Catalogue text by Meira Perry.

Maurice Spertus Museum of Judaica, Chicago, "Israeli Art in Chicago Collections," July 15-August 25, 1974. Catalogue Introduction by Grace Cohen Grossman.

Museum of Modern Art, Haifa, "Aclim [Climate]," June-July 1974. Catalogue text by Miriam Tal.

Worcester Art Museum, Massachusetts, "Three Israeli Artists: Gross, Neustein, Kupferman," September 10-October 5, 1975. Catalogue text by Yona Fischer and Richard Stuart Teitz.

Louisiana Museum, Copenhagen, "10 Kunstnere fra Israel [10 Israeli Artists]," January 15-February 13, 1977. Catalogue Preface by Hugo Arne Buch; catalogue text by Yona Fischer [Danish].

Canada-Israel Cultural Foundation, Ottawa, "Israel Art Festival To Celebrate Israel's 30th Anniversary," 1978. Circulated to Ottawa Art Centre, Toronto. Catalogue Introduction by Gabriel Tadmor.

Illinois Bell, Lobby Gallery, Chicago, "Printmaking in Israel Today," October 18-November 16, 1978. Catalogue text by Yona Fischer.

Museum of Modern Art, Haifa, "Exhibitions from the Museum Collections on the Occasion of Its Re-opening," Spring 1978. Catalogue Introduction by Gabriel Tadmor; catalogue text by Ioana Nicolau.

Uri and Rami Nechushtan Museum, Kibbutz Ashdot Yaakov, "Location/Duration," 1978.

Catalogue Introduction [Hebrew] by Ygal Zalmona.

The Tel Aviv Museum, "Artist and Society in Israeli Art 1948–1978," August-September 1978. Catalogue Introduction by Marc Scheps; catalogue text by Sara Breitberg.

The Tel Aviv Museum, "Israel Art 30 + 30," Summer 1978.

Tel Aviv University, University Gallery, "Graphic Works by 30 Israeli Artists," 1978. Catalogue text by Mordecai Omer.

Los Angeles County Museum of Art, "Seven Artists in Israel, 1948-1978," November 21, 1978-February 4, 1979. Circulated to the Brooklyn Museum. Catalogue text by Stephanie Barron and Maurice Tuchman.

A.I.R. Gallery, New York, "Artists from Israel: An Exhibition of Works by Six Women," September 6-22, 1979.

Centraal Museum, Utrecht, "Abstracte Grafiek uit Israël," 1979. Circulated in The Netherlands. Catalogue text [Dutch] by Meira Perry-Lehmann and Wouter Kotte.

The Israel Museum, Jerusalem, "The Kadishman Connection," Winter-Spring 1979. Catalogue text by Stephanie Rachum and Nurit Shilo-Cohen.

Museum of Modern Art, Haifa, "30 Years to New Horizons, 1948-1978; Works from the Museum Collection," Spring 1979. Catalogue text by Gabriel Tadmor.

The Tel Aviv Museum, "Artist's Choice," March-April 1979. (Organized by Israel Painters and Sculptors Association.)

The Israel Museum, Jerusalem, "Borders," Spring-Summer 1980. Catalogue text by Stephanie Rachum, Amia Lieblich, and Ehud Ben-Ezer.

Jerusalem City Museum (David's Tower), "Jerusalem and the Israeli Printmaker," March 9-May 15, 1980. Catalogue text by Mordecai Omer.

University of Haifa Art Gallery, "The Myth of Canaan: The Influence of the Ancient Middle East on Modern Israeli Art," June 7-July 31, 1980. Catalogue text by Avram Kampf.

Müncher Stadtmuseum, Munich, "Israelische Künstler Heute [Israel Art Today]," October 17-31, 1980. Catalogue text [German] by Yona Fischer.

Selected Bibliography of Israeli Art

Books

Gamzu, Haim. *The Painter's Eye in Israel*. Tel Aviv: Hazvi, 1957.

————. *Painting and Sculpture in Israel*. Tel Aviv: Dvir, 1958.

Katz, Karl; Kahane, P. P.; and Broshi, Magen. *From the Beginning: Archaeology and Art in The Israel Museum*. Jerusalem: The Israel Museum, 1968.

Newman, Elias. *Art In Palestine*. New York: Siebel Company, 1939.

Rahmani, L. Y. *The Museums of Israel*. London: Secker and Warburg, 1976.

Schwarz, Karl. *Modern Jewish Art in Palestine*. Jerusalem: Reuven Mass, 1941.

Shechori, Ran. *Art in Israel*. New York: Schocken Books, 1976.

Tammuz, Benjamin, and Wykes-Joyce, Max, eds. *Art in Israel*. Tel Aviv: Massada, 1965.

Articles and General References

Ardon, Mordecai. "Whither Israel Art?" *Ariel* 10 (Spring 1965):33-38.

Baruch, Adam. "Young Israeli Artists: Part I: The Context." *Studio International* 193 (January-February 1977):32-34.

————. "Young Israeli Artists: Part II: The Artists." *Studio International* 193 (March-April 1977):142-43.

Breitberg, Sara. "Women's Art in Israel." *Ariel* 49 (1979):50-68.

Coates, Robert M. "Israel, Past and Present." *New Yorker* 29 (June 1953):71-73.

Debel, Ruth. "What Does It Mean To Be an Israeli Artist?" *Art News* 77 (May 1978):52-56.

Encyclopaedia Judaica. Jerusalem: Keter Publishing Ltd., 1972.

Fischer, Yona. "Israeli Art Today." In Will Grohmann, ed., *Art in Our Time*. London: Thames and Hudson, 1966. Pp. 258-61.

————. "From 'New Horizons' to 'Ten Plus.'" *Ariel* 22 (Spring 1968):63-67.

————. "Young Israeli Art." In *Readings in Jewish Art*, No. 6. New York: National Council on Art in Jewish Life, under the auspices of the American Jewish Congress, n.d.

Frank, Peter. "Worcester: A Specifically Israeli Flavor." *Art News* 75 (January 1976):95-97.

————. "Israelism and Abstraction." *Village Voice*, August 20, 1979, P. 79.

Friedman, Mira. "Art in Israel Today." In *Readings in Jewish Art*, No. 6. New York: National Council on Art in Jewish Life, under the auspices of the American Jewish Congress, n.d.

Goldfine, Gil. "In the Galleries: From Gordon-Dizengoff to Khutsot Hayoster." *Art News* 77 (May 1978):64-70.

Herzog, Chaim. "What Israel Is Really About." *Art News* 77 (May 1978):87-88.

Kasher, Steven. "Seven Artists of Israel." *Artforum* 17 (Summer 1979):50-54.

Katz, Karl. "Painting and Sculpture in Israel." *Atlantic Monthly* 208 (November 1961):100-110.

————; Roth, Cecil; and Gamzu, Haim. "Museums in Israel." *Art International* 9 (September 1965):21-48.

Larsen, Susan C. "The New Prominence of Israeli Art." *Art News* 78 (March 1979):92-94.

Lippard, Lucy. "Artists from Israel at A.I.R." *Art in America* 68 (January 1980):109-10.

Megged, Matti. "The Old-New Land: Israel." *Arts Canada* (December-January 1979-80):30-34.

Mindlin, Meir. "The Israeli Scene." *Commentary* 27 (March 1959):209-11.

Newman, Amy. "Martin Weyl: We Have To Describe What's Alive." *Art News* 77 (May 1978):62-63.

Ofrat, Gideon. "Tel Aviv and Jerusalem Art." *Ariel* 50 (1979):45-62.

Pincus-Witten, Robert. "The Sons of Light: An Observer's Notes in Jerusalem." *Arts Magazine* 50 (September 1975):64-74.

————. "Six Propositions on Jewish Art." *Arts Magazine* 50 (December 1975):66-69.

Plaut, James S. "Seven Painters of Israel." *Carnegie Magazine* 27 (March 1953):86-89.

Politzer, Heinz. "Two Artists and the Hills of Judea." *Commentary* 6 (December 1948):539-41.

Ronnen, Meir. "Art in Israel." *Midstream* 10 (September 1964):51-62.

————. "An Ancient Land's Newborn Art." *Art News* 77 (May 1978):44-52.

————. "Preserving the Past, Securing the Future." *Art News* 77 (May 1978):57-62.

————. "Grappling with Ambivalent Feelings." *Art News* 79 (Summer 1980):216-18.

Rouve, Pierre. "Israel with Us." *Art News and Review* 10 (March 1958):1, 3.

Schack, William. "Art in Modern Palestine." *Arts* [Brooklyn, N.Y.] 14 (October 1928):208-13.

————. "Israeli Painting: After Twenty-Five Years." *Commentary* 15 (June 1953):595-601.

Seitz, William. "23 Israel Artists." *Ariel* 8 (Summer 1964):5-17.

Spencer, Charles S. "Art in Israel: Sculpture in the Sun." *Studio International* 168 (August 1964):54-59.

————. "Israel, the Surrealist and Fantastic Factor in the New Art." *Studio International* 174 (October 1967):160-63.

Tal, Miriam. "Trends in Israeli Art." *Art International* 9 (September 1965):41.

————. "Israel Art Comes of Age." *Ariel* 29 (Winter 1971):8-22.

Werner, Alfred. "The Newest Israeli Art." *Congress Bi-Weekly, American Jewish Congress*, November 23, 1964. Pp. 11-13.

————. "Melting Pot: Third Phase." *Arts Magazine* 39 (January 1965):40-45.

————. "Art — Israel's New Frontier." In Robert Gordis and Moshe Davidowitz, eds., *Art in Judaism*. New York: National Council on Art in Jewish Life and Judaism, 1975. Pp. 98-105.

————. "Israeli Art and the Americans." *American Zionist* 68 (May 1978):24-26.

Wilkinson, Sadie. "Art and Music." In Israel Cohen, ed., *The Rebirth of Israel: A Memorial Tribute to Paul Goodman*. London: E. Goldston & Son, 1952. Pp. 298-310.